Galveston
CHRONICLES

Galveston
CHRONICLES

THE QUEEN CITY OF THE GULF

Edited by Donald Willett

THE
History
PRESS

Published by The History Press
Charleston, SC 29403
www.historypress.net

Cover: All cover images courtesy of Special Collections, Rosenberg Library, Galveston, Texas. *Top front*: "The Strand, 1894." *Bottom front*: *Beach Umbrellas Under Murdoch's Pier, Galveston*, by Grace Spaulding John. *Top back*: Dorothy Dell Goff, 1930 Miss Universe. *Middle back*: 1910 bathing beauty. *Bottom back*: *Street in Galveston*, by Boyer Gonzales.

First published 2013

Manufactured in the United States

ISBN 978.1.62619.182.2

Library of Congress CIP data applied for.

To Dr. Archie McDonald.
My friend and mentor who gently introduced me to the wonders of Texas history.

Contents

Acknowledgements

I wish to thank the many people who helped me complete this book. I especially want to thank the many archivists who found the artwork for this undertaking. This includes John Anderson, preservation officer, Texas State Library and Archives Commission; Sarita B. Oertling, manager, Library Services, the Blocker History of Medicine Collections, Moody Medical Library at the University of Texas Medical Branch in Galveston, Texas; and Andrea R. Jackson, head, Archives Research Center, Atlanta University Center, Robert W. Woodruff Library in Atlanta, Georgia. I also wish to thank the staff of the Rosenberg Library in Galveston, Texas. I especially want to thank Eleanor Barton, the head curator, and Travis Bible, the museum collection curator, at the Rosenberg Library Museum. Along with them, I also wish to thank Casey Green, the director of the Special Collections, and Carol Woods, the head archivist of the Galveston and Texas History Collection at this magnificent library. Special thanks go to the Kempner family of Galveston, especially former Galveston mayor Lyda Ann Thomas. She provided rare family pictures for use in this book. The Kempner Foundation generously provided funds to help defray the cost of publication. Without Joshua Anklam's technical expertise, this book would still be on a yellow legal pad.

I also wish to thank my commissioning editor, Becky LeJeune; my project editor, Ryan Finn; and the staff of The History Press for bringing this project to fruition. Any errors contained in this book are the fault of its editor.

Cannibals and Pirates

The First Inhabitants of Galveston

Donald Willett

The English settled Jamestown. The French settled Quebec. The Dutch settled New Amsterdam. And, the Spanish settled Mexico City. But who settled Galveston? Why cannibals and pirates, of course! Even though this sounds like a canned speech from a local island tour guide, there is more truth than fancy to this statement. The first known inhabitants of Galveston were the Karankawa Indians. Actually, that is not quite true. "Karankawa" is the collective name of five coastal Indian tribes who lived between Galveston and Matagorda Bays. Technically, the Cocos lived around Galveston Bay, but everyone (except anthropologists) calls the first residents of Galveston the Karankawa Indians.

The origins of the name "Karankawa" are somewhat obscure. All five tribes spoke the same language, Karankawa, but unfortunately, only about one hundred words exist to this day. Many early Texas chroniclers who wrote about the first Galvestonians believed that the word meant "dog-lover" or "dog-raiser." Many of these writers also mentioned that the Karankawas domesticated a small shorthaired dog that didn't bark. Maybe these facts are interrelated.

Archaeologists have not been able to pinpoint the Karankawas' origins. Some scholars believe that these people migrated from the Mississippi Valley and originally belonged to the Caddo Confederation. Other historians believe that these people arrived on the Texas coast via Central America and the Caribbean Islands and are an extension of the South American Carib culture.

Like the Galvestonians who followed, the Karankawas were a strange but interesting group of people. At first glance, their most striking characteristic was their height. They were huge, at least by fifteenth-century European standards. While the average European males stood about five foot, four inches tall, skeletal remains suggest that Karankawa males were at least six feet tall and that females stood over five feet, eight inches. The males were slender, well muscled and graceful; European descriptions of the Karankawa women suggested that they were not.

Both genders liked to decorate their bodies. They tattooed their faces and bodies with elaborate geometrical patterns and painted their torsos with black and ocher paints. They used these markings to signify marital status and tribal affiliation. Karankawa warriors also used these oils as a type of war paint. For most of the year, men wore little or no clothing, while women wore short skirts made of animal skins or Spanish moss. When the temperature dropped and a "blue norther" put a chill in the air, they wore animal skins and carried blankets over their shoulders. Apparently, Karankawa males were the fashion leaders in their tribe. They perforated their nipples and lower lips and wore cane ornaments in the piercings. Women did not decorate their bodies in this fashion.

The Karankawas evolved into a classic hunter-gatherer culture. They ate anything they could catch. Since they lived near the ocean, seafood dominated their diet. Like Galvestonians today, they feasted on oysters during the "r" months (September through April). They particularly liked the salty-sweet oysters that grew near sources of fresh water, like the Trinity River and Buffalo Bayou, both of which empty into Galveston Bay. To this day, middens of oyster shells dug up by the Karankawas litter the bay. They also liked to eat a large local clam whose flesh is tougher than shoe leather and whose shell is thick and impenetrable. To get around these natural defenses, the Karankawas tossed these bivalves on a fire, and within minutes, the shells opened and dinner was served!

The Karankawas caught and ate a lot of fish. They shot the fish with arrows and spears or constructed long reed traps and placed them during high tide at the mouths of shallow bayous and streams. When the tide crept out, the traps sometimes contained tasty delicacies like crabs, small fish and an occasional turtle. Maybe because seafood was so easy to catch, the Karankawas never invented the cast net, fishing pole or the hook.

They also dined on animals. These included deer, bear, snakes, other small mammals like rabbits and rodents and even buffalo. Since Galveston Bay lay on the southern boundary of the western Buffalo herd, occasionally

stragglers from this herd roamed near the bay, and some of them fell prey to Karankawa hunting parties. They also liked to eat berries, nuts, seeds and plants. During the summer months, these Indians stayed on the island and gorged on dewberries that still grow in abundance. In late summer, these Galvestonians migrated to local cactus patches. They ate the nopales (green oval-shaped cactus leaves) and feasted on the brightly colored and delicately sweet fruits called "tunas." In the late fall and early winter, they also harvested cattail roots. They split the tuber in half, scooped out the white fleshy strands and ground them into a meal. They used this flour to make a dough that they cooked into a type of Texas tortilla.

The Karankawas constructed the first ocean-view condos on Galveston Island. These dwellings, called *ba-aks*, were oval-shaped teepees that used willow branches for the frame. Women, who handled all domestic chores, including *ba-ak* building, first thrust these sticks into the sand until they formed a circular shape. Next they tied these rods together at the top. Finally, the women draped skins or reed mats over the portion of the *ba-ak* that faced the Gulf of Mexico. These structures perfectly fit the Karankawa lifestyle. They were highly portable, easy to build and could comfortably accommodate seven or eight early Galvestonians.

The Karankawas were skilled artisans. They wove distinctive reed baskets and mats and manufactured pottery vessels, which they coated on the inside with asphalt that washed up on the beach. They shaped wide-mouth jars, bowls and bottles with rounded bottoms and painted them with geometric patterns. These oddly shaped vessels perplexed early European settlers. Why produce pottery that could not stand up on a hard surface? The answer was simple. The Karankawas designed these vessels to stand upright in their natural environment: the sandy beaches of Galveston Island.

The Karankawas' main social and political unit was the family. Karankawa bands usually consisted of thirty to forty kinsmen who were guided by two chiefs—a civil chief, usually a respected elder, and a war chief, usually a younger male who led his warriors by physical prowess and acts of valor. Whenever bands needed to communicate over great distances, they used an elaborate system of smoke signals to bring the family together to fight an enemy or catch up on the latest news.

Marriage and children were the glue that held the band together. Parents arranged their children's marriages. After an exchange of gifts from the groom to the bride's parents, the couple began to live together. However, for several months after the marriage, the groom gave all foodstuffs he gathered to the bride's family, and they gave some of this food to their daughter. After

a prescribed amount of time, the young couple could enter the husband's family or band. After this, the husband ended all contact with his parents-in-law. The wife could socialize with members of either family. Unlike modern culture, problems with in-laws never plagued Karankawa families.

Karankawa culture revolved around the male-dominated "Cult of the Warrior." Every written account of the Karankawas, complimentary or not, agreed that they were fierce warriors who defended their homeland with skill and tenacity. Karankawa warriors never backed down from a fight, but they seldom engaged in offensive activities against any enemy. If another Indian tribe was foolish enough to invade Karankawa territory, these marauders were in for the fight of their lives.

A major key to their success was their waterborne and land-based mobility. Karankawa warriors loved to run. It was not unusual for them to traverse the length of the island, about twenty-one miles, and hardly break a sweat. The Karankawas also constructed large dugout canoes that they used in everyday life and on the battlefield. When they found an uprooted tree floating in the bay, they dragged it ashore. They first removed the branches. Then they hollowed out the middle of the trunk by setting small fires on top of the trunk and then removing the burnt wood after the fire died. They leveled the bow and the stern of the canoe and used these areas as platforms to fire at their enemies or to pole their craft. Particularly during the pre-Columbian era, this ability to deploy rapidly by land and by sea usually gave the Karankawa warriors a tactical advantage over any Indian war party foolhardy enough to invade their turf.

If the invaders chose to attack, the Karankawas met them with an arsenal of weapons crafted from local material. They fought with lances tipped with shell fragments or flint arrowheads. They acquired the flint from inland Texas Indian tribes in exchange for seashells gathered on the beach. They deftly swung jagged clubs or tomahawks topped with smooth stones that washed ashore or settled in the riverbeds that flowed into the bay. Their most effective weapon was the bow and arrow. The Karankawa bow and arrow was a powerful and accurate weapon. The arrow was about three feet long and made out of cane. The Karankawas placed a three- to four-inch solid wooden dowel at each end of the shaft. They notched one end and attached three feathers above the notch. The other end contained the arrowhead, made either of sharpened shell or of flint.

The bow stood as tall as the man who used it, usually about six feet in length. The Karankawas constructed the bow from a local salt cedar tree that is very rigid and gnarled and possesses tremendous tensile strength.

These powerful bows could shoot an arrow a long distance with great speed and accuracy. Several early accounts suggested that Karankawa arrows could easily pass through a human or animal body seventy-five yards away. One early Anglo settler spied a Karankawa hunter who "[a]imed at a bear, three years old, that had taken refuge in the top of a tree, it [the arrow] went through the brute's body and was propelled forty or fifty yards beyond." Another Texan recalled an incident when Karankawa warriors fired several arrows at him. Although he was more than two hundred yards away, these projectiles "[w]ere driven to the feather in the alluvial bank."

Captured enemies of the Karankawas confronted a gruesome future. They faced the "mitote." Tribal members staked the prisoners to the ground and then built a bonfire. As the fire blazed, members of the tribe began to dance around the flames and imbibe a local intoxicant. At the appropriate moment, the warriors sliced a piece of the victim's flesh, roasted it in the fire and then consumed it in front of the captive. One Spanish friar, after spending three days observing a Karawanka mitote, described what followed: "Thus they continue cutting him to pieces and dismembering him, until, finally, they have cut away all of the flesh and he dies. They cut off the skull and, with the hair still clinging to it, place it on a stick so as to carry it in triumph during the dance. They do not throw away the bones, but pass them around, and whoever happens to get one sucks it until nothing of it is left." The Karankawas believed that this ritualistic cannibalism helped them to absorb their enemy's strength and valor.

Although they did not know it at the time, the year 1519 marked the beginning of the end of the Karankawa people. Sometime after March of that year, Karankawas walking on Galveston beach spied four strangely shaped clouds hovering close to the horizon. These unfamiliar formations, which looked like they rested on tiny moving islands, continued to drift strangely toward the south and slowly fell out of view. In fact, these clouds were the outlines of four Spanish ships, under the command of Álvarez de Pineda. This moment in history marked the first time that a European spied Galveston Island and the first time that a Karankawa saw a Spanish vessel. This "clash of cultures" would eventually lead to the extermination of Galveston's first inhabitants.

After this startling event, life on Galveston Island quickly returned to normal and remained so for the next nine years. On November 6, 1528, the Karankawas made "first contact" with creatures from parts unknown. That morning, ninety pasty-looking men washed ashore from two hide-covered rafts. They were survivors from the ill-fated 1527–28 expedition of Pánfilo

de Narváez. As these strangers waded ashore, the Indians made a fateful choice. They decided to feed these people and treat them kindly. Thanks to the Karankawas' help, most of the Spaniards survived. These survivors, because of the worsening weather, decided to spend the winter on the island and continue their journey down the coast as soon as possible.

That winter was one of the coldest on record. The bay froze, and normally reliable sources of food disappeared. By the time the weather moderated, only fifteen Spaniards remained. For one group, the situation became so extreme that they ate their fallen comrades. This act of dietary cannibalism angered and disgusted the local Indians. In *The Narrative of Alvar Nuñez, Cabeza de Vaca*, the first book to mention Galveston, the author observed, "This [the discovery of the eaten bodies] produced great commotion among the Indians giving rise to so much censure that had they known in the season to have done so, doubtless they would have destroyed any survivor." This famous passage led some anthropologists to theorize that the Spaniards introduced cannibalism to the Karankawas. Other scholars claimed that this practice existed long before any European walked on Galveston's beaches. However, this academic jousting brought no comfort to anyone who underwent a Karankawa mitote.

Eventually, the Spaniards departed, but not before they nicknamed Galveston "La Isla de Malhado" (the Isle of Misfortune). After seven years of wandering throughout the Southwest, Cabeza de Vaca and three companions, including the first African in Galveston, Estevanico, returned to Spanish-occupied Mexico. De Vaca's book—particularly his grim descriptions of the land, especially La Isla de Malhado, and his mention of the seven golden cities of Cibola—caused government officials to rethink their policy of settling the coastal areas near the Gulf of Mexico. This change of heart bought the Karankawas almost three centuries of relative freedom, but they would never again know peace.

With the Spaniards gone, the Karankawas' world returned to normal. Occasionally, the white man returned to Galveston, but only for a while. Some accounts suggested that during the seventeenth century, Dutch pirates sometimes used Galveston as a base of operations while plundering the Spanish Main. In 1785, the Spanish navigator and explorer Jose Antonio de Evia briefly anchored near the island, sounded the bay and drew the first map of Galveston Bay. He named this body of water for the viceroy of Mexico, Bernardo de Gálvez, but labeled the island "Isla de Culebra" (Snake Island). Strangely, he never mentioned anything about the local inhabitants.

By the first decades of the nineteenth century, the winds of change had swept over the Spanish world and eventually reached Galveston. Napoleon Bonaparte's conquest of the Iberian Peninsula left the Spanish empire in tatters. After Napoleon's defeat at Waterloo, many Latin Americans of Spanish descent, especially in Mexico, began to question the need to submit to Spain's control. They, like the Anglo-Americans a generation before, dreamed of independence and self-rule. In 1810, Mexico, which at this time included the northern province of Texas, declared independence and began an eleven-year struggle for nationhood. This declaration unleashed two powerful forces—political revolution and piracy—that changed Galveston forever and signaled the genocide of the Karankawa people.

The Mexican Revolution reached Galveston Island in 1816, and things quickly changed. Luis Michael Aury, a pseudo-revolutionary pirate, arrived on the island, hoisted the rebel flag and proclaimed it to be an official port of entry for the new Mexican republic. This slight of hand allowed him legally to receive a letter of marque from the rebel government and engage in naval operations as a legal pirate against the Spanish government. Business was good, and booty was bountiful.

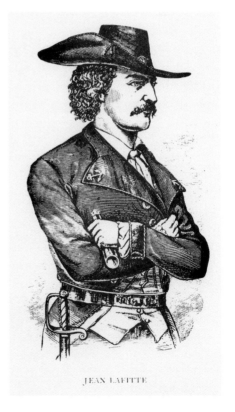

JEAN LAFITTE

Jean Lafitte, Galveston's most famous pirate. *Courtesy of Special Collections, Rosenberg Library, Galveston, Texas.*

Soon, treasures from Galveston arrived in New Orleans. Two groups in particular took note: exiled Mexican revolutionaries and ex-pirates looking to get back into the business. The first group, led by Henry Perry, an American soldier with ties to the Mexican Revolution, and Francisco Xavier Mina, a young Spaniard who favored the Mexican cause, headed to Galveston to continue their war against Spain. Soon their calls to attack the Mexican coast and take the battle to the Spanish clashed with Luis Aury's smoothly operating

pirate enclave. In order to rid himself of these two noisy impediments to business, Aury agreed to transport these rebels to their proposed invasion site near the port city of Soto La Marina. After that, they were on their own. Soon, Mina and Perry lay dead, cut down by the Spanish army, and Aury and his tiny pirate fleet headed home to Galveston to face the surprise of their lives.

Before them, resplendent in all his glory, stood Galveston's greatest pirate, Jean Lafitte. Outgunned and outmanned, Luis Aury quickly decided to move elsewhere. For Lafitte, it was time to start over again. He would use Galveston to reestablish one of the most infamous and profitable pirate operations in the history of the United States. Jean and his brother, Pierre, probably arrived in New Orleans in 1804 and quickly went to work. The siblings made a perfect team. Not unlike Rose Maceo in Galveston a century later, Pierre worked behind the scenes and took care of business while Jean Lafitte, and later Sam Maceo, served as the public face to their different criminal syndicates. Pierre established a blacksmith shop on Bourbon Street in New Orleans and used it as a cover to fence goods that his brother liberated on the high seas.

Jean went to Grand Terre, an island off the Louisiana coast just south of New Orleans, and built the port city of Barataria. It became the largest and most profitable pirate enclave on the Gulf of Mexico almost overnight. The plan was simple. Jean and his minions would capture Spanish ships on the high seas and bring them to Barataria. He would then transport this booty to New Orleans, where Pierre would sell this heavily discounted and tax-free loot to eager customers in and around the Crescent City. Everything worked smoothly until 1814, when the United States Navy arrived in Barataria and shut down the operation. Fate briefly intervened in January 1815 when Jean and his men helped General Andrew Jackson defeat the British at the Battle of New Orleans. These newly earned heroic accolades bought the Lafitte brothers some time, but the clock was ticking. In 1817, the United States Navy again returned to Barataria and ordered the pirate turned patriot turned privateer to leave the United States forever.

When Lafitte arrived on Galveston Island, he quickly took over Aury's buccaneering operation and continued business as usual. First, Lafitte pledged loyalty to the Republic of Mexico, and then he issued to himself a letter of marque. Next, he named his new headquarters Campeche and ordered his minions to raid the Spanish Main. Business was very good. Soon gold, silver, jewels and African slaves poured into Campeche. Pierre fenced the gold, silver and jewels at his blacksmith shop, while

Jean, along with help from another famous Texan, Jim Bowie, herded these illegal slaves up the Texas coast and into Louisiana. Once they crossed the border, Jean and Jim collected a reward from the United States government for turning in contraband African slaves. They then repurchased the reclassified legal American slaves and sold them for one dollar per pound to local plantation owners.

Lafitte located Campeche near the present-day University of Texas Medical Branch campus. At its peak, this pirate den counted more than two thousand inhabitants and 120 buildings (including the obligatory saloons, whorehouses and even a billiard hall) and grossed more than $2 million per year in stolen goods. On one occasion, a pirate ship returned to Campeche with a load of paint. Lafitte expropriated the cargo and ordered his followers to paint his newly constructed two-story headquarters with the bright-red paint. Lafitte named the building the *Maison Rogue*, or Red House, and it stood as one of the most notorious structures in early Texas history. He surrounded the building with a tall earthen wall and strategically placed two large cannons that overlooked the Campeche harbor.

Lafitte lived like a king. Several servants attended to his personal needs, and a gourmet chef, arguably the best in Texas, filled the pirate's dining table with decadent delights. He dined off gold and silver tableware and drank rare and exotic wines and liqueurs from priceless crystal goblets—all courtesy of captured Spanish plunder.

Shortly after he arrived in Galveston, the pirate met with local Karankawa leaders and hammered out an agreement between the two groups. The pirates promised to stay on the East End of the island in and around Campeche, and the Karankaws agreed to stay on the West End of the isle near their main campground at the "Three Trees." Most importantly, both sides agreed to leave the other alone. After all, business was business, and the last thing that Lafitte needed was a war with the local natives. To sweeten the deal, Jean promised to trade trinkets and baubles to the Indians in exchange for wild game and fresh fish. He even invited the Indians to come to town and visit the *Maison Rouge*.

For a while, this status quo held. However, the lack of female companionship in Campeche soon caused some buccaneers to cast furtive glances toward the Karankawa squaws. On one occasion, a group of Lafitte's men hiked to the West End of the isle, supposedly on a hunting trip, and kidnapped a young maiden near the "Three Trees." They raped her and then returned to Campeche. When the Karawanka warriors returned to their camp and learned of this outrage, they swore revenge.

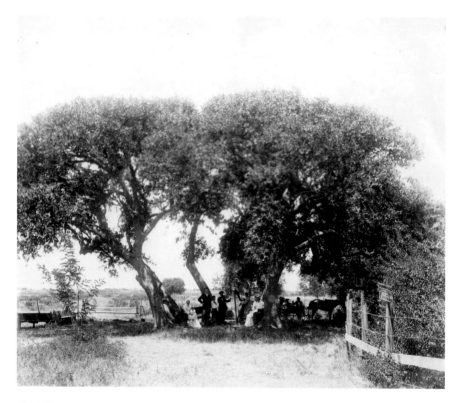

The "Three Trees," the site of the battle between Lafitte's pirates and the Karankawa Indians, as photographed in 1894. *Courtesy of Special Collections, Rosenberg Library, Galveston, Texas.*

For several days, they tracked everyone who entered and left the town and then waited for the best time to retaliate. Finally, a small band of men headed toward the other end of the island in search of game. The warriors ambushed the party and killed four. When the survivors returned, they reported to Lafitte, and he swore to settle this problem with military force. This confrontation between the cannibals and the pirates was the first battle ever fought on Galveston Island.

With muskets and sabers in hand, two hundred pirates dragged two artillery pieces toward the Karankawa encampment. Three hundred or so Indians filled their quivers with wooden arrows, grabbed their cane spears and prepared to repel these invaders. The Indians engaged Lafitte's men in a series of running skirmishes that spanned three days. The Karankawas fought gallantly and wounded many enemies. But in the end, their arrows and war clubs were no match against Lafitte's guns and cannons. In the Battle of the Three Trees, nineteenth-century technology crushed Stone

Age valor. And this defeat was decisive. Thirty Indians died, and many more were wounded. The rest of the tribe fled the island forever. As a tribe, the Karankawas never returned to their homeland of Galveston Island.

Lafitte's victory over the Karankawas was mercurial at best. In September 1818, a powerful hurricane slammed into Campeche and caused catastrophic damage to the city and its pirate fleet. The storm covered the island, sank four ships and sent all hands to Davy Jones's locker. At almost the same time, diplomats from Spain and the United States were haggling over a new boundary between the two countries. In the end, the Adams-Onis Treaty of 1819 ceded Spanish Florida to the Americans in exchange for a new boundary line in Texas and a subtle promise to use the United States Navy to rid the Gulf of Mexico of all pirate activities. In 1820, one of Lafitte's captains foolishly plundered and sank an American ship off the coast of Texas. In early 1821, the United States government used this incident to send the American navy to Galveston Island. The Americans informed the pirate prince that it was once again time for him and his followers to cease illegal maritime operations or face the wrath of American naval might. Like his Indian counterparts, Lafitte abandoned his fortress, put Campeche to the torch and left Galveston Island forever.

Chapter 2

Founding the Galveston City Company

Nineteenth–Century Politics, Entrepreneurs and Land Speculation

Margaret Swett Henson

During the first half of the nineteenth century, many men in the Republic of Texas and in the United States dabbled in real estate ventures. Sometimes these business schemes turned a huge profit, but most of the time they did not. Sam Houston captured this speculative spirit in 1831, writing that he had parted from friends the night before, "I to my <u>law business</u> and <u>they</u> to the more animating pursuits of speculation." Land speculating was an exciting game and a way to amass a fortune—if one's luck held. Only those who lacked the means to engage in these "animating pursuits" denounced those speculators who acquired bargains and sold them for profit. Three American expatriates' obsession to develop the eastern end of Galveston Island led directly to the founding of the city of Galveston.

Land scandals in Mississippi and Kentucky early in the century formed the basis for suspicion and criticism of many early Texas capitalists. Nevertheless, those with means or influence continued to acquire land whenever opportunity offered. For example, between 1833 and 1837, Michel B. Menard, a signer of the Texas Declaration of Independence, used his influence and ingenuity to acquire and develop 4,605 acres (one league and labor, a standard Mexican head right) on the eastern end of Galveston Island.

Although Galveston Island offered the best harbor along the Texas coast, neither the Spanish empire nor the Republic of Mexico authorized anyone to settle on this thirty-mile-long sandbar. As a result of this shortsighted

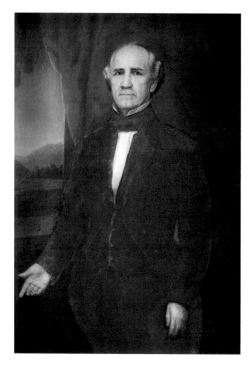

General Sam Houston. *Courtesy of Special Collections, Rosenberg Library, Galveston, Texas.*

policy, the island remained virtually uninhabited. The only exceptions during this period were the annual visits by nomadic Native Americans, mostly the Karankawas, who sought seasonal food sources that included seafood and berries. Also between 1815 and 1821, groups of revolutionary adventurers who wanted to liberate Mexico from Spain and colorful pirates who successfully plundered the Spanish Main briefly called the island home.

After Mexico won its independence from Spain in 1821, suspicious politicians in Mexico City wanted to protect the Texas frontier from invasion by residents of the United States. Their fears were well founded. Since the 1790s, groups of Americans had been illegally crossing into Texas to seek fortune and fame. And many times, these "Filibusters" used Galveston Bay as a jumping-off point for their incursions into Spanish Texas. In 1824, the newly formed Mexican government took legal steps to halt these illegal invasions of Mexican Texas. That year, the government passed the National Colonization Law. This legislation dramatically altered the future of Galveston. Specifically, the new statute forbade foreign-born persons from living within twenty-six miles from the Texas coast and/or fifty-two miles from an international boundary without permission from the president of Mexico. Plainly stated, no Americans could own or develop land near the Texas coast. The only exceptions were colonists who had entered Texas with Stephen F. Austin prior to the new decree. However, none of these immigrants lived near Galveston Bay. They settled around the mouth of the Brazos River and Matagorda Bay.

The Mexican government, however, failed to establish a military presence on the Texas coast until 1830. As a result, thousands of Americans illegally settled in Texas. And many of these first Texas "wet backs" built their homes near Galveston Island. The first Mexican soldiers did not arrive at

the entrance to Galveston Bay until April 1832. That year, the Mexican army assigned a few soldiers to Galveston Island and ordered them to help customs officials stop and search incoming ships heading up Galveston Bay to Buffalo Bayou. This military presence on the island did not last long. Shortly after these troops arrived in Galveston, the three-year-long civil war between Federalists (who favored a federal republic similar to the United States) and Centralists (who did not) came to an end. Quickly, the new Federalist government ordered all Mexican troops to leave Texas. By autumn, all troops in Texas were withdrawn except for those in San Antonio. These soldiers continued their operations against the belligerent Indians of the Texas plains. Thus the island was again vacant but not forgotten.

The potential for a port city on Galveston Island was obvious to many, including Colonel Jose de las Piedras, the Mexican commander of the garrison at Nacogdoches from 1827 to 1832. By 1830, he had sufficient political influence among Centralist politicians in Mexico City to begin the preliminary paperwork for a title to Galveston Island. However, the Federalist victory in the Mexican civil war ended De las Piedras's dream of being the first owner of Galveston Island and instead earned him a one-way ticket back to the national capital. The De las Piedras claim remained incomplete as late as March 1836.

In 1833, shortly after De las Piedras left Texas, Michel B. Menard, a Quebec native and a new resident of Nacogdoches, seized the initiative to acquire land on Galveston Island. He and Thomas F. McKinney, a merchant and Indian trader in the same city, finagled a land title from three hapless local Mexican land commissioners who found themselves in jail after the Mexican civil war. The grant consisted of eleven leagues (more than forty-nine thousand acres) of land certificates. However, only native Mexicans could own or develop this land. This grant applied to any vacant land in Texas, including Galveston Island, and it contained an interesting loophole that included one of the new owners: Menard was uniquely eligible to apply for a head right on Galveston Island. As a Canadian and not a native of the United States like McKinney, Menard claimed that the National Colonization Law of 1824 did not apply to citizens of the British empire. The logic was obviously flimsy, but somehow it worked.

Menard had grown up in the fur trade. He first worked for John Jacob Astor's company on the headwaters of the Mississippi River. Later, he joined his uncle's trading company, Menard and Valle, in Kashaskia, Illinois. Due to his youthful experience, Menard became the resident trader with a band of Shawnee Indians and accompanied them into Missouri, Arkansas and finally northeastern Texas, arriving there by 1830.

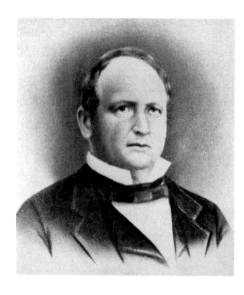

Michel Menard was a cofounder of Galveston. *Courtesy of Special Collections, Rosenberg Library, Galveston, Texas.*

Menard and McKinney shared a frontier background. McKinney's father was a noted hunter who in 1819 moved his family from Kentucky to Missouri. Young McKinney became a Santa Fe trader in 1822 when he and his cousin, Phil Sublett, joined a Missouri caravan to the New Mexican frontier. McKinney and Sublett continued their journey to El Paso and Chihuahua and returned through Saltillo and San Antonio. In 1824, McKinney arrived in San Felipe de Austin, the center of Stephen F. Austin's colony. Although he received a head right from Austin, McKinney settled in Nacogdoches to be closer to his uncle, Stephen Prather, who ran an Indian trading post nearby.

When the Federalist administration took charge of the national government in 1833, Menard and McKinney received some good news concerning their plan to acquire and develop Galveston Island. A well-placed Mexican government official strongly suggested that Menard and McKinney should persuade a well-connected native Mexican, perhaps one from San Antonio, to apply for land on Galveston Island. Once that certificate was issued,

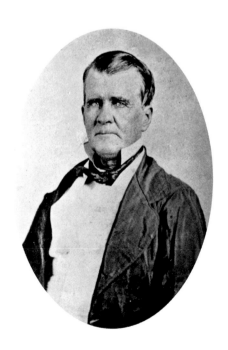

Thomas McKinney was a cofounder of Galveston. *Courtesy of Special Collections, Rosenberg Library, Galveston, Texas.*

Menard could be named agent for the owner and then use his land certificates to settle in the area. At this time, McKinney brought his new mercantile partner, Samuel May Williams, into the partnership. Williams, whose family connections included merchants in Mobile and Baltimore, had been Austin's assistant in colonial business affairs and was fluent in Spanish.

The trio asked a friend, Juan N. Seguin of San Antonio, to apply for the island tract. A rising political figure in Texas, he was the son of the venerable Erasmo Seguin, who helped to create the constitution of the Republic of Mexico and who

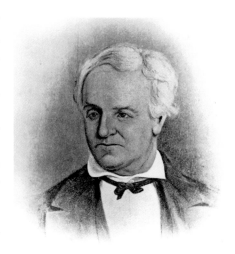

Samuel May Williams was a cofounder of Galveston. *Courtesy of Special Collections, Rosenberg Library, Galveston, Texas.*

had served as postmaster of Texas. The plan to develop a port on Galveston Island evidently appealed to the Seguins, who, along with other native Texans, had long wanted a better connection with New Orleans. Juan Seguin was also a clever politician who recognized the opportune moment.

On January 17, 1833, Juan Seguin asked that land the Mexican government recently granted him for his service against the Indians be located on the eastern end of Galveston Island. The town council in San Antonio approved the request the next day and sent it to the state capital at Saltillo for the governor's signature. Governor Martin de Veremendi was a San Antonio native and the father-in-law of Jim Bowie, a longtime acquaintance of McKinney's. The governor signed the document on April 27 and returned it to Texas, where Seguin, as planned, named Menard his agent to secure title to the 4,605 acres. This step required ingenuity because no town council or empresario in Texas had authority to issue a title in the coastal reserve.

About this same time, Menard's wife of one year died of cholera on May 14, 1833, a personal blow that delayed implementing the plan. In March 1834, eleven months after Saltillo officials approved Seguin's request, Menard asked McKinney and Sam Williams to take a one-quarter interest in "[t]he wild project of Galveston." Later, Menard asked his two partners to invest $200 each, a "trifling" risk, to get the ball rolling.

As required by law, on July 7, 1834, Michel B. Menard, acting as Juan Seguin's land agent, asked the alcalde (similar to a mayor) at Liberty for permission to permit Seguin to settle his Galveston Island grant. Liberty, located on the upper reaches of Galveston Bay, had been created in 1831 on the lower Trinity River as an Anglo-Texan community on the bay. Alcalde James B. Woods, doubtlessly privy to the Menard-Seguin scheme, approved the request the next day on grounds that his office was the closest town government to the island. He assigned a surveyor, who filed field notes three weeks later on July 30, 1834. Alcalde Woods issued the title to Menard the same day.

Again, politics delayed development. In January 1835, Mexican troops and customs collectors returned to Galveston Bay and to other entrances to Texas. President Antonio López de Santa Anna, no longer the reformer elected in 1833, denounced Federalism and shifted his support to the Centralist faction in Mexico. Quickly, Santa Anna began to reduce the states to departments and to eliminate self-government. He sent more troops to Texas, not only to aid in collecting the tariff needed for revenue but also to quell the restless Anglo-Texans, who favored Federalist policies for Mexico. In June 1835, Texan volunteers successfully seized the small Mexican garrison at Anahuac, but word that more troops were landing near Goliad caused volunteers to march westward. After a confrontation on October 2 with the Mexican cavalry over a cannon at Gonzales, the Anglo-Texans laid siege to San Antonio and forced General Martin Perfecto de Cos in December 1835 to surrender his troops. The Texas Revolution was up and running, but Michel Menard, Samuel May Williams and Thomas McKinney's plans to develop Galveston had once again ground to a screeching halt.

The trio of Galveston partners played important roles in the struggle for Texas independence. Michel Menard, who had settled on the lower Trinity River, represented the city of Liberty at the rebel convention in Washington-on-the-Brazos. On March 2, 1836, he signed the Texas Declaration of Independence. Samuel May Williams journeyed to New York in July 1835 on personal and government business and remained in the United States for the next two years. Thomas McKinney funneled men and supplies to the Texan army and helped to evacuate families from the lower Brazos River on his steamboat after Santa Anna's bloody victories at the Alamo and Goliad.

The First Congress of the Republic of Texas convened in Columbia on October 3, 1836. The nascent government faced many problems, including numerous claims to ownership of the eastern end of Galveston Island. One group of Virginia and Kentucky investors loaned money to the new republic

in March and received land scrip from the interim government for 640 acres, with the privilege of first location. Of course, the investors contended that a clear title to the eastern end of the island would clear the debt. Another group of New York speculators that also held scrip for money and provisions loaned to the young republic likewise implied that ownership to this valuable piece of real estate would repay the obligation. However, only Michel Menard held a title to the land.

In December 1836, Menard organized the Galveston City Company to promote the formation of the town of Galveston, and the republic formally charted the city two years later. Amid much criticism of favoritism, the Menard claim prevailed. To help smooth things over, Menard and McKinney wisely added two influential congressmen, Mosey Baker and John Kirby Allen (who along with his brother had founded Houston in August 1836), to the partnership. The subsequent chain of events demonstrates the adept political maneuvering that occurred in the crowded temporary capital.

Congress, needing funds and sensitive to public opinion, approved the Menard claim on December 9, 1836, but ruled that he and his partners had to pay $50,000 to the government to clear the title—$30,000 due on February 1, 1837, and the rest by May 1. At the suggestion of Menard and McKinney, Congress named David White, a Mobile merchant who had helped supply the Texas volunteers during the revolution, as a special agent to provide funding for the deal. The republic allowed the special agent to pay the debt in cash and military supplies. After independence, Texans continued to fear a reinvasion from south of the Rio Grande, and their army desperately needed more arms and ammunition.

To complicate matters, White held a lien on the Menard title. This forced the five partners to pay the White lien with money from the sales of lots in the newly proposed city of Galveston. Immediately, Menard discovered that White, contrary to their agreement, was issuing his own scrip for land on Galveston Island. Menard quickly met with his former rivals, the Virginia and Kentucky investors, and agreed to give them a 60-acre plot of land within his 4,605-acre Galveston land grant in exchange for the money needed to settle the White claim. As a further consolation, Menard added some of the Virginians to the board of directors and allowed them to choose their own real estate agents.

With the new infusion of money and leadership, Menard settled with David White early in 1837. The Galveston City Company ordered a survey of blocks from the Gulf to the bay and from Seventh Street on the east to Fifty-sixth Street on the west. The Republic of Texas claimed the areas east

of Seventh Street and designated it a military reserve. Once the lots began to sell, McKinney used his proceeds to build a wharf and a warehouse on the waterfront at the foot of Twenty-fourth Street for his company, McKinney, Williams and Company. Later that year, the business partners also erected the legendary Tremont Hotel at the corner of Twenty-third and Church, a hometown tavern near their wharf, a number of small rental houses and a racetrack on the beach near Forty-first Street. They hoped that these other recreation-oriented businesses would attract other visitors and influence potential buyers.

A minor setback occurred in October 1837 when a major hurricane struck the island and caused extensive damage. Nicknamed "Racer's Storm" after the British brig of war (HMS *Racer*) that first encountered the storm off the Yucatan Peninsula, the cyclone sent ships anchored in the channel crashing into the port area and destroyed most of the buildings on the island. The unusual storm began in the Windward Islands on September 29 and then cut across the Yucatan Peninsula. It swept across the Gulf of Mexico, smashed into Veracruz and then turned northward and followed the coastline toward Matamoros. Next, it struck the mouth of the Brazos River and then slammed into Galveston Island. Finished with Texas, it turned eastward and struck New Orleans, Mobile and Pensacola, Florida. The storm emerged into the Atlantic on October 10 near Charleston, South Carolina, and made its final landfall near Wilmington, North Carolina. McKinney quickly repaired the damage to his new commercial buildings, and business returned to normal.

Company shareholders scheduled their first meeting for December 15, 1837. The shareholders elected Menard president of the Galveston City Company and elected the other four original investors—McKinney, Williams, Baker and Allen—to the board of directors. They appointed Dr. Levi Jones from Kentucky as the business agent for the company. Baker and Allen lived in Houston, but convenient steamboats connected the two boomtowns several times a week.

In 1839, Menard, McKinney and Williams built comfortable homes on individual suburban ten-acre lots west of Twenty-fifth Street and south of Broadway. They chose this section of town because it was far from the noisy business district and even farther from the wharves and harbor district. These large garden tracts attracted other city elite. Soon this area became one of the most desirable pieces of real estate in the Republic of Texas. The Menard and Williams mansions still grace Galveston's historical district.

It is not clear from extant records how much the Galveston City Company contributed to the trio's wealth. According to the 1850 United States Census,

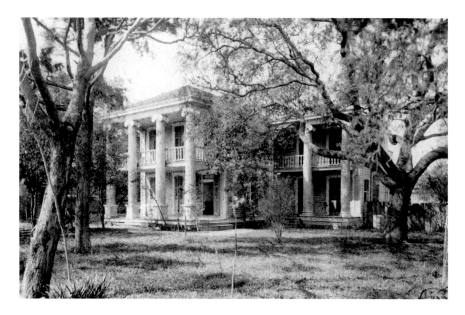

The 1838 Michel Menard mansion on Thirty-third Street. *Courtesy of Special Collections, Rosenberg Library, Galveston, Texas.*

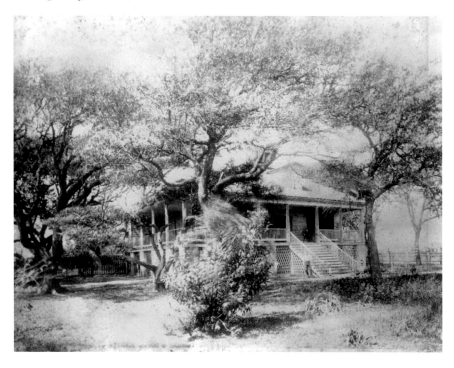

The 1839 Samuel May Williams home, circa 1887. *Courtesy of Special Collections, Rosenberg Library, Galveston, Texas.*

Michel Menard was the wealthiest man in Galveston, with property worth $75,000. He remained the president of the Galveston City Company until his death in 1856. In 1842, McKinney and Williams dissolved their business partnership and later severed their commercial ties with the Galveston City Company, although Williams still held stock certificates. Thomas McKinney moved in 1849 to Austin, where he concentrated on ranching and stock raising. He died near the state capitol in 1873. In 1848, Samuel May Williams founded the Commercial and Agricultural Bank of Galveston. He remained president of the controversial and powerful bank until his death ten years later.

These three entrepreneur-speculators—Michel Menard, Samuel May Williams and Thomas McKinney—are representative of upwardly mobile Texans between the 1830s and the Civil War who invested in Texas land on the island and elsewhere. They were respectable men who served in the Congress of the Republic of Texas or later in the state legislature. Like their counterparts in the United States during these years, they lived on their credit and reputations but were often without ready cash. Like most public figures, they were envied by some for their wealth, position and political influence and beloved by others because of their acute business sense and, as Sam Houston once noted, their "animating pursuits." Their dedication to the founding and development of the city of Galveston, however, will remain their lasting legacy.

Chapter 3

"A More Pusillanimous Surrender"

The Battle of Galveston

Donald Willett

E very winter, the Civil War returns to Galveston. When the blistery north wind blows the water out of the bay, it exposes several tiny islands near the Galveston causeway. These reefs are the last reminders of a wooden railroad bridge built by Galvestonians during the 1850s to connect the "Queen City of the Gulf" to the mainland. During the Civil War, this bridge was a key component to the largest military action in the state of Texas. On New Year's Eve 1862, Rebel forces crossed the bridge and attacked Federal troops in the Battle of Galveston.

The Civil War came to Galveston on July 2, 1861. That morning, locals walking on the beach spied the ominous silhouette of two Union naval vessels on the horizon. The steamship *South Carolina* and the schooner *Dart* were the first Union vessels to blockade Galveston. The next day, the *Dart* reconnoitered the Gulf side of the island looking for Rebel gun emplacements. When the small gunboat passed the Twenty-first Street battery, the boys in gray lobbed a cannonball at the enemy vessel. It quickly returned fire. The *South Carolina* soon came to the aid of the smaller vessel. The local citizens, hoping to get a better view of this exciting event, packed their picnic baskets and scurried toward the beach and into harm's way. As the artillery duel commenced, one of the Union shells exploded over a large group of spectators. This wayward shot killed one local and sent a large percentage of the population fleeing to the relative safety of Houston.

Like it or not, the city of Galveston was now on the front line of the American Civil War. Life on the island would never be the same. Soon

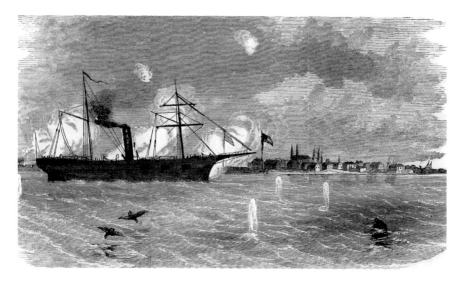

The *South Carolina* bombarding Galveston on July 3, 1861. *Courtesy of Special Collections, Rosenberg Library, Galveston, Texas.*

other units from the Union's Western Gulf Squadron began to tighten the blockade along the Texas coast. This impasse continued for fifteen months. On October 4, 1862, the *Harriet Lane*, a converted mail carrier named after President James Buchanan's niece, entered Galveston Harbor under a flag of truce. A messenger from the vessel informed city officials that Captain William B. Renshaw, the newly appointed commander of the Texas blockading fleet, wished to discuss terms for the surrender of the city of Galveston. To convince his enemies that he was serious, Renshaw ordered his ships to bombard the Confederate batteries in the harbor. A few well-placed Union broadsides transformed these Rebel strongholds into piles of rubble. Having gained the upper hand, Renshaw granted city officials four days to evacuate the civilian population while also maintaining the military status quo. For the next ninety-six hours, civilians fled their homes while military forces stripped the city of anything that could aid the enemy, including the liquid contents from the local icehouse. General Hébert ordered his soldiers to remove the remaining Confederate artillery to Virginia Point, on the mainland side of the wooden railroad bridge. For the first time since the Texas Revolution, Galveston looked like a ghost town.

On October 9, 1862, the unspeakable happened. Union officials rowed ashore and accepted the peaceful surrender of the city. For the only time in its history, "foreign" troops occupied the Queen City of the Gulf. As the

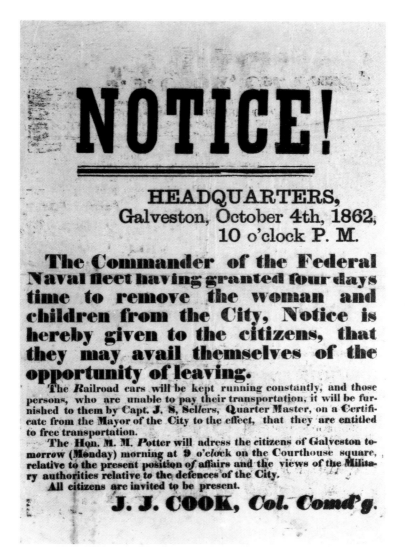

NOTICE!

HEADQUARTERS,
Galveston, October 4th, 1862,
10 o'clock P. M.

The Commander of the Federal Naval fleet having granted four days time to remove the woman and children from the City, Notice is hereby given to the citizens, that they may avail themselves of the opportunity of leaving.

The Railroad cars will be kept running constantly, and those persons, who are unable to pay their transportation, it will be furnished to them by Capt. J. S. Sellers, Quarter Master, on a Certificate from the Mayor of the City to the effect, that they are entitled to free transportation.

The Hon. M. M. Potter will adress the citizens of Galveston to-morrow (Monday) morning at 9 o'clock on the Courthouse square, relative to the present position of affairs and the views of the Military authorities relative to the defences of the City.

All citizens are invited to be present.

J. J. COOK, Col. Comd'g.

Union notice to evacuate Galveston. *Courtesy of Special Collections, Rosenberg Library, Galveston, Texas.*

Federal occupation commenced, an eerie status quo evolved. During the day, downtown Galveston and the harbor belonged to the Union. Each morning, a detachment of sailors rowed ashore and raised the Stars and Stripes over the United States Customhouse. Small detachments patrolled the Strand and Ship Mechanics Street and searched for possible Rebel activity. With most of the stores closed and the civilian population relocated inland,

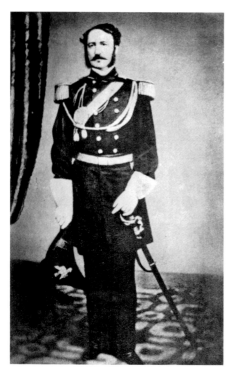

General John Bankhead Magruder, the Confederate commander at the Battle of Galveston. *Courtesy of Special Collections, Rosenberg Library, Galveston, Texas.*

Galveston looked abandoned. At twilight, another detachment of sailors rowed ashore, marched to the customhouse and lowered the Stars and Stripes. The men quickly returned to the harbor and rowed back to their ship.

The capture of Galveston cost General Hébert his job. He returned to his home state, where he commanded the subdistrict of north Louisiana. Two days after the surrender of Galveston, Hébert's replacement, General John Magruder, arrived in Texas. Virginia-born, John Bankhead Magruder graduated from West Point in 1830. Fellow officers nicknamed Magruder "Prince John" because of his gentlemanly airs and elegant clothing. He fought during the Mexican-American War under General Zachary Taylor in northern Mexico and General Winfield Scott in central Mexico. Magruder earned a reputation as a brilliant artillery officer who loved a hard fight. Magruder stayed in the army until the eve of the Civil War.

When his home state seceded, Magruder resigned his commission and offered his services to his home state. Magruder's first assignment was command of Confederate forces on the Yorktown peninsula. On June 9, 1861, he fought and won the Battle of Big Bethel, the first land battle of the Civil War. Next, General Magruder constructed an elaborate series of trenches and earthworks between Yorktown and the James River. He hoped that this would deter any Union attempt to invade his homeland and capture the national capital at Richmond.

In April 1862, General George McClellan landed more than 100,000 Union soldiers at Fort Monroe on the Yorktown peninsula. This marked the beginning of the famous Peninsula Campaign. Facing McClellan were 10,000 Rebels led by John Bankhead Magruder. For a month, the timid

McClellan refused to leave the fort and engage the enemy. Eventually, McClellan left the relative safety of Fort Monroe and slowly marched up the peninsula. His army came within eyesight of the Confederate capital in Richmond. Then two events occurred that forever changed the Civil War career of bonnie Prince John. First, a serious wound to General Joe Johnston, the commanding Confederate general, forced the Rebel leaders to place Robert E. Lee in charge of the army. Second, General McClellan ordered part of his army to cross the Chickahominy River. Lee took most of his troops and attacked the smaller number of Union troops who had crossed the river. Lee ordered Magruder and his 25,000 troops to stop the rest of McClellan's troops from capturing Richmond.

Once again, McClellan ordered his army to withdraw. Thus began the Seven Days' Campaign (June 25–July 1) and the end of Magruder's military career in Virginia. With the Union army in full retreat, Lee vigorously ordered Magruder to pursue the enemy to Malvern Hill. He also ordered Magruder to lead a frontal attack on this strongly defended position. Well-placed Union artillery slaughtered his men. Lee relieved Magruder of his command, and the Confederate army shipped Prince John to Texas.

Kuhn's Pier, photo circa 1861. *Courtesy of Special Collections, Rosenberg Library, Galveston, Texas.*

In Galveston, Commodore Renshaw implored Admiral David Glasgow Farragut, the commander of the West Gulf Blockading Squadron, to send soldiers to Galveston. On Christmas Eve, 260 army troops under the command of Colonel Isaac Burrell, the commander of the newly formed Forty-second Regiment of Massachusetts, arrived at the entrance to Galveston Harbor. Commodore Renshaw ordered Burrell to station his men at Kuhn's Pier, a four-hundred-foot-long and twenty-foot-wide "tee head" pier on Eighteenth Street. Renshaw assured Burrell that in case of an attack a navy vessel would remove his soldiers from the pier in five minutes. This order was the first of several mistakes by Renshaw that ultimately cost him his life.

The next morning, as soon as the troops disembarked at Kuhn's Pier, things began to go wrong. Burrell soon discovered that longshoremen in New Orleans had inadvertently loaded the wrong type of ammunition onto his transport vessel. If attacked, his troops would not have enough bullets to defend themselves, and Kuhn's Pier would be a nightmare to defend. He converted this structure into a barrack and a hospital and ordered his men to pile sacks of plaster up the interior wall facing the city. Next, his soldiers ripped up some planking on the pier closest to the shore and used it to construct a barricade for the sentries. He later established another barricade at the other end of the pier adjacent to the "tee head." He hoped that these modifications would deter a frontal attack by the Rebels.

The Confederate government placed General Magruder in command of the district of Texas, New Mexico and Arizona. Since the Confederate defeat at Glorieta Pass, near Santa Fe, New Mexico, had left that state and Arizona in Union hands, Magruder only had to worry about defending the Lone Star State. The key to Texas and the entire Trans-Mississippi, in Prince John's opinion, was Galveston Bay. "Whoever is master of the railroads of Galveston and Houston is virtually master of Texas." In Magruder's mind, his course of action was clear: he had to attack Galveston and recapture its railways.

The Magruder battle plan consisted of a two-pronged attack on Federal occupational forces in Galveston. The land force, consisting of troops and field artillery, would, under the cover of darkness, cross the two-mile-long railroad bridge, march another two miles over open ground, evade enemy detection, enter downtown Galveston and position itself and its fieldpieces near the waterfront. The naval fleet would steam down the bay from Houston and position itself just out of sight of the Federal fleet. At the appointed time, the land troops would attack the army position at

Kuhn's Pier and hope to divert the navy's attention from the simultaneous seaward approach to Galveston. Once the navy focused its firepower on the attacking Rebels, the Confederate fleet would sneak up, attack and capture the *Harriet Lane* and turn its guns on the other enemy vessels. The attack was a bold but risky plan. As one military historian noted, "None but a Magruder would have attempted such a hazardous undertaking; it was contrary to all the maxims of scientific warfare. Buy,the battle plan was no more bold or unconventional than Prince John himself."

Now that he had his plan, all Magruder needed was some ships and soldiers, as well as a little bit of luck. Most of the soldiers came from New Mexico. In December 1861, General Henry Sibley launched an ill-fated campaign from Texas into New Mexico. He hoped that the military conquest of New Mexico would bind the state to the Confederacy. A crushing defeat at Glorieta Pass ended the Rebel dreams of victory and forced the ragtag army of Texas volunteers to retreat to the Lone Star State. By the time Magruder arrived in Texas, Sibley's Texas Brigade found itself bivouacked on the banks of Buffalo Bayou, not far from Houston. Magruder soon enlisted these soldiers in his crusade to liberate Galveston.

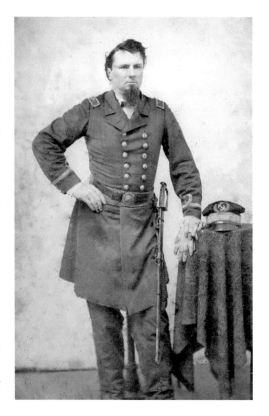

The ships came from Galveston Bay. Magruder took command of four steamboats and ordered shipyard workers to convert two of these paddle-wheelers into "cotton clads" capable of capturing the fifteen warships in the Federal fleet. Prince John selected Leon Smith, an old friend, to supervise this difficult task. Smith first wandered the sea as a young man and on the eve of the Civil War captained sailing ships in the trade from New York City to Galveston.

Leon Smith, commander of Confederate naval forces at the Battle of Galveston. *Courtesy of Special Collections, Rosenberg Library, Galveston, Texas.*

Smith instructed the workers to fasten five-hundred-pound cotton bales around the engine, boilers and machinery of three of the boats. He hoped that the bales would protect the ships from Union cannon fire and serve as a platform for army sharpshooters. He then ordered laborers to rig boarding planks, similar to the ancient Roman *corvus*, from the king post of his two largest vessels—the *Neptune*, an old wooden mail packet, and the *Bayou City*, a wooden hulled paddle-wheel bay boat. He proclaimed the boats ready for war after workmen mounted a thirty-two-pound cannon on the bow of the *Bayou City* and two twenty-four pounders on the bow of the *Neptune*. Silhouetted against a setting sun, the Galveston Bay flotilla was an impressive sight.

On New Year's Eve, Prince John informed his commanders that it was time to march on Galveston and drive the Yankees into the sea. During the day, the Galveston Bay Confederate naval flotilla—consisting of the *Bayou City*, the *Neptune* and two support vessels, the *John F. Carr* and the *Lucy Gwin*—slipped their cables and steamed toward Galveston. The fleet stopped at Harrisburg and loaded three hundred "Horse Marines," cavalry veterans of the earlier failed invasion of New Mexico. At about dusk, the ships passed Morgan's Point and spied a rowboat in the middle of the channel. Quickly, a courier from General Magruder boarded the *Bayou City* and handed Commodore Smith his orders. They read, "I will attack from the City about one o'clock; take the boats as near as you can to the enemy's vessels, without risk of discovery, and attack when signal gun is fired from the City. The Rangers of the Prairie send greetings to the Rangers of the Sea."

At the same time that Commodore Smith received his final orders from General Magruder, Prince John ordered his troops to begin their march across the railroad bridge. First, his men used railroad cars to transport twenty-one cannons onto the island. Amazingly, the train transported the guns from the bridge halfway to the town without Union detection. Then the soldiers crossed the bridge.

Shortly after the Confederate soldiers formed up on the other side of the bridge, they spied the Union signal rockets. Fearing the worst, Magruder ordered his troops to remove their field guns from the train and drag them into position. At that time, Magruder did not know that Union forces had only discovered Smith's cotton-clad flotilla. This preoccupation with an anticipated naval attack may explain why the Federals did not discover the Rebel land forces until the battle began.

General Magruder placed most of his guns and troops near the port and wharf area. After departing the railroad track, the troops crossed McKinney Bayou, near the beach, and then marched up Broadway. Starting near the

railroad depot on Thirty-third Street, they spread these artillery pieces for a mile along the waterfront. Prince John ordered his waterfront cannons to focus on the army troops stationed on Kuhn's Pier and the naval vessels stationed near the wharfs.

By 4:00 a.m., the moon had set and a thick fog blanketed the waterfront. Positioning the cannons took longer than expected, and Magruder and his staff patiently awaited the report announcing that all the cannons were in place. When bonnie Prince John received the news, he walked to the fieldpiece located at Twentieth Street, near Kuhn's Pier, and yanked the lanyard. The cannon fired a projectile toward the *Owasco*, a converted ferryboat similar in design to the *Westfield*, the squadron's flagship. As the smoke cleared, Magruder spoke, "Now, boys, I have done my best as a private, I will go and attend to that of General." Immediately, Confederate guns opened fire and created a thunderous boom that shattered the calm. The Union fleet quickly returned fire, first with solid shot and later with canister and grapeshot. Soon shot and shell littered downtown Galveston.

Within minutes of the first barrage, Magruder ordered five hundred troops to storm Kuhn's Pier and engage the enemy. The Rebels grabbed scaling ladders and ran from both sides of the pier into the gently sloping harbor. They hoped to place their ladders behind the Federal barricade on the "tee head" pier, scurry up the ladders and capture the Union army position, but things did not go as planned. The Rebels waded out until the water was hip deep. Here they became victims of the "short ladder syndrome." Like General Edward Parkenham's British troops at the Battle of New Orleans and General Santa Anna's Mexican soldiers at the Battle of the Alamo, the Rebel troops quickly realized that their ladders were not long enough. The Rebels ditched their ladders and retreated to shore. The Union ships peppered the trapped Texans with a deadly fire of grapeshot and canister. Aided by a hail of sharpshooter bullets and light artillery fire, the storming party finally rejoined its comrades on shore. After this failed attack, Magruder ordered his men to retreat to downtown Galveston. Here he would make his last stand.

Shortly after Magruder's signal gun fired, Commodore Smith ordered his ships into battle "with all the steam we could crack on." He noted, "We must get there as quick as we can and attack them." In the engine room, the men tossed rosin and pinecones into the glowing firebox, and the pressure in the boilers soared. With the *Bayou City* in the lead, the *Neptune* second and the *John Carr* close behind, the tiny flotilla retraced its steps back to Pelican Island and then set a course toward the nearest Yankee ship, the *Harriet Lane*.

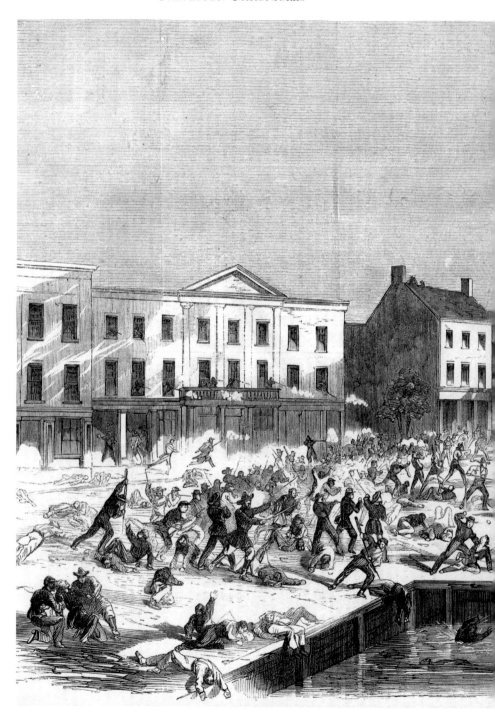

The attack on Kuhn's Pier. *Courtesy of Special Collections, Rosenberg Library, Galveston, Texas.*

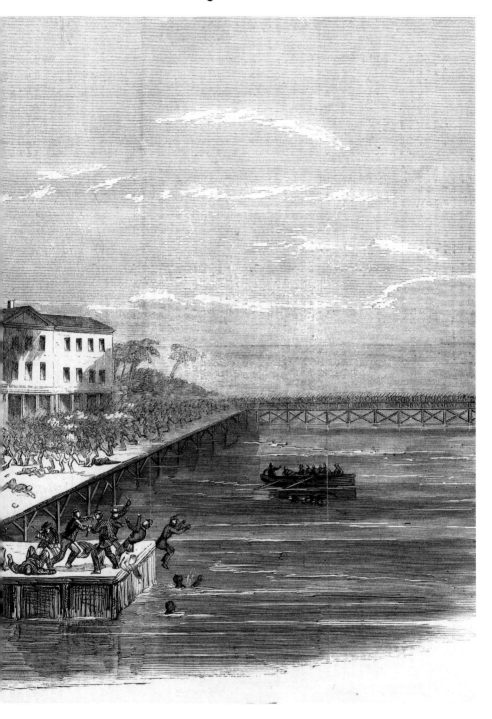

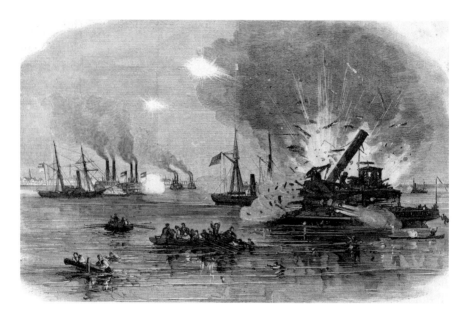

The Confederate naval attack during the Battle of Galveston. *Courtesy of Special Collections, Rosenberg Library, Galveston, Texas.*

What happened next was one of the most dramatic episodes in the naval history of the Civil War.

At daylight, a dense fog engulfed the harbor. The *Bayou City*, about one mile from the *Harriet Lane*, fired its thirty-two-pound cannon toward an unidentified Union vessel. The second shot, according to Henry Lubbock, the captain of the *Bayou City*, found the *Harriet Lane* "[p]lumb behind the [paddle] wheel knocking a hole in her big enough for a man to crawl through." For the third shot, the gun crew forgot to ram the shot completely down the barrel. When they lit the fuse, the gun exploded.

When the smoke cleared, the *Harriet Lane*, at anchor and bucking a strong ebb tide, was less than two hundred yards away. Captain Lubbock set the *Bayou City* next to the *Harriet Lane* so Commodore Smith and his "Horse Marines" could rake its decks with rifle fire, force the Union bluejackets below decks, board the vessel and capture it. He miscalculated the ebb tide, and the paddle-wheeler struck a glancing blow near the *Lane*'s bow. This jolt crushed the *Bayou City*'s port wheelhouse and sent the Rebel warship heading toward the shore, out of control.

When the *Bayou City* began its attack, the *Neptune* was not far behind. Its captain decided to board the *Harriet Lane*. As he maneuvered his ship, the Federal gun crews returned to the deck and fired at the little steamer. A

shell struck the cotton bales and shattered some decking. Before the Yankees could reload, the *Neptune* slammed into the *Lane* about ten feet behind the starboard paddle wheel. The impact crumpled the wooden steamer, and it began to flood. It backed off and grounded in eight feet of water near the decaying hull of another famous Texas naval vessel, the *T.N. Zavalla*.

With one ship disabled and the other out of control, the Confederate naval action seemed doomed to fail. However, Captain Lubbock regained control of his vessel and again pointed it toward the *Harriet Lane*. Even though the *Neptune* was sinking, its sharpshooters pelted the *Harriet Lane* with a blanketing fire. This forced the Union sailors to once again seek shelter below decks. This time, the *Bayou City* struck its opponent a thunderous blow to its port paddle wheel. The two ships "stuck fast together." Immediately, Commodore Smith, cutlass and pistol in hand and his men at his side, jumped on board the *Harriet Lane*. Smith encountered Captain Jonathan Wainwright on the bridge and ordered him to surrender his ship. Wainwright, who was already severely wounded, replied that he "would rather die." Smith obliged, shooting Wainwright in the head. The next sailor Smith encountered surrendered the ship. This marked the first time since the War of 1812 that a United States naval vessel submitted to an enemy boarding crew.

During the assault, the *Owasco* closed to within three hundred yards of the mêlée and fired a broadside at the *Harriet Lane*. Quickly, sharpshooters from the *Bayou City* and the *Neptune* turned their small arms on the attacking Union vessel and sent its deck crew scurrying for cover below decks. This Rebel barrage forced the *Owasco*'s skipper to called off his attack and remove his ship from harm's way. What happened next was one of the most embarrassing moments in United States naval history.

As the *Owasco* fled the scene, Captain Lubbock hoisted a white flag above the *Harriet Lane*. Union ships in the harbor quickly did the same. Commodore Smith ordered his captain to contact the Union naval commander and demand the surrender of the entire Union fleet except for one vessel, which they could use to transport all naval personnel out of the harbor. Lubbock rowed over to the *Clifton* and ordered its commander, Captain Richard Law, to surrender. Law, claiming that only Commodore Renshaw could make that decision, agreed to a three-hour truce and rowed to the flag ship, the *Westfield*.

For the captain and crew of the *Westfield*, the previous twenty-four hours had been a nightmare. On New Year's Eve, the ship grounded three times. Each time, the pilot successfully freed the vessel from the shallow sandbars. Finally, Renshaw positioned his ship near the entrance to Galveston Bay. At

midnight, when Federal lookouts first spied the Confederate flotilla and fired their signal flares, the commodore ordered his men to weigh anchor, proceed north of Pelican Island and cut off the Rebels' avenue of retreat. Before the ship could reach full speed, it crashed into another shoal and found itself hard aground at low tide. When the firing began, Renshaw and his crew stood helplessly and watched the battle unfold.

After his meeting with Captain Lubbock, Captain Law rowed to the *Westfield* and explained the situation to Commodore Renshaw. Fearing the worst, Renshaw ordered his fleet to leave Galveston immediately. He then instructed his crew to scuttle the *Westfield*. Several officers argued that Renshaw should use his fleet to protect the *Westfield* until high tide. Then they could pull the flagship off the reef. These pleas fell on deaf ears. After offloading his crew to an awaiting ship, Renshaw poured turpentine over the forward magazine and set his ship afire. Just as he stepped off the deck, the magazine prematurely exploded. The blast ripped the ship apart and instantaneously killed the ill-fated commodore and twelve shipmates. At the same time, Union vessels, all flying a flag of truce, abandoned their army colleagues at Kuhn's Pier, fled the battlefield and returned to New Orleans. Thus the United States Navy, which earlier entered Galveston Harbor under a flag of truce and demanded that the city surrender, now left the city flying the same flag, but under radically different circumstances.

On Kuhn's Pier, Union troops looked over Galveston in utter shock and disbelief. A few hours earlier, these brave soldiers from Massachusetts repulsed a determined Confederate attack and were poised to counterattack the Rebels and drive them from the island. Now, as the last Union warship dipped below the horizon, Colonel Burrell and his men found themselves, along with captured bluecoats from the *Harriet Lane*, prisoners of war. In all, 369 Union forces (109 on the *Harriet Lane* and 260 on Kuhn's Pier) surrendered to the Confederates. Another 19 Union troops perished, while 150 received wounds from Confederate sharpshooters. On the other side, 26 Rebels died during the battle, and another 117 soldiers suffered wounds.

The Battle of Galveston's legacy to American military history is long and strange. The capture of the *Harriet Lane* marked the first time that an enemy force had boarded and captured an American naval vessel since the War of 1812. Just 104 years later, the USS *Pueblo* suffered a similar fate at the hands of the North Korean navy. Likewise, the USS *Westfield* is the only American flagship to be scuttled during battle. When Captain Richard Law led the retreat to New Orleans, he became the only naval commander during the Civil War to abandon Union army troops ashore. This less than gallant

action merited Law a guilty verdict at his court-martial and a dishonorable discharge from the service.

Once the Federal fleet departed, Galveston became the only Confederate port to break the Union blockade during the Civil War. This reprieve from this naval stranglehold only lasted a few days. When Admiral Farragut learned of this disaster, he quickly ordered other naval vessels to restore the blockade of Galveston. But the damage was done. In commenting on the disaster at Galveston, Farragut angrily quipped, "It is difficult to conceive a more pusillanimous surrender of a vessel to an enemy already in our power than occurred in the case of the *Harriet Lane*." The Queen City of the Gulf was once again in Rebel hands, and it would remain so until the end of the war.

"How Sweet It Is!"

The Eliza and Harris Kempner Legacy

Elise Hopkins Stephens

The four Kempner brothers, Stanley, R.L., D.W., and I.H., have contributed mightily to the building of Texas as well as their native Galveston. When he [Harris Kempner] died in 1894 he had put together "The House of Kempner," with interests in all parts of the State. The Kempners either bought, built, or operated eight Texas railroads, started irrigation projects; organized banks in a dozen towns. The eight members of the House of Kempner, four brothers and four sisters, Mrs. Henry Oppenheimer, San Antonio; Mrs. L.A. Adoue and Miss Gladys Kempner, of Galveston, and Mrs. D.F. Weston of Cincinnati, have made no partition of the family's wealth down through the years, except division of profits from the many enterprises. All differences of opinion have been settled by majority rule. Their business activity has been matched through the years by a contribution to civic affairs.
–*Senator Lyndon B. Johnson,* Congressional Record, *April 25, 1950*

When Harris Kempner first met his future wife, Eliza Seinsheimer, she made such a powerful impression on him that he determined to make her his bride. Little did he know that their union would produce one of the most powerful and beloved families in Galveston history. By the time Harris Kempner married in 1872, he was a successful man wise beyond his thirty-five years. A Polish immigrant born in 1837 in the city of Krzepice, which was then a part of Russian Poland, Harris had good reason to leave his homeland.

Czarist Russia, especially under Nicholas I, systematically oppressed its Jewish population. The Czarist government demanded assimilation and

threatened expulsion and constant harassment to those who clung to their Jewish legacy. Assimilation meant forsaking the religion his grandfather, a rabbi, had taught him to love, and that was something Harris and his family would not do. Expulsion meant relocation to drab villages that contained limited resources for survival. Harris was old enough to become fodder for the czar's army, but he was also at an age when he could set out for America and freedom. There he could work and save enough money to help his family survive the Russian Peril or, better yet, bring them to America.

In 1854, the seventeen-year-old arrived alone in New York City. He spent a year or so as a day laborer and learned the language and customs of his newly adopted country. Harris explained what Americanization meant to him: "I came to America to be an American, and I tried to adapt my ways to American ways. I was young, and the right to participate in all phases of American life—political, social, economic, even military—was wonderful to me."

"How sweet it is!" One of the major enterprises of the Kempner family was Imperial Sugar Company, with home offices in Sugar Land, Texas. I.H. Kempner incorporated the company in 1907. It became widely popular for its advertising and sugar recipes in the 1920s and 1930s. Lyda Ann Quinn poses here for the camera in the early 1940s. *Courtesy of the Kempner Family Collection, Galveston, Texas.*

In 1858, he headed to Texas, where he hoped to seek his fortune as a peddler in the backwoods of east Texas. He settled in Cold Springs in San Jacinto County and quickly opened a mercantile store. A scrupulously honest and reliable tradesman, Kempner quickly won the confidence of the surrounding settlers, who preferred trading with him and knew that they could count on his attention to their needs—even the need for credit. Success and prosperity soon followed. It seems that this immigrant boy from Poland had found a home in the piney woods of Texas.

Although Harris had been unwilling to fight in the czar's army, when America's Civil War erupted, he joined the Ellis County Blues, a local militia unit that later joined the Twelfth Texas Cavalry Regiment, the famed Parson's Texas Cavalry Brigade, and fought for the South. Although he opposed slavery, he later explained, "The people around me were all for the South. I was one of them and as

Top: Harris and Eliza's daughter Hattie Kempner Oppenheimer. *Courtesy of the Kempner Family Collection, Galveston, Texas.*

Bottom: Harris and Eliza's daughter Fannie Kempner Adoue. *Courtesy of the Kempner Family Collection, Galveston, Texas.*

Harris and Eliza's daughter Sara Elizabeth Kempner Weston. *Courtesy of the Kempner Family Collection, Galveston, Texas.*

Harris and Eliza's daughter Gladys Kempner. *Courtesy of the Kempner Family Collection, Galveston, Texas.*

I reasoned it out then the right of a people to govern themselves as they thought best [was worth fighting for since] I knew what it meant not to have that right, either individually or collectively."

By war's end, Harris had proven himself a hero. Early in the war, his unit fought in and around New Orleans and in southern Missouri. During the 1864 Red River Campaign, a Union cannonball struck Kempner's horse in the neck. The blow seriously wounded the young Texan. After he recovered from the wound, he once again volunteered for combat. His commander denied this request but allowed Harris to remain with his unit. He served the rest of the war as the unit's quartermaster sergeant.

His business acumen was as sharp as any Yankee's. However, in 1864, he bought a $1,000 Confederate bond at a point in the war when optimism had soured. That investment in the "Lost Cause" underscored his belief that a man must do his "full duty." Honor, integrity, justice and charity were as meaningful to him as God and family and more valuable than the "almighty dollar." These were the characteristics that ensured his success not only in combat and life but in business and marriage as well.

After the war, Harris returned to Cold Springs and reopened his mercantile store. His old clientele returned, and his business boomed. However, Harris soon realized that

Left: Harris Kempner, the patriarch of the family. *Courtesy of the Kempner Family Collection, Galveston, Texas; Right*: Eliza Seinsheimer Kempner, the matriarch of the family. *Courtesy of the Kempner Family Collection, Galveston, Texas.*

his business opportunities in rural east Texas were limited. A few trips to Galveston convinced the young man that his future lay with this bustling seaport. In 1871, with $50,000 in his pocket, Harris moved to the Queen City of the Gulf. Neither would ever be the same.

Shortly after he arrived in the city, Harris met Marx Marx, a local wholesale grocer. They quickly formed a partnership that dealt with the wholesale grocery and liquor importing business. They were perfect partners. Kempner was a quiet, almost shy, no-nonsense sort of guy, while Marx was a gregarious and warmhearted person who reached out to and attracted people. Both loved business, and they realized that Galveston was the perfect place to establish a wholesale network that could service the export needs of cotton planters and supply small retail stores throughout Texas and the Southwest.

Apparently, it was difficult for people to speak or write about Harris in anything other than flattering terms. The *Houston Chronicle* in 1909 called Harris Kempner "[p]erhaps the ablest business man ever in Texas." Maybe these kind words also help to explain why he did not marry until he had accumulated a considerable fortune and an unblemished reputation. Harold

The Kempners built Galveston's first skyscraper (1923–25). Its history traces back to 1874, when Harris was asked by the bank's investors to take over the Island City Savings Bank, which the family renamed in 1902 the Texas Bank & Trust Company. In 1923, the name was changed to the United States National Bank. It was the last bank allowed by federal law to contain the words "United States" in its name. *Courtesy of Special Collections, Rosenberg Library, Galveston, Texas.*

M. Hyman, the author of *Oleander Odyssey: The Kempners of Galveston, Texas, 1854–1980s*, concluded that by 1872, Harris Kempner was sufficiently well heeled that he was ready to make the most important decision of his life. "Marriage was now his highest priority, and he took time for life's premier amenity. He courted and wed, with, to be sure, his customary decisiveness."

Although she hailed from Cincinnati, Harris met his future wife, Eliza, when she visited New York City. Not surprisingly, they met at a dining room table. The two were seated across from each other. The table was crowded with food and fellowship, as befitted a middle-class Jewish hotel or boardinghouse. Harris sized Eliza up with the swiftness

Young matron Eliza. This early photo encapsulated Eliza's serene beauty, inside and out. Following the 1900 storm, she wrote to Rabbi Cohen from Colorado stating her desire to help in every way possible those who had suffered such great loss. Returning home to Galveston, she and all family members worked to restore order and hope for those who remained on the island. *Courtesy of Special Collections, Rosenberg Library, Galveston, Texas.*

of a stockbroker making a trade. He noted her good looks and vivaciousness. What convinced him that she was the woman for him was her appetite for food, which matched his own. Being the speculator that he was, he keenly observed that "[s]uch a girl must be vigorous and healthy." Thus, Harris concluded, "here was a girl who knew how to work and who would have healthy children and make the kind of a home he wanted."

When Harris Kempner sat across the table from Eliza Seinsheimer at a hotel in New York City, their eyes exchanged more than the polite greeting of two strangers. Although Eliza was a native-born American and Harris a naturalized citizen, their cultural roots grew from the same Germanic sources. European Jews who immigrated to the United States before the American Civil War were not "wretched refuse" or "huddled masses." They were adventurous and enterprising individuals who broke their bonds with their native land and looked to the New World for freedom of

opportunity. These German Jews and German-speaking Jews from central Europe arrived as an integral part of the general German immigration and tended to remain culturally a part of the German community at large. This early wave of newcomers to American shores included Eliza's parents and Harris Kempner.

Most importantly, the two shared a common religious background from the Old World as well as the New. Harris was an Ashkenazi or German Jew. His name, Kempner, probably does indicate his family's roots in the German district known as Kempener Land, which includes the small village of Kempen, both situated in the Rhineland to the west of Dusseldorf.

As a wholesale grocer, Harris Kempner carried an ample stock of wines and liquor. People usually have some excuse for drinking whiskey. In Harris's case, he used whiskey as the rationale to travel to Cincinnati, a leading producer and distributor of that product, and pursue his courtship of Eliza. Family legend suggested that Harris "convinced himself that on his next trip

Eliza surrounded by her grandchildren. *On floor*: Harris K. Oppenheimer. *Seated, left to right*: Cecile Kempner; Lyda Kempner (Quinn); Frances Oppenheimer (Ullman), on lap; Mary Jean Kempner (Thorne); Leonora "Nonie" Kempner (Thompson); Frances Oppenheimer; and Harris L. Kempner. *Standing in sailor suits, left to right*: Herbert Kempner and Dan Oppenheimer. *Courtesy of the Kempner Family Collection, Galveston, Texas.*

north he should go to Cincinnati (where he had learned she resided) where he undertook to buy whiskey by the carload. He, without calling on any stimulation from his whiskey purchase, proposed, was accepted, the wedding date fixed and marriage followed."

Eliza and Harris wed in 1872. No doubt Harris was reluctant to introduce his wife to the rough-and-tumble Galveston that he knew so well. Yellow fever, an annual threat, had hit in epidemic proportions in 1867 and struck again in 1870. The stench of black vomit and cartloads of yellowed bodies were all too familiar to him. Quarantines kept the sick in and the well out, but not without dire consequences to commerce. Harris knew that epidemics and quarantines were bad for business, but thinking as a potential husband and father, it now dawned on him that yellow jack could threaten the existence of his family.

A vigorous wife could not only defend herself from disease, she could also sustain herself and her family in times of hurricanes and storms. The year before they wed, Galveston experienced three tropical storms. Four people died, and the property damage was extensive. Between 1865 and 1872, thirty-six murders occurred in Harris's hometown. Health and vigor might shield the fairer sex from some aspects of life in Galveston, but could they protect her from crime? Rowdy, riotous living by a largely male population, gambling and threats of racial flare-ups greeted Eliza upon her arrival in Galveston.

Harris chose well. Eliza was not only stouthearted, she was also good-hearted. Her steadfast character may have shown through from across that all-important dinner table. Her table manners surely indicated her station in life. Her vivacious demeanor most likely conveyed poise and self-assurance. On the verge of turning twenty, Eliza projected an inner strength anchored in freedom, family and her strong Jewish faith.

Eliza Seinsheimer was born in Cincinnati on January 21, 1852. That year, Harriet Beecher Stowe was giving birth in serial form in Cincinnati to another Eliza, the fictional heroine of *Uncle Tom's Cabin*, whose courage, devotion to her child and abhorrence of slavery would empower her to brave ice floes to escape to freedom, with her child, Harry, clinging precariously to her bosom. America's most influential voice for freedom of those held in bondage, Stowe's book grew out of her experiences and insights gained from living in Cincinnati, where her father was president of Lane Theological Seminary and her husband was a professor. As a major station and distribution point on the North's growing Underground Railroad, Cincinnati provided daily dramas of human suffering and villainy as slave catchers and abolitionists struggled over possession of runaway slaves.

Eliza Seinsheimer may not have read the book, but it is doubtful that she could have missed its impact. Years later, her son, Ike, wrote lovingly of his early recollections of his mother. He remembered that she took time away from a busy schedule to gather the employees (many former slaves) and their children and teach them to read. She did not just nourish their minds, but she also made certain that they had enough food to go about their daily life. This impulse to tend to the needs of the less fortunate— be they former slaves, orphaned children or the elderly and infirm—united Eliza Seinsheimer and Harriet Beecher Stowe in a sisterhood of spirit.

There is a link between Eliza, George Harris and young Harry of *Uncle Tom's Cabin* with Eliza, Harris Kempner and their children that goes beyond the

Top: Aunt Eveline, a former slave, helped Eliza with childcare. Posing for the camera with Ike and five-year-old brother, Abe, who died in 1879, she was a beloved figure in the Harris Kempner household. Eveline's passing in 1891 was mourned and remembered by Ike in his memoirs, *Recalled Recollections*, published in 1961. *Courtesy of the Kempner Family Collection, Galveston, Texas.*

Bottom: Ike and Abe Kempner as young boys. *Courtesy of the Kempner Family Collection, Galveston, Texas.*

coincidence of naming. This link was the role of family and, most notably, the role of women in their quest for freedom and self-realization within the family. Eliza Seinsheimer did not hazard her life on ice floes in her quest for freedom. She was born free in this country. But she was born of German Jewish parents. They bravely crossed the Atlantic and one-fourth of a continent to forge a new life in a new world. They faced frontier conditions and experienced many hardships so they could experience freedom. The early travails of her parents were not lost on Eliza. She knew the life of a rag peddler's daughter until she was almost ten, when her father established a prosperous paper manufacturing business. Her father, Bernard, literally built a "rags to riches" legacy for his family.

Bernhard Seinsheimer left his native Bavaria at a time when the government indiscriminately taxed Jews and denied them the rights of citizenship. Bernard faced humiliating restrictions that governed where he could live, who he could marry and what occupations he could pursue. He met his wife-to-be in the United States. Deborah Bauman was born in Frankfurt, and her family's immediate background may well have sprung from the Frankfurt ghetto. And why did they leave? It may be that the lure of greater freedom and fortune in America prompted their departure from the Old World more than oppression pushed them to take the leap. But leap it was, for freedom and for all the opportunities attendant to an open society. They met and married in the United States and made their way to Cincinnati, where they joined the congregation led by Rabbi Isaac Meyer Wise, the founder of Hebrew Union College and leader of the Reform movement in this country. The rabbi personally ministered to the Seinsheimer family, encouraging Eliza to sing in the choir. Later, he officiated at her marriage to Harris Kempner. Among Wise's co-religionists was Rabbi Henry Cohen, who would move to Galveston in 1888. He became the Reform leader in Texas and the rabbi of Congregation B'nai Israel, where he ministered to Harris and Eliza and subsequent generations of Kempners.

Eliza and Harris, like most of their fellow citizens, were relative newcomers to Galveston. The population had tripled since the 1860 figure, going from 7,300 to 22,248 in 1880. The city and seaport were thriving and the citizens welcoming, although danger lurked in the dreaded annual visits of yellow fever and other epidemics, as well as frequent windswept fires and storms. But not all in Galveston was doom and gloom. A reporter from the *New York Herald* visited Galveston in 1874. He left an attractive picture of the island city:

> *Some of the immigrants came with money, and immediately settled in to enjoy the languid, luxurious pleasures that Island living offered. They*

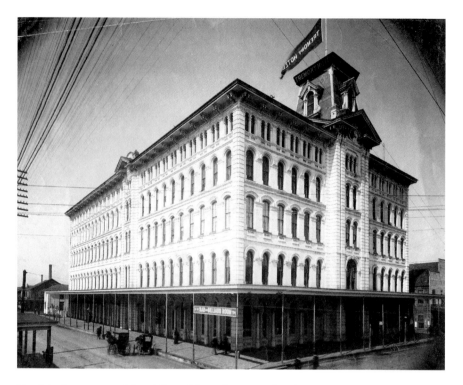

Harris built a commercial and financial conglomerate. Less known was his role in bringing Nicholas Clayton to Galveston to transform the city into what has become a national showcase of Victorian architecture. Clayton had honed his skills in Cincinnati and was strongly influenced by the design of the Isaac Mayer Wise Temple, where the Seinsheimers worshipped. Harris had Clayton finish work on the Tremont Hotel, which Marx and Kempner had purchased. Clayton also designed the Marx and Kempner Building on Twenty-fourth and Strand and renovated the Congregation B'nai Israel Synagogue. *Courtesy of Rosenberg Library, Galveston, Texas.*

woke with the sun, puttered or strolled in their gardens, and bathed in the Gulf—the women wearing long Mother Hubbards and large sun hats tied securely under their chins. At 7 A.M. the hotels across the Island rang their breakfast bells. After breakfast the men went to their offices on the Strand for a few hours, then played billiards or nine pins until lunch. Lunch was always laid out at the bar of the Tremont. In the late afternoons people gathered on the veranda for mint juleps—with ice, if a ship had chanced to arrive—or a glass of Madeira and bitters. After a tea supper the men smoked or talked business, and the women sat on the veranda, listening to a serenade of guitars and violins.

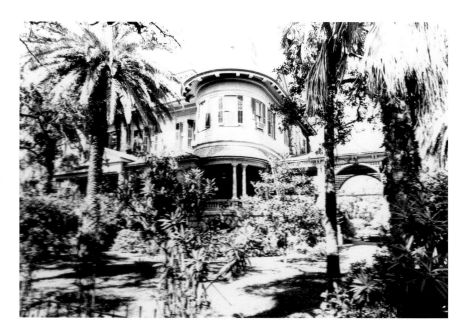

Their first two homes were destroyed by the fire of 1886. Later, Harris Kempner moved his family into a lovely home on the corner of Sixteenth and Sealy. Eliza Kempner purchased the League House in 1919 and lived there with her bachelor sons, Lee and Stanley, and daughters Fannie and Gladys until her death in 1947. *Courtesy of Rosenberg Library, Galveston, Texas.*

The new Tremont Hotel made a proper wedding gift for his bride. It was Harris Kempner who brought architect Nicholas J. Clayton to Galveston in April 1872 to supervise construction of that symbol of Galveston hospitality and gentility. However, the first home Harris and Eliza shared was a large two-story dogtrot house on Twentieth Street and Avenue M that bordered Hitchcock Bayou. This first home was far more practical for a man in the wholesale grocery business. It occupied seven city lots, enough room to support the warehousing of commodities, serving as a depot for all the drays, trucks and mule teams used by Marx & Kempner Wholesale Grocers.

Later, Harris moved his growing family into a second house located on Eighteenth Street and Post Office. The Great Fire of 1885, which began early Friday morning on November 13, swept its wind-driven flames from the Strand and Sixteenth Street through both Kempner homes. Inside of five hours, the flames gobbled 566 other structures within a forty-two-block span that reached Avenue O.

Eliza had moved into a ready-made world that revolved around the business needs of her husband. Harris Kempner worked hard to secure

railroad connections for the island that took products and passengers into the Texas hinterland and connected with the Midwest. He saw the need for a deep-water port and for federal dollars to get the job done.

Between 1873 and 1893, Eliza bore Harris eleven children. Not surprising, she wanted her first child to be born in the familiar setting of her Cincinnati home, where her mother could oversee the birth and help her regain her strength. Three months after Isaac Herbert, soon to be called "Ikey," came into the world, Eliza, the baby and her brother, Joseph, boarded the train for Galveston.

Joe remained in Galveston and added another link between the Seinsheimer and the Kempner families. Harris hired Joe as his general office manager and partner in many of his ventures. At first, Joe lived with the Kempners. In 1879, he fell in love with and married a Texas beauty, Blanche Fellman. Their two daughters, Emma and Edith, became playmates and travel companions of the Kempner girls. Their son, Joseph Fellman, founded the American Indemnity Company, one of Texas's largest insurance companies.

Having established himself as an independent cotton exporter with credentials and credit sources in the United States and abroad, Harris invested in railroads, banks and a number of local and regional companies, serving on their boards of directors and on the prestigious Deep Water Commission. He sent his two eldest sons to college. Isaac Herbert attended Washington and Lee University, and Daniel Webster graduated from the University of Virginia. He directed each son to continue his education abroad, learn several languages and become "refined and honorable" and "distinguished in your generation."

Opposite, top, left to right: Stanley Eugene ("Pat"), born on April 7, 1885; Robert Lee ("Lee"), born on January 21, 1883; Daniel Webster ("Dan"), born on March 28, 1877; and Isaac Herbert Kempner ("Ike"), born on January 14, 1873. At his death, Harris Kempner's diversified portfolio of more than $1 million holdings and business enterprises were left in good hands. Together, his four sons, equally devoted to their father's memory and to their mother's wishes to keep the family and estate intact, contributed a uniquely beneficial and complementary business acumen to the family enterprises. *Courtesy of the Kempner Family Collection, Galveston, Texas.*

Opposite, bottom: Proud father with sons. Both Harris and Herb Kempner volunteered to serve in World War II. Ironically, because of their training, both ended up in Washington, D.C., with important desk jobs. For their service, the government awarded them the Legion of Merit and the rank of commander in the navy. Following service, Herb pursued a career at Imperial Sugar Company, while Harris chose a career in H. Kempner Cotton Enterprises, centered in Galveston. *Courtesy of the Kempner Family Collection, Galveston, Texas.*

This dancing pavilion, which was a part of the German social club Garten Verein, is the centerpiece of Kempner Park. In its prime, the park also contained a clubhouse, bowling alleys, croquet lawns, tennis courts and paths for strolling. Falling victim to anti-German sentiment in World War I, the property fell into neglect. Stanley Kempner purchased the park and gave it to the City of Galveston in memory of his parents, Harris and Eliza. *Courtesy of Rosenberg Library, Galveston, Texas.*

Harris Kempner died at the age of fifty-seven on Friday, April 13, 1894, without a signed will. He had a handwritten will drawn up hastily in February 1894, prompted by dawning knowledge that his health was failing. He left all his worldly possessions to his beloved wife and appointed her the executrix.

Eliza knew that Harris wanted her to keep their estate intact. How else could she care for the large family entrusted to her? The intent of this will became the guiding force for Eliza Kempner. Backed by generous and trusting friends, closely advised by her doting brother and assured by her lawyer-to-be son, I.H. or Ike, Eliza determined to hold the estate together as tightly as she would hold her family together, not to further the estate so much as to sustain the family. The important thing was to perpetuate the estate so that the youngest child could be assured the same place at the table as the oldest. While the female children were not brought into the businesses, they were equally represented in the estate. As he came of age, each son contributed his time and talents—a facet of the growing house of Kempner. Ike fit perfectly into his father's shoes, overseeing the

In 1902, Ike Kempner married Henrietta Cecile Blum. Much of the family's legacy over the generations emanates from this union. The IHKs bore five children: Harris Leon (born on October 6, 1903); Isaac Herbert Jr. (born on October 1, 1906); Cecile Blum (born on May 11, 1908); Lyda (born on November 15, 1911); and Henrietta Leonora, nicknamed "Nonie" (born on August 5, 1913). Ike's wife, Hennie, became the heart and soul of the Galveston chapter of the American Red Cross. Bridging both world wars, she served as chairman of volunteers for the local chapter. *Courtesy of the Kempner Family Collection, Galveston, Texas.*

Three Kempner girls. *Courtesy of the Kempner Family Collection, Galveston, Texas.*

Left: Dan Kempner's wife, Jeane Bertig, served in the Red Cross in World War I and then led the Galveston and the Texas League of Women Voters in the years before World War II. She became the local, state and national organizer and leader of the American Women's Volunteer Service in World War II. *Courtesy of the Kempner Family Collection, Galveston, Texas.*

Below: Dan and Jeane's daughter, Mary Jean, a writer for *Vogue* magazine, joined the Office of Strategic Services (OSS) in World War II. In 1944, she served as a war correspondent for the navy in the Pacific Theater. This photo was taken in Guam in 1945. *Courtesy of the Kempner Family Collection, Galveston, Texas.*

family and H. Kempner enterprises. Dan managed land and real estate investments and backed Ike when needed. Lee became the banker and money manager. Stanley branched out and built the Texas Prudential Insurance Company.

Another imperative passed on beyond the grave was the philanthropy that Eliza and Harris had made a cornerstone of their life. How better could Eliza Kempner honor the memory and meaning of her husband's life than to preserve intact the material and spiritual foundations of their marriage? She and Harris, followed by their children, never begrudged a gift they gave. It came from the heart or from the religious conviction that to be a Jew is to give of one's self and property. In America, to be a Reform Jew was to love and serve one's country as well.

Memories too rich to lose surround the earlier days of Kempner giving. Eliza and Harris would take the horse and buggy, fill the latter with groceries and distribute food and sundries to the large families and to the elderly who had little. Eliza would send a note to the bank that ordered the teller to pay such and such, a widower perhaps, so much money every Saturday after temple. They also allowed Rabbi Henry Cohen, the family's spiritual advisor, access to the Kempner bank accounts and use their money to help those in need as he saw fit.

Harris Kempner gave generously to members of his extended family, and this tradition continues today. As long as they lived, Harris's Confederate veteran friends and their organizations could count on his support. He also remembered the freedmen who worked for him after the war. If they needed money for any legitimate reason, he always offered a helping hand. Eliza gave quietly, usually asking that her name not be listed as a donor. She funded a "rabbinage" or home for Henry Cohen and his family, and bought an organ for the synagogue. She also contributed time and money to B'nai Israel and the Rosenberg Women's Home. Stanley Kempner purchased the Garten Verein, a local German Dance Pavilion, and gave it to the city to be named Kempner Park in honor of Eliza and Harris Kempner.

For a family founded in philanthropy, there was no better way to perpetuate the giving than by establishing a charitable foundation dedicated to that purpose. In December 1946, preparing for what would be Eliza's last birthday celebration, her children decided to endow and manage a permanent fund that would help Galveston and honor their parents. After her death on September 26, 1947, the children named this legacy the Harris and Eliza Kempner Fund. The board of directors, composed mostly of family members, keeps a close eye on community needs and individual

Harris ("Bush") and Ruth Kempner romping with Harris Leon Jr. ("Shrub") and Marion Lee ("Sandy"). Harris senior ("Bush") became a leading proponent of fair housing in the 1930s and, with Ruth, acted to secure peaceful racial integration in Galveston in the 1950s and 1960s. Ruth led the movement to change the city government from the city commission form to the council/city manager form. In 1961, she became the first woman elected to serve on Galveston's governing body. Shrub created and heads Kempner Capital Management. Younger brother Sandy, age twenty-four, sacrificed his life in Vietnam in 1966 fighting for the rights of a people to govern themselves free of persecution and arbitrary rule, much the same reason his great-grandfather, Harris Kempner, had for refusing to fight in the czar's army and willingly fighting in the American Civil War. *Courtesy of the Kempner Family Collection, Galveston, Texas.*

aspirations. The fund supports the University of Texas Medical Branch and Texas A&M University at Galveston. It also funds the arts, education, historical restoration and social services and has responded to emergencies such as providing expedited business recovery loans after Hurricane Ike in 2008 devastated Galveston Island and partnering with other foundations to form the Galveston County Recovery Committee.

The essence of the Kempner legacy is not its lineage, holdings or wealth. Rather, it is the daily record of service built up over the past one hundred plus years. The family's legacy lies in service to the community, to the state,

Ike Kempner, a former mayor of Galveston, and his granddaughter, Lyda Ann Thomas (née Quinn), a future mayor of Galveston, at her debut in 1957. Ike served as city treasurer in 1899 and helped lead Galveston's recovery from the 1900 storm. He served as commissioner of revenue and finance from 1901 to 1916 and as mayor in 1917–19. Thomas served six years on the city council and six years as mayor. Her term-limited tenure catapulted her to national attention in 2005 during Hurricane Rita and again in 2008 when Hurricane Ike's devastating surge crippled the city. *Courtesy of the Kempner Family Collection, Galveston, Texas.*

Nonie Thompson. *Courtesy of the Kempner Family Collection, Galveston, Texas.*

Kempner Fund Fiftieth Anniversary cake decorated with flowers. *Courtesy of the Kempner Family Collection, Galveston, Texas.*

To honor Nonie Kempner Thompson's philanthropies and service to the city, the 1894 Grand Opera House, which she helped restore, awarded Nonie the Grand's first Community Enrichment Award. Annually, a banquet is held, and a worthy citizen or family is presented the "Nonie." When she died in 2010, the community gathered at the Grand to celebrate her life with a banquet, and all were invited to the table. *Courtesy of the Kempner Family Collection, Galveston, Texas.*

to the nation and to international struggles for freedom. Family members have boldly fought the enemy abroad and the enemies of discrimination and injustice at home. They have let their love of freedom and their fellow man take precedence, even over religious conformity. Yet each generation has proudly and generously supported Jewish relief, resettlement and philanthropy. Kempners offer to help anyone in need, be they Catholic, Protestant, Moslem or Jew.

The enduring legacy of the Kempner family is sweet because, like the bees freely at work tending their flowers, the honey the family gathers is a communal banquet for all to share. And all are invited to the table.

George T. Ruby

Galveston's First Black Senator

Merline Pitre

During the Reconstruction era, Southern whites unmercifully scrutinized black legislators. However, Galveston's first African American state senator, George Thompson Ruby, won the admiration of many of his Republican Party colleagues and even some Democrats. His personal qualities of tact and diplomacy, plus his education, tended to soften the reactions of his political opponents. Dapper in dress, Ruby made Conservative Republicans uncomfortable when he took a white woman for his bride and refused to act passively in politics. On the other hand, Ruby flattered Radical Republicans as he supported and spoke out in favor of their program. At the same time, he angered many black Galvestonians because he catered more to his white constituents.

George T. Ruby, the most prominent black politician of Galveston, was born to Ebenezer and Jemina Ruby in New York in 1841. After spending ten years in New York, Ruby and his family moved to Portland, Maine, where he received a sound liberal arts education. At twenty-one, Ruby left Portland and began his career as a newspaperman. His first job in 1861 took him to Haiti, where he worked as a correspondent for the *Pine and Palm*, a New England newspaper edited by abolitionist James Redpath. While in Haiti, Ruby also served as a correspondent for the *Anti-Slavery Standard*, the *New York Times* and the *Toledo Blade*. He collected information about Haiti and sent it back to the United States so black Americans who sought an alternative to slavery and discrimination could learn more about this Caribbean nation.

George T. Ruby, while serving as a senator from Galveston in the Thirteenth Texas legislature. *Courtesy of Texas State Library & Archives Commission.*

In 1864, Ruby returned to the United States and settled in New Orleans, Louisiana. He maintained his ties with these newspapers and founded a night school for freemen. Later, he served as a teacher and a principal at Fort Douglass Grade School. His interest in the education of African Americans led him to join the Bureau of Refugees, Freedmen's and Abandoned Lands in 1866. The Louisiana Freedmen's Bureau hired him to organize schools in the Pelican State.

In September 1866, Ruby left Louisiana and joined the Texas Freedmen's Bureau in Galveston. He received a salary of $100 per month to teach at the Methodist church of Galveston. During his first year in Galveston, Ruby also served as a correspondent for the *New Orleans Tribune*. Later, he founded his own newspaper, the short-lived *Galveston Standard*. He used this publication as a forum to lobby for voting and civil rights for African Americans. Such visibility in the community caused Governor Elisha Pease to appoint him as the first black notary public in Galveston.

Ruby arrived in Galveston at a time of heightened racial violence in the state. The Freedmen's Bureau, as well as many of the state's leading newspapers, reported daily beatings and killings of blacks by whites. Disgusted by what he saw and read, Ruby told the editor of the *New Orleans Tribune* that blacks "were not safe here [in Texas]." In his opinion, this situation would not change until the Federal government ousted the ex-Confederate rebels from state government. Ruby's interest in politics and his earnest desire to advance the political rights of blacks led him to ally with Edmund J. Davis, the leader of the Radical Republicans. A Texan who supported the Union during the Civil War, Davis voiced his support of suffrage and the civil rights of blacks as early as 1866, and he became a leading figure in the Texas Republican Party after its formation in July 1867.

After one year in Galveston, Ruby exhibited such organizational skills that the Freedmen's Bureau in 1867 promoted him to a new position, traveling agent. He visited Washington, Austin, Bastrop, Columbus, Fort Bend and a number of other counties in east and central Texas, where he rendered assistance to the freedmen. Ruby enjoyed this new job because it enabled him to evaluate the performance of the local bureau agents and influence the bureau's policy toward blacks. But this job was a two-way street for Ruby. It also called for the bureau to evaluate him. General Charles Griffin, bureau commissioner of Texas, gave Ruby high ratings. Writing to the Freedmen's Bureau president, General Oliver O. Howard, Griffin said that "[Ruby is] an energetic man" and "has great influence among his people." The head of the Texas bureau particularly praised Ruby as a traveling agent because, as he put it, "[i]n that capacity many freed people may be reached and much good accomplished."

It was largely due to Ruby's influence as a traveling agent that former Unionists founded chapters of the Loyal Union League (an organization that instructed blacks about their political rights) in a number of counties in the state. Ruby organized the Loyal Union chapter in Galveston. He used this organization to gain firsthand information about the socioeconomic conditions of African Americans. He also learned about their political aspirations and the obstacles that stood in their path to progress. His tireless work with the Union League laid the groundwork for his political career. Although Ruby relinquished his post as a traveling agent in 1867 when the governor appointed him the deputy collector of customs in Galveston, he still maintained strong ties to the Loyal Union League. He became the organization's president in 1868. It was the league more than anything else that enabled him to climb up the ranks of the Republican Party. Ruby's influence in the league allowed him to control the bulk of the party's black vote. He quickly became a powerful politician in the island city.

The Reconstruction Act of 1867 ordered each former Confederate state to draft a new constitution before it could reenter the Union. This legislation further mandated that the new constitution contain a proviso that granted the vote to all male African Americans. As a result, voters from Brazoria, Matagorda and Galveston Counties chose George T. Ruby to represent the Twelfth District as a delegate to the Constitutional Convention in Austin. As a delegate, Ruby expressed a genuine concern for the general welfare of the state of Texas, of African Americans and particularly of black Galvestonians. He authored and championed bills and resolutions on suffrage rights, public education, teacher salaries and internal improvements

for the state. Ruby introduced a resolution that "prohibited anyone from interfering with or preventing one from exercising the ballot." He clashed with conservative delegates who demanded lenient suffrage restriction for all ex-Confederates. Disgusted with the entire affair, Ruby resigned as delegate before the Constitutional Convention finished its work. He subsequently joined a commission headed by Governor Edmund J. Davis that traveled to Washington and lobbied against the document.

After failing to influence the United States Congress, Ruby accepted the new state constitution and refocused on his organizational work in Galveston. He helped prepare the way for himself and others for election to local and state offices. Having gained a stronghold in the politics of the Twelfth District, he decided to run for state senator. For the first time in Texas history, the election, held on November 30, 1869, elevated Ruby as well as thirteen other blacks to state office. Ruby became Galveston's first African American state senator, and he served in that capacity through 1873.

When he arrived in Austin on February 8, 1870, Ruby was no political novice. Senator Ruby soon became one of the most influential and powerful men of the Twelfth and Thirteenth legislatures. He served on several Senate

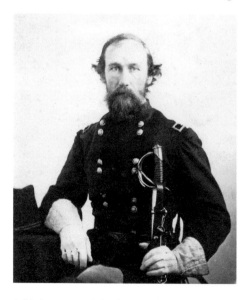

committees, including the judiciary, militia, education and state affairs committees. Membership on those committees enabled Ruby to put his beliefs into practice, translate his political views into law and show his loyalty to his party and his race. By the end of the first session of the Twelfth legislature, Ruby was not only a senator from Galveston, but he was also part of the inner circle of the ruling party.

When the regular session convened on April 28, 1870, Governor Edmund J. Davis presented his wish list to the legislature. The list included new legislation for public schools, internal improvement and frontier protection, as well as adequate financial support to implement

A Union general during the Civil War and a Radical Republican after the war, Edmond J. Davis was elected governor of Texas in 1869. He and George Ruby soon became political allies. *Courtesy of Texas State Library & Archives Commission.*

his package. Davis also demanded tougher legislation to deal with the growing violence committed by whites against freedmen. Racial turmoil, which existed prior to 1865, increased after Davis took office. Racial Republicans quickly responded to this dangerous racial climate. They called for the creation of a state police force and the reestablishment of the state militia. During the antebellum years, the state operated a police agency, the Texas Rangers, but restricted its jurisdiction to the frontier. The new state policy bill called for an integrated force of 258 men with the authority to enforce civil law anywhere in the state. The legislation placed this law enforcement organization under the complete control of the governor. The new militia bill did not differ significantly from the prewar militia bill, but it did enlarge the power of the governor. It gave the governor the power to activate this force, suspend civil law and declare martial law where lawlessness obstructed justice. The bill also forced citizens in any "lawless area" to pay for the militia's expense.

These bills created quite a furor both within and outside the General Assembly. Some critics charged that the "real purpose of these bills was not to preserve law and order, but to perpetuate Negro and Carpetbaggers' rule." Others argued from concern for "constitutional rights and the plan of government abuse of power." Others complained that both forces, militia and police, would be racially integrated. Despite such criticisms and obstacles, these two measures easily passed the House on May 21 and June 7, 1870. The situation in the Senate was quite different. After some legislative wrangling, the police bill passed the Senate on June 12, 1870, but passage of the militia bill was an uphill battle.

The two black senators, George T. Ruby and Matthew Gaines, played instrumental roles in pushing these laws through the Senate. Ruby argued for the militia bill because he believed in the centralization of power inherent in the state and federal constitutions, while Gaines supported the bill because it afforded more protection for blacks. Ruby argued that the militia bill, as originally proposed, would only give the chief executive power already delegated to him by the constitution. Ruby told conservatives and moderate Republicans that the militia bill had its origin in the racial violence that existed in Texas, but he was quick to add that these acts of violence were not committed by peaceable residents of the Texas counties.

Ruby, like other black legislators, wanted to protect the civic, political and educational rights of African Americans and promote the general welfare of the state. He also played a vital role in the passage of the education and election bills. The election bill, at least temporarily, protected blacks' right to vote, while the education bill allowed blacks equal, though segregated,

participation in the state public system. Ruby also authored a bill that authorized a geological survey of the state's public domain. The role Ruby played in the passage of these bills did not go unnoticed. Most legislators considered Ruby the administration's chief spokesperson.

Ruby also was the chief patronage broker of Galveston County. He literally ran the county. Ruby's endorsement of Victor McMahan, a moderate Republican, for mayor of Galveston ensured his victory over Radical Republican William Sinclair. Likewise, H.G. Sprague, sporting Senator Ruby's support, became the district county clerk of Galveston over the opposition of county judge Samuel Dodge. In 1870, Ruby used his growing political power to secure for Norris Wright Cuney an appointment as the first assistant to the sergeant-at-arms of the Twelfth legislature.

While Ruby dominated the black vote in Matagorda and Brazoria Counties, he did not control the African American vote in Galveston. Many islanders perceived Ruby as a carpetbagger. While cognizant of Ruby's role with the white business establishment within the Republican Party, black Galvestonians wondered how well Ruby served his black constituents. To that end, Ruby's personal letters, his speeches in Senate debates and his editorials in the extant copies of the *Galveston Standard* and the *Freedman's Press* make one wonder how much he identified with blacks. He spoke out for the rights of blacks. However, if his ideological commitments conflicted with his loyalty to the Republican Party, he always picked the party. This was evident by his behavior on four important issues: first, his support of a white man, James P. Newcomb, over a black man, Johnson Reed, for leadership of the Loyal Union League; second, his posture and voting record on racially sensitive issues; third, his siding with the William T. Clark faction over a black candidate for the congressional seat in the Third District; and fourth, his close ties with well-to-do conservative white businessmen.

Although Ruby controlled the Loyal Union League, in 1868, his white Republican allies removed Ruby from the presidency and left it in the hands of a white man, James P. Newcomb. Ruby never protested this action. He continued to work as a good soldier in the organization. Moreover, in 1871, when Republican Party Executive Committee chairman James G. Tracy sought to break up the Loyal Union League, he used Ruby to pacify blacks by appointing him to a school directorship in Galveston. Ruby served in that capacity for only three months before stepping down. In August 1871, Jacob De Gress of the Freedmen's Bureau informed Ruby that "[t]he governor deems [his] place as a school director incompatible with [his] official position as a state officer." In a letter to James Newcomb, Ruby lamented that "[w]hile

in [Austin] the matter of this appointment as a director was taken up with the Governor and Colonel De Gress, but at that time, there was no incompatibility with his present position." Again, without protest, Ruby acquiesced to higher authorities. Rather than express anger, Ruby aided and abetted the breaking up of the Loyal Union League in Galveston and named his protégée, Norris W. Cuney, as president of a new chapter in that city.

Ruby's positions on racially sensitive issues such as immigration and the militia bills also left a lot to be desired. Ruby sided with white Republicans and Democrats and defeated fellow African American state senator Matthew Gaines's amendment to the immigration bill, which ordered the state to send recruiting agents to Africa. Instead, Ruby favored a bill to recruit immigrants from France and Great Britain. Given the desperate economic conditions of most freedmen in Texas, most white Republicans at the same time felt that it was necessary to extend the "right hand of fellowship" only to men of European ancestry.

If Ruby's loyalty to his party over his race was ever in question, his support of the white conservative Republican William T. Clark's nomination for congressman from the Third District demonstrated where his loyalty lay. The majority of blacks either sided with Senator Matthew Gaines and his support of a black candidate or backed a more liberal white candidate, Louis Stevenson. Ruby supported the conservative Clark. Ruby almost single-handedly controlled the nominating convention by preventing any of Clark's opposition from entering the convention hall. The day after the convention, he wrote to James Newcomb, "Of course you are well informed that our Standard Bearer (Gen) Clark has been chosen. The action of the malcontent and bolters will only tend to strengthen us in that we are freed of the dead weight on the party." Ruby suggested that the party replace these men with "better and stronger Republicans." In his opinion, victory by the Gaines and Stevenson factions "would [only] lead to the destruction of the party."

The week following Clark's nomination, Governor Davis visited Galveston. According to newspaper accounts, the governor failed to salve the wound inflicted by Ruby and others at the Clark nominating convention. Davis received a chilly reception from prominent island blacks. Their loud cries of protest drowned out the governor when he suggested that Clark was the legitimate Republican nominee. Moreover, when he asked the group to vote for Clark, a black editor, Frank Webb, answered with a resounding, "*No.*" Ruby, the only high-ranking government official to accompany Davis on this political canvass, ordered Webb's immediate arrest, but the governor,

obviously shaken by this embarrassing experience, told the police to leave the defiant man alone.

After this ugly incident, Ruby's popularity in Galveston plummeted. His support of blacks likewise lessened. In June 1870, blacks accused Ruby of refusing to support any black person for public office except himself. This allegation stemmed from Ruby's support of Thomas Ochiltree's amendment to the city charter over that of a black man's, John De Bruhl. Ochiltree's amendment stated that in order to sit on the city council, one had to post a $5,000 bond, an amount very few blacks could afford. Also, Ruby requested that Governor Davis replace alderman John Reed with Norris W. Cuney. Ruby told the governor that this would enable the city's Republican government to prepare better for the forthcoming election. The implication was that Reed was not loyal to the party. Davis, however, turned a deaf ear to that request.

Whenever Ruby attended an all-black gathering, he usually "took" the Republican Party with him. Two cases in point were the Colored Men's National Labor Convention of 1871 and the Colored Men's Convention of 1873. In May 1870, Ruby, along with John De Bruhl and Richard Nelson, organized the Labor Union of Colored Men at Galveston. It was a spinoff from the first Colored National Labor Convention held in 1869. These labor leaders emphasized the need to improve the working conditions of all blacks and believed that organized labor unions were the best vehicle for this goal. Ruby pursued this idea, not only because he believed in the national organization but also because he needed black workers to strengthen his urban power base. Before the Civil War, whites controlled jobs on Galveston's docks. After 1870, the situation changed. A large number of blacks began to work as longshoremen. So, black workers on the docks welcomed Ruby's organizational activities.

Under Ruby's leadership, these local black unions sided with the Republican hierarchy. On June 8, 1871, the annual labor convention met in Houston. Ruby made sure that the convention spoke favorably about the Republican Party. He also urged black workers to vote for the party's conservative white nominee for the Third Congressional District, William T. Clark. Daily, Ruby canvassed the convention floor with Clark by his side. He tried to impress upon blacks that Clark supported their aspirations. The convention did not make a public endorsement, but everyone knew that Clark was the favored son.

Ruby, who helped to organize the Colored Men's Convention of 1873, believed that it was "something monumental in the life of blacks"

but shuddered at the thought that its motives might be misinterpreted. The convention called together African American leaders to discuss the political, economic and social conditions of blacks. Strangely, when asked to comment on these issues, Ruby refused. When called on to speak, he told his black brethren that "with little moderation [they] could become equal to whites." He encouraged blacks to acquire land and homesteads as a means of securing complete freedom. And despite suggestions from the floor that blacks form an independent party, Ruby steered the delegates away from this course of action. Instead, in August 1873 at the Republican convention, Ruby persuaded most black delegates to support Governor Davis.

While most of Ruby's supporters resided in Brazoria and Matagorda Counties, Galveston was his economic power base. Ruby soon realized that black voters alone could not keep him in office; therefore, he would have to support the interests of whites. To do this, Ruby often catered to the needs of whites at the expense of blacks, who made up the bulk of the votes in his district. Ruby sponsored considerable legislation that aided the interest of white Galveston businessmen. He authorized a joint resolution that instructed the Texas congressional delegation to urge Congress to survey and construct a ship canal across Florida that would bring Europe closer to Galveston. He also championed a bill to incorporate several local railroad lines, including the Galveston and El Paso, as well as the Galveston, Houston and Tyler Railroads. Similarly, he pushed for the incorporation of the Harbor Trust Company, as well as a number of insurance companies. During Ruby's four years in Senate, Galveston businessmen had little to complain about. The value of their exports rose from $14,869,601 in 1871 to $17,629,633 in 1875.

Ruby was the chief patronage broker for Galveston and displayed such favoritism toward his white well-to-do conservative friends in his choices for local and state offices that some of his black constituents became restive. Having been disappointed in his search for a high position within the Galveston Customhouse, Silas Blonover, a former black employee of the Freedmen's Bureau, complained bitterly to Governor Davis that "this George T. Ruby is not a favorite of colored people of Galveston." Except for Norris W. Cuney, Ruby seemed to have been at odds with most of the important blacks of the city. Likewise, the record does not show that he encouraged any black person to run for office.

In 1869, Ruby was known as "a militant nigger Carpetbagger," a black man who went to Washington to bar Texas's entrance into the Union because he said that the state's constitution was "soft" on ex-Confederates. However,

once Ruby hitched himself to the Republican saddle, he became "soft" on certain issues relative to blacks. Ferdinand Flake of *Flake's Daily Bulletin* bore out this point when he wrote, "Ruby has improved very much over the past year. He has abated and concealed his egotism that made him offensive in the constitutional convention. He is one of the most gentlemanly senators on the floor." To a certain extent, this was true. While no one can deny that Ruby fought for the rights of blacks, it appears that at times he had problems identifying with them.

Ruby did not stand for reelection in 1873. This failure did not stem from lack of personal skills and judgment. It occurred because he failed to serve simultaneously the interests of both black and white constituents with their diverse and contradictory needs and desires. By 1873, Ruby's support among black Galvestonians had begun to wane. Yet blacks in Brazoria and Matagorda Counties urged him to seek reelection. On the other hand, his white supporters deserted him because of his stand on some racial issues and because they could not out vote his black supporters. Ironically, disgruntled black leaders of Galveston reluctantly supported his reelection. White members of his own party pressured him not to seek reelection. They wanted a white man to run for the office. Because Ruby realized the unlikelihood of his reelection and thought that the German Republican Chauncey B. Sabin might have a better chance, he refused to run again. Ruby's fall from power occurred because the Republican Party of Texas betrayed him.

After the 1873 election, George T. Ruby left Texas and returned to New Orleans. He returned to his journalistic roots and edited the *New Orleans Tribune* and the *New Orleans Observer*. In New Orleans, he became clerk of the surveyor of the Port of New Orleans and worked with the Intertidal Revenue Department. In the late 1870s, he strongly supported the Exoduster movement, a popular, unorganized migration of more than twenty thousand blacks from the South to the Kansas frontier. He never left New Orleans. Ruby died there in mid-1882.

Chapter 6

Galveston's Nineteenth-Century Medical Legacies

Chester R. Burns

In January 1839, almost three years after their town became a port of entry for the new Republic of Texas, an estimated 300 Galvestonians incorporated as a city. During that year, 228 ships docked at Galveston, bringing valuable cargoes and 4,376 passengers into Texas. Recognizing the sanitary and medical challenges of such rapid growth, the city's aldermen imposed a fine on anyone who threw filth, garbage or dead animals onto the streets. They also required captains of all ships arriving from foreign ports to pay a tax of one dollar per passenger so the city could establish a city hospital. These two local ordinances showed how aware Galvestonians were of potential health problems on their barrier island seaport. These laws also marked the beginning of a medical legacy that set Galveston apart from other Texas cities.

That September, an epidemic of yellow fever struck Galveston. It filled the new City Hospital with more than twenty patients. The disease was terrifying. A twenty-five-year-old man could be healthy one day and dead three days later. The victim passed from stages of fever and pains in the extremities to vomiting blood clots (the "black vomit"), jaundice and, finally, death. While treating the afflicted, Dr. Ashbel Smith, the "Father of Texas Medicine," tasted this vomit and did not become ill. He concluded that the disease was not contagious. He noticed that some patients lived and some died, even though he treated each patient the same. Since so many victims lived on the Strand, the main business street in Galveston, he believed that there was a causal connection between their plight and the filthy, marshy waters underneath many buildings. Others believed

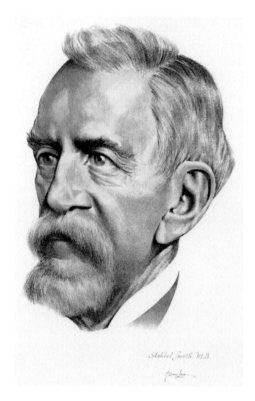

Ashbel Smith, M.D.

Ashbel Smith, the "Father of Texas medicine."
Courtesy of the Blocker History of Medicine Collections, University of Texas Medical Branch, Galveston, Texas.

that the epidemic occurred because a previously infected visitor, probably an immigrant or traveler, entered the town. As the disease spread rapidly, many believed that it passed from one human to another. Of an estimated one thousand residents, only about six hundred remained after the epidemic abated in December.

The fear of yellow fever now suffused the public image of Galveston. Many visitors also noticed the stench from decaying oysters and other garbage scattered throughout the streets by the four thousand residents of the city (1840 estimate). Was there a connection? Many citizens believed that this refuse caused the summer fevers. But city leaders did not usually enforce sanitary ordinances until another epidemic of yellow fever motivated emergency cleanups.

By 1845, the city's stewards had collected enough money from the hospital tax to construct a building on block 668 at Ninth and Strand that could house 85 patients. Local doctors competed for the right to serve as a City Hospital physician. In 1851, for example, Samuel Hurlbut paid the aldermen twenty dollars each month for the use of the hospital, and he charged them seventy-five cents per day for each patient. Hurlbut provided food, bedding, drugs and attendants. He admitted between 250 and 500 persons annually during the 1850s. Hurlbut and others did not view the hospital as a deathtrap. The mortality rate, even during yellow fever epidemics, ranged between 5 and 8 percent. By cultivating an image as a hospitable and friendly port city, first-generation Galvestonians made a strong commitment to institutionalized medical care for travelers and indigents. Galveston teemed with charity for sick strangers. The city's stewards also used tax dollars to reimburse private

practitioners who treated indigents and citizens who boarded sick transients, to help transport sick paupers to other towns and to bury unclaimed bodies.

Galveston also teemed with mosquitoes, especially in the smelly, marshy areas along the Strand. In June 1857, occupants of buildings on the Strand spread sand to raise the level of the street and dumped sand in other downtown shallows so that stagnant pools of water would not easily develop. The city's physicians announced that Galveston would never experience another yellow fever epidemic. In July and August of that year, yellow fever killed at least 250 citizens. The removal of garbage and wastes did not stop the epidemic, nor did quarantines. Jack Frost did, but no one knew why at that time.

By 1866, about seven thousand citizens produced garbage and wastes. The filthy condition of the city astonished Greensville Dowell, the City Hospital physician. Throughout the city, yards and alleys contained human garbage and piles of feces from local animals, as well as their carcasses. After more than one thousand people died during a yellow fever epidemic the following summer (1867), Galvestonians again cleaned their city and began to pay more attention to city sanitation.

In the spring of 1867, a group of French-speaking Sisters of Charity of the Incarnate Word moved to Galveston and opened the first Catholic hospital in Texas. When the yellow fever epidemic struck, the nuns at Charity Hospital treated a number of victims in their infirmary. However, that November, the sisters closed this infirmary because there were not enough patients or operating dollars. It reopened in 1869 as St. Mary's Infirmary. However, the City Hospital was a very busy place. In 1867, Dr. Dowell admitted 1,352 patients to the hospital (96 women, 63 blacks and 371 foreign-born). Because of yellow fever, the mortality rate increased to 14.2 percent (192 patients). Between 1865 and 1868, Dowell admitted a few private patients, blacks authorized by the Freedmen's Bureau, sailors and foreign nationals and indigents authorized by the city or county. No one doubted Galveston's continuing legacy of providing medical care to those in need.

As a native of Virginia, a graduate of Jefferson Medical College in Philadelphia and a Confederate army surgeon, Dr. Dowell was an aggressive and energetic doctor. A new wave of medical professionalism spread throughout the nation during the postbellum and Reconstruction years. Embracing this reform spirit, Dowell symbolized a new era for Galveston's medical legacies. In July 1865, he spearheaded the creation of the Galveston Medical Society, a group of doctors that adopted the American Medical Association's code of ethics and met periodically to share clinical knowledge. In November 1865, Dowell organized the Galveston Medical College, the first medical college in

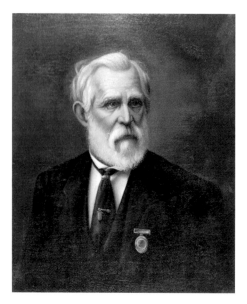

Greensville Dowell. In 1865, he organized the Galveston Medical College, the first medical college in Texas. *Courtesy of the Blocker History of Medicine Collections, University of Texas Medical Branch, Galveston, Texas.*

Texas. He affiliated the medical college with Soule University, an early Methodist institution in Chappell Hill, Texas. In January 1866, he edited and published the first medical journal in Texas. By December, almost six hundred of the state's two thousand doctors had subscribed to the *Galveston Medical Journal.* In 1873, Dowell became a member of the first board of medical examiners for Galveston County, authorized by the state to license properly trained physicians. These path-breaking events made Galveston the center of medical education and research in the state of Texas.

The state's earliest medical journals originated in Galveston. The *Galveston Medical Journal* published its last issue in 1871. Two years later, John D. Rankin of Galveston founded the *Texas Medical Journal.* It survived for six years. In 1881, Cary Wilkinson, the physician-in-chief at St. Mary's Infirmary, initiated the *Texas Medical and Surgical Record.* It lasted two years. These early journals strengthened the medical reputation of the island city and enhanced its medical legacies.

Medical societies provided identity, shared experiences and professional camaraderie. In June 1869, three members of the Galveston Medical Society— Greensville Dowell, T.J. Heard and John H. Webb—helped to reorganize the Texas State Medical Association and elect Dr. Heard their president. In 1876, the Galveston Medical Society reorganized as the Galveston County Medical Society and offered to host the state society's annual meeting the following year. About seventy-five members attended this meeting in Galveston, and they elected W.D. Kelly of Galveston as their new president. Both of these societies still exist.

Medical journals and medical societies were important legacies from Galveston. But contributions by the medical community of Galveston in the areas of public health, hospital care and medical education cemented the reputation of the city as a great medical community.

PUBLIC HEALTH

With more than twenty thousand waste-producing citizens interacting in a hub of migrant and commercial bustle, Galveston by the mid-1870s was the largest and wealthiest city in the Lone Star State. Proud of their images as a healthy seaport and the cultural center of Texas, Galvestonians wanted to prevent yellow fever epidemics, and they wanted to keep their city clean. Uncertain about the cause of yellow fever, they enforced both quarantine and sanitary policies.

After 1870, Galveston officials began more rigorously to enforce quarantine regulations. Aldermen authorized the construction of new stations in 1870, 1876 and 1879. In 1879, the legislature adopted statewide quarantine regulations and authorized the construction of five new stations, including one for Galveston. This station was opened in 1885. City and state quarantine regulations allowed the port physician to order a ship to leave the city if anyone on board suffered from yellow fever. If there were no sick persons aboard but the ship had departed from a port with yellow fever, the port physician could force the ship to anchor offshore for twenty days. During that time, the cargo of the ship could land at a disinfecting warehouse at the quarantine station. While in quarantine, the crew could disinfect the ship with a bichloride of mercury solution and sulfur dioxide gas. In 1884, Galveston's health physician inspected 939 ships and placed 17 in twenty-day quarantines. Local officials had become very serious about enforcing quarantine regulations.

In similar fashion, during the 1870s and 1880s, Galveston aldermen and citizens became serious about adopting and enforcing sanitary regulations. Aldermen, health physicians, "superintendents" of streets and alleys, policemen, health inspectors, draymen and scavengers were all players in the webs of political patronage and deference that evolved during these years. When the aldermen had enough money, they allowed the health physician to hire health inspectors to check alleys, streets and yards. Otherwise, policemen performed this service. They could issue tickets and make arrests for violations of the sanitary code.

Depending on the policemen or inspectors' reports, the health physician could hire scavengers to collect garbage and wastes and draymen to fill marshy streets and alleys with extra sand. During 1873, only nineteen cases of yellow fever occurred in the city, even though other areas of the country experienced epidemics. George Peete, Galveston's health physician, attributed this to the vigilance of Galveston in enforcing its strict sanitary

policies. To ensure continual vigilance, aldermen in March 1877 empowered a new board of health to enforce the codes. During the following year, while yellow fever rampaged throughout the South (claiming more than five thousand lives in Memphis), the Galveston Board of Health threatened to auction twenty square blocks of unsanitary lots if their owners did not clean them. Most proprietors complied, and Galveston did not experience a yellow fever epidemic.

By the mid-1880s, garbage and waste collectors had submitted contract bids to the city council. But even this improvement had its problems. The carts used to remove the "night soil" to a dumping site on the East End of the island were smelly and unsanitary, and they leaked urine and feces onto the streets As the population of Galveston increased from twenty to thirty thousand during the 1880s, the use of these privies and scavengers' carts upset the citizens.

In 1886, the Galveston Sewer Company laid cement pipes to collect rainwater and human wastes. By 1893, the company had installed pipes in most of the territory between Broadway and Galveston Bay from Fourteenth Street to Twenty-seventh Street. By 1899, more than eight miles of pipes connected over four hundred sections of property. But the sewer system was quite expensive to use. The company charged its subscribers for connections between their shops and homes and the centralized pipes that discharged their contents into Galveston Bay. Many citizens, including Mayor Ashley Wilson Fly (a physician), believed that the City of Galveston should handle sewerage as a public utility.

As mayor from 1893 and 1899, Fly nurtured these new sensibilities. In 1895, Galveston's centralized waterworks improved dramatically when a thirty-inch water main connected the city to thirty artesian wells in Alta Loma (a town on the mainland about twenty miles away). In 1896, Fly invited George W. Waring, one of the nation's leading sanitary engineers and the commissioner of street cleaning for New York City, to come to Galveston as a consultant. With help from Waring, Fly and the city council launched a campaign to sell sewer bonds. They wanted the city to buy the Galveston Sewer Company and assume responsibility for managing city sanitation. In 1899 and 1900, the city issued sewer bonds. As the nineteenth century ended, Galveston was honoring the same public health imperatives that animated the rest of the nation.

HOSPITAL CARE

As more immigrants and transients arrived in Galveston, care at the City Hospital became more costly. Worried about unnecessary admissions and private gain, the aldermen dismissed Dr. Dowell in May 1868 and appointed Clarke Campbell as the new house surgeon. During the next eight months, Campbell admitted 1,100 patients, and the aldermen calculated that this new approach saved the city almost $7,000. But circumstances changed. The Catholic Church reopened St. Mary's Infirmary in the summer of 1869. The United States Department of the Treasury awarded the contract for treating merchant marine patients to St. Mary's, not the City Hospital. Also, Dowell opened a private infirmary associated with the Galveston Medical College and competed for the medical patients from the county. Now three institutions were competing for patients and dollars. And there were more patients than ever.

The state's largest city attracted immigrants, laborers, transients and indigents. In 1873, city officials realized that 80 percent of the more than one thousand patients admitted to the City Hospital each year were not permanent residents of Galveston. For that year, the city expended more than $17,000 for unreimbursed hospital care. That equaled almost 10 percent of the budget of the city. Even with these increasing costs, the city could not abandon its proud social legacy as a haven for the sick. The city passed a new ad valorem tax to cover the construction costs of a new one-hundred-bed City Hospital. This three-story frame building, completed in October 1875, contained bathtubs, commodes and marble urinals. Like St. Mary's Infirmary, the new hospital featured open-air galleries that permitted the sick to enjoy sea breezes from the Gulf of Mexico.

To maintain their competitive edge in local "hospitality," the Sisters of Charity built a new 250-bed, three-story, brick building at St. Mary's in May 1876. Other realities also motivated the Sisters. The United States Department of the Treasury threatened to terminate the lucrative contract for treating merchant marine patients if St. Mary's did not improve its facilities. The new building included three wards for sick and disabled seamen. Satisfied with these new improvements, the federal government renewed the contract.

For more than thirty years, the city provided charitable medical care for Galveston's transients. But the costs of this care sapped the city's budget. In 1877, the city received $2,229.50 for medical services from the county, British consul and private patients. The city expended $14,332.28 for non-

reimbursed hospital care. In 1878, three years after its opening, city officials were ready to close their splendid new hospital unless they could negotiate a deal with another hospital to take over care of indigent patients. In May 1879, St. Mary's agreed to provide this care for $875 per month. The city agreed and ordered City Hospital to transfer indigent patients to St. Mary's. During the 1880s, St. Mary's admitted more than one thousand patients annually, and the city council renewed its contract with St. Mary's until the John Sealy Hospital opened in 1890.

MEDICAL EDUCATION

The Galveston Medical College was a reputable school. Greensville Dowell and seven other practitioners began instruction in November 1865. The school offered a rigorous curriculum that included anatomy, chemistry, physiology, obstetrics, medicine and surgery. In 1869, Dowell obtained money from Soule University to construct a new Galveston Medical College and Hospital building at Twenty-second and Avenue L. Dowell rented a portion of this building for his residence and used another area as an infirmary for patients who required surgery.

In 1873, Dowell obtained a state charter that reconstituted the school as a proprietary institution with a new name, the Texas Medical College and Hospital (TMCH). Unlike many similar schools, TMCH expected candidates for professorships to obtain a medical degree from a reputable school and pass a rigorous exam given by a board of doctors. Dowell and his faculty worked hard to maintain high standards. In 1879 and 1880, Dowell represented the TMCH at the annual meetings of the newly formed Association of American Medical Colleges, a group of teachers and deans dedicated to the highest standards of progressive medical education.

The physician-teachers at the TMCH were quite successful. Between 1865 and 1881, 381 students, mostly Texans, matriculated at these two schools; 40 percent (152) graduated. However, in 1881, Dowell died, and the TMCH closed. The remaining faculty believed that a new state medical school would soon open.

In 1881, the state legislature approved a bill that authorized an election to determine the location of a new state university. Quickly, Senator James B. Stubbs of Galveston introduced an amendment that would permit the state of Texas to open the new university's medical school in a different city.

Because of its remarkable legacy in hospital care and medical education, the legislators chose Galveston as the site of the first state-run medical school and chose Austin for the main campus. But ten years passed before the medical school opened.

Due to a lack of funds, the University of Texas Board of Regents decided first to construct the main campus and open that college in the fall of 1883. The medical school would have to wait. A properly organized medical school needed a teaching hospital and an academic building that included laboratories and classrooms. All of this required many dollars. In Galveston, city leaders closed the City Hospital. The only other hospital in the

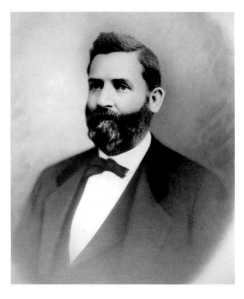

John Sealy was a successful Galveston businessman who helped fund the first hospital on the University of Texas Medical Branch campus. *Courtesy of the Blocker History of Medicine Collections University of Texas Medical Branch, Galveston, Texas.*

city, St. Mary's Infirmary, was a private institution. How could the State of Texas fulfill its promise to locate the first public medical college in Galveston?

John Sealy, a native of Pennsylvania, moved to Galveston in 1846. He was a shrewd businessman who became a millionaire through his involvement in merchandising and banking and, later, in railway, shipping and natural gas companies. Sealy died in 1884. In his will, Sealy stipulated that his estate should expend $50,000 on a public charity. In 1887, his widow and brother decided to use the money to construct a new city hospital. This hospital would provide medical care for the indigent of Galveston and serve as a teaching hospital for the new medical school. In February 1887, the city council of Galveston donated the old City Hospital building and the surrounding land to the medical school. Next year, Walter Gresham of Galveston, chairman of the House Finance Committee, persuaded his colleagues in the Texas legislature to appropriate $50,000 for the construction of the medical school building.

The next three years were rich with pivotal events in the evolution of Galveston's medical legacies. Some of Galveston's doctors renovated the former City Hospital building and revived the Texas Medical College and

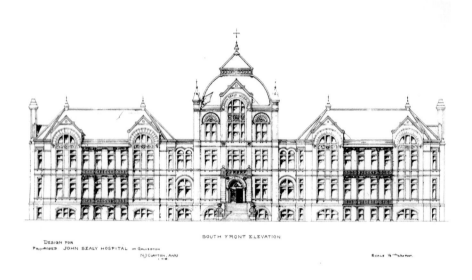

Nicholas Clayton's sketch of the John Sealy Hospital. *Courtesy of the Blocker History of Medicine Collections, University of Texas Medical Branch, Galveston, Texas.*

Hospital. They began instruction in October 1888 and pledged to donate their supplies and equipment to the new state medical school when it opened. The University of Texas regents realized that the school needed more land for the hospital and the medical school. To remedy this, the Twenty-first Texas legislature and the Galveston City Council each contributed $25,000 to the project. This allowed the regents to purchase additional land near the old City Hospital. The regents also hired architect Nicholas Clayton to design both buildings. Clayton had designed both of the hospitals constructed in Galveston in the mid-1870s.

The John Sealy Hospital opened on January 10, 1890. It was a magnificent structure that contained a pavilion and two wings. The three-story center pavilion included offices, rooms for private patients and an operating amphitheater. Each wing included two stories of ward pavilions that each held twenty-four beds. The basements beneath the ward pavilions contained outpatient clinics, a pharmacy and storerooms. A separate structure behind the central pavilion housed the kitchen, the staff dining room, a boiler room and a laundry.

To meet the desperate need for professional nurses, a group of Galveston ladies organized the John Sealy Hospital Training School for Nurses. This school opened in March 1890 with eighteen student nurses. Physicians

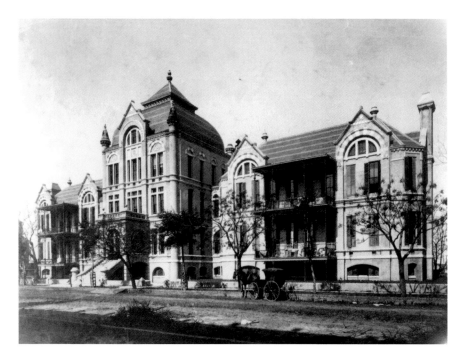

The John Sealy Hospital opened on January 10, 1890. *Courtesy of the Blocker History of Medicine Collections, University of Texas Medical Branch, Galveston, Texas.*

associated with the reorganized TMCH taught the nurses and a few medical students. In March 1891, this facility graduated two medical students. Outside, next door, the new medical school building stood empty and useless.

The contractors completed the basic structure three months earlier, but the state legislature did not appropriate money for furnishings, equipment, supplies and salaries. Finally, in the spring of 1891, the Twenty-second legislature appropriated $74,000 for the school in Galveston. Although less than what they wanted, both regents and Galvestonians rejoiced because the legislators had assigned this money from the general revenues of the state. The ten-year dream of a state university medical school was a reality.

That summer, the local medical community prepared to occupy the Medical College Building (known today as the Ashbel Smith Building or, more affectionately, as "Old Red"). The board of regents selected nine faculty members. Despite tremendous local pressure, the regents chose a faculty dedicated to progressive medical education. The professor of anatomy (William Keiller) and the professor of surgery (James E. Thompson) abandoned promising careers in Britain to participate in this uncertain

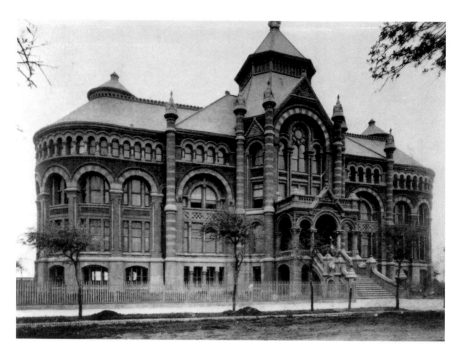

The Medical College Building, now renamed the Ashbel Smith Building, or "Big Red," opened during the summer of 1890. *Courtesy of the Blocker History of Medicine Collections, University of Texas Medical Branch, Galveston, Texas.*

educational adventure on a barrier island in the Gulf of Mexico. This was an extraordinary tribute to the superlative ideals and persuasive styles of those who established the University of Texas Medical Branch (UTMB) and the John Sealy Hospital.

On October 5, 1891, the college welcomed its first class of twenty-two medical students. Only fourteen remained after a few weeks, and twelve eventually graduated. The educational backgrounds of these students were substandard. The rigorous curriculum of lectures and labs that met during days, nights and weekends challenged this first generation of students. Only 37 percent of these medical students in the 1890s actually graduated.

In 1893, the faculty added a school of pharmacy. Three years later, the regents assumed control of the nursing school. The physician-professors also taught the nursing students, who worked twelve-hour shifts that included time for lectures and meals. By 1900, UTMB graduated 186 doctors (182 men, 4 women), 50 pharmacists (44 men, 6 women) and 33 nurses (all women). During a meeting in 1900, representatives of several colleges and preparatory schools praised UTMB's high standards. This

led UT president William Prather to declare that UTMB was the "best medical school in the South."

Its own board of directors governed the hospital. The Sealy family had given the hospital to the city, the city had given it to the state and the city had leased the hospital from the state for one dollar a year for twenty-five years. In the lease agreement, signed in 1889, the city agreed to pay the salaries of all employees except the physician-professors, to provide furniture and equipment and to pay the costs of insurance and maintenance. Ten years earlier, the city council had abandoned its new hospital and negotiated a deal with St. Mary's for the care of the sick indigents of Galveston. Now it agreed to spend much more money to keep Galveston's legacy of medical "hospitality" alive and well. The political leaders of the state and the city, along with the Sealy family, pooled economic resources and established a nationally recognized teaching hospital and academic medical center.

Nineteenth-century Galvestonians were intensely proud of their city. They believed that after 1867, yellow fever epidemics no longer struck their city because everyone supported strict public health codes. The islanders pointed with pride to their steadfast attention to quarantine and their significant improvements in sanitation. By the 1880s, Galveston was the wealthiest and most powerful city in the Lone Star State. More than forty millionaires resided in Galveston. The ratio of millionaires to citizens was the highest in the world. Citizens rode electric streetcars and stared at magnificent Victorian homes and public buildings. They walked the steps of the city hall, the county courthouse, the post office and the customhouse. They attended concerts at the Grand Opera House and welcomed tourists staying at the huge Beach Hotel. They rode horses, wagons and railway cars across a new bridge to the mainland. They watched larger ships enter a harbor deepened by jetties financed by the federal government. They placed phone calls to Houston and other cities. They boarded students enrolled in the schools at UTMB, and they sent family members and employees to John Sealy Hospital for medical care. As the two last decades of the nineteenth century evolved, Galveston's Gilded Age glory glittered in every direction, glories that still attract tourists, patients and students to this day.

Norris Wright Cuney

African American Politician and Businessman

Robert Shelton

In the fall of 1908, a group of African American community leaders posted flyers throughout Galveston urging black citizens to reject efforts by white southerners to construct a Jim Crow society that relegated them to second-class status. Pay your poll taxes, the flyers exhorted, and defy the efforts of white racists to quiet your political voice. They also urged their fellow citizens to remember the lessons and example of Norris Wright Cuney. Although he had died a decade earlier, he spent a lifetime vigorously fighting for the rights of African Americans. These pleas failed to forestall the construction of a southern apartheid system. But the fact that these political activists appealed to the memory of Wright Cuney testified to his reputation as a champion of African American political and civil rights at the city, state and national level.

In practical terms, Cuney's greatest success and lasting legacy in his struggles for equality came not in politics but in commerce, not as a politician but as a businessman and labor leader. Cuney's leadership secured for African American men a significant share of the highest-paying jobs on Galveston's busy waterfront. This economic equality allowed the African American community to exert far more political and financial power than their contemporaries in other southern cities.

Until Houston completed a deep-water ship channel, Galveston remained the most important seaport and commercial hub in the Lone Star State. Even after railroads transformed Dallas and other inland cities into major centers of commerce, most of Texas's agricultural bounty—especially cotton— left the Galveston wharves for markets throughout the world. Waterfront

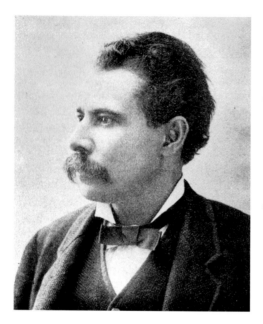

Norris Wright Cuney, Galveston African American politician and labor leader. *Courtesy of Special Collections, Rosenberg Library, Galveston, Texas.*

jobs, particularly during the busiest times of the year, provided thousands of men work as longshoremen, cotton jammers, draymen, railroad roustabouts, warehousemen and day laborers. After the Civil War, the highest-paying, most dependable and most prestigious work on the waterfront—cotton jamming—was the exclusive domain of white males. The leadership of Wright Cuney and the determination of the men who supported him eventually broke this racial monopoly and provided a secure economic livelihood for African American Galvestonians for more than a century.

Galveston's prosperity, its place as a bustling seaport and the resulting jobs on the city's wharves, depended on the growth of large-scale farming in Texas. This productivity began to increase shortly after Texas won its independence from Mexico. Once Texas joined the Union in 1845, farming boomed. By 1850, Texas grew approximately 2.4 percent of the United States' cotton crop and ranked ninth nationally in the production of cotton. By 1860, Texas had climbed to fifth among cotton-producing states. After the Civil War, Texas remained the fifth most productive cotton-growing state. By 1880, Texas ranked third, and by 1890, it led the nation in cotton production. By 1900, Texas farmers were growing 2.6 million bales of cotton, more than one-fourth of all the cotton produced in the United States. That year, the state also produced a significant portion of the nation's other crops and ranked third behind Illinois and Iowa in total value of farm products. Most of this produce reached the world markets through the port of Galveston.

As Texas's agricultural output grew, so did Galveston. From 1838 to 1845, an average of 190 ships called at the port each year. During the period from 1870 to 1895—the year that Wright Cuney died—an average of 1,221 ships called at the port. And the size of the vessels also increased. During the days

of the republic, small wooden sailing ships and paddle-wheeled steamers that averaged 60 tons of cargo capacity visited Galveston. After 1870, steel-hulled, steam-powered vessels with an average tonnage of 775 docked at the Queen City of the Gulf. Although these vessels carried a variety of goods and products, their primary and most profitable cargo was cotton. By 1890, 725,625 bales (valued at almost $40 million) crossed the wharves of Galveston bound for the textile mills of the eastern United States and Europe. After the completion of a federal improvement project in the early 1890s deepened Galveston's channel to accommodate even larger vessels, a third boom began. This deep-water channel attracted more than 60 percent of the Texas cotton crop, exports increased by more than 50 percent and imports increased by more than 35 percent.

Since marine commerce played such an important part in the economic life of the city, it was not surprising that waterfront work constituted one of the major sources of employment for the city's laboring class. Before the Civil War, jobs on the docks were seasonal. Usually, sailors, recent European immigrants and African American slaves loaded and discharged the ships. After the war, increased trade created dependable, year-round employment. In 1866, a group of white stevedores formed the Screwmen's Benevolent Association, the city's first dockworkers union. Within a year, it had established work rules that barred union members from working with African Americans. Within ten years, white labor organizations had excluded black men from work on all but one of the city's wharves. White labor solidarity controlled the most abundant and highest-paying jobs on the Galveston waterfront.

Into this situation stepped Norris Wright Cuney. Wright Cuney was born on May 12, 1846, in Waller County on the Sunnyside plantation near Hempstead, Texas. He was the fourth of eight children of Adeline Stuart, a slave at Sunnyside, and Philip Cuney, the owner of the plantation and its 105 slaves. Wright Cuney was the third generation in his family with such a parentage. Adeline Stuart and her mother, Hester Neale Stuart of Virginia, were also the offspring of slave-master unions. As a result, Wright and his brothers possessed relatively light skin. His mother was a house slave at Sunnyside who, in addition to catering to the sexual appetites of her master, took care of the household. Her children also worked as house slaves. Wright and his siblings received at least a rudimentary education. Wright Cuney mastered the basics of reading and writing and learned at a young age to play the violin from one of the older Cuney slaves. Throughout his life, he loved to entertain his family and friends with his musical abilities. He favored

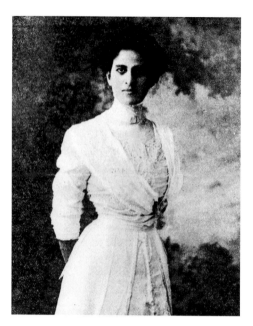

Maud Cuney Hare (photo circa 1912–13). Norris Wright Cuney's daughter was born in Galveston but later left the island to pursue a successful career as a musician and musical educator. *Courtesy of Atlanta University Center, Robert W. Woodruff Library, Atlanta, Georgia.*

Irish ballads and folk songs and passed on this love of music to his daughter and biographer, Maud Cuney Hare. Maud, who had a long and intense relationship with the scholar and activist W.E.B. Du Bois, became a highly respected musician and music educator.

In 1853, when Wright was seven, Philip Cuney moved the household to Houston, freed two of his slave sons and sent them to the Wylie Street Public School for free blacks in Pittsburgh, Pennsylvania. In 1859, Wright Cuney, then thirteen, gained his freedom and joined his brothers at this school. When the Civil War broke out, Wright's brothers left school. Wright remained in school until 1863, when at the age of seventeen he signed on as a crewman on the *Gray Eagle*, a steamship that plied the Mississippi River between Cincinnati and New Orleans. During his steam boating days, Wright Cuney learned about life and work on the waterfront and met other free African Americans who later rose to prominence during Reconstruction.

After the war, Cuney returned to Texas and settled in Galveston. He chose the island city because he hoped that his father's prewar business connections with city leaders would prove valuable. In 1867, Wright Cuney persuaded all but two members of his family to join him. Four years later, he married Adelina Dowdie of Woodville, Mississippi. She bore him two children, Maud and Loyd Garrison Cuney. The Cuney families lived near the beach on the East End of the city.

In 1869, Wright Cuney first entered the political arena. He received an appointment as sergeant-at-arms to the Twelfth Texas legislature. Locally, starting in 1871, he served as one of the school directors for Galveston County. This began a lifelong quest to secure quality public education for African Americans. From the beginning, Cuney championed integrated public

schools in Texas. He struggled in vain for the integration of Galveston's Ball High School, and he denounced the state's plan to establish separate black schools for the deaf, dumb and blind. He insisted that building segregated facilities was financially imprudent and morally repugnant. After years of bitter opposition, he finally acknowledged the implacable opposition of whites to such mixed-race institutions and reluctantly supported the separate-but-equal paradigm for members of his race. He also played an integral part in the founding of Prairie View A&M University.

He ran unsuccessfully for mayor in 1875 but befriended his white opponent, Robert L. Fulton. After the election, the two men became political allies. Cuney became Fulton's trusted advisor during his twelve years as mayor and delivered the black vote that kept Fulton in office. In 1882, Cuney ran unsuccessfully for the state legislature. In March 1883, Cuney won election as alderman for Galveston's Twelfth Ward. He was one of the few African Americans who served in Galveston municipal government during the nineteenth century. As alderman, Cuney championed the city's commercial development. He voted for improving streets, contracted for a water system, worked to amend the city charter and expanded the city's port facilities. Cuney and his allies, however, proved somewhat more conscientious than most when it came to managing the city's finances. He constantly criticized city government for its bloated budget and rampant corruption. He also opposed efforts to silence the political voices of blacks and working class whites. He denounced a charter amendment, favored by many in the business community, that would have replaced the single-member wards with an at-large election system. Cuney believed that this amendment would effectively disfranchise minority groups.

Cuney's scruples and honesty begrudgingly earned the respected of even his toughest political enemies. Cuney repeatedly charged other aldermen with corruption, abuses of power and irresponsible spending. During his second term, he accused the city gas company of overcharging the city. The board of directors, which comprised many of Galveston's prominent citizens, took exception to Cuney's charges and put their weight behind Cuney's opponent. Cuney lost the 1887 alderman election. Despite this defeat, he continued to serve the city as a waterworks commissioner.

Cuney also actively participated in state and national politics. He staunchly supported the Republican Party. Eventually, he became the most powerful Republican leader in the state and one of the most influential Republican politicians in the South. He served as a delegate to the state and national Republican conventions in 1876, 1880 and 1884. In 1886,

he cemented his leadership of the state party when delegates elected him the permanent state party chairman and national committeeman from Texas. As a committeeman, he helped to draft the national Republican platform, direct party strategy and award patronage. When Republican Benjamin Harrison won the election in 1888, Cuney emerged as the most powerful politician in Texas. President Harrison appointed Cuney to the most powerful position in Texas and one of the most important on the Gulf Coast: customs collector for the port of Galveston.

As party chairman, he soon came under attack by a faction in the party that he, and historians, called the Lily-White Republicans. This white coalition believed that the Republican Party in Texas would only grow when it reduced the influence of African Americans such as Cuney. It believed that "Negro domination" cost Republicans the white votes. These potential voters agreed with the party platform but did not embrace its racial policies. Cuney maintained his control of the party until 1896.

That year, though, he alienated Mark Hanna, the national Republican kingmaker. Cuney refused to support the party's nomination of William McKinley for president. At the national convention, Hanna refused to seat the Texas delegation led by Norris Wright Cuney. Instead, Hanna validated the credentials from a delegation of Lily-White Texans. When William McKinley defeated Democrat William Jennings Bryan, the new president bestowed all federal patronage in Texas to the Lily-White party members. Without federal patronage, Cuney lost control of the party.

After the election, he retired to San Antonio, where he hoped the drier climate would cure his lung problems. However, his health continued to fail. On March 4, 1898, in the company of his family, he uttered his last words, "My work is done," and passed away. The family transported his remains to Galveston. More than two thousand people attended his funeral in Lakeview Cemetery.

During his public career, Cuney struggled ceaselessly for African American equality. In 1877, he delivered a ringing speech that protested the lenient sentence given to a white theater owner after he violated the Civil Rights Act of 1875. The act prohibited discrimination in public places. The speech, which he delivered before a rally of African Americans, appeared in newspapers throughout the state and the South. In Fort Bend County, white supremacists threw out black county office holders and threatened to lynch anyone who opposed them. Cuney courageously traveled to the county, denounced these political thugs and helped the ousted black officials find federal employment elsewhere. Later, with Cuney's encouragement,

these men successfully filed a federal lawsuit against the Fort Bend whites. In 1889, Cuney vehemently but unsuccessfully fought a state law that required railroads to provide segregated passenger cars. He also unsuccessfully challenged the establishment of the white primary. Despite his impressive political victories, his tireless advocacy of civil rights and the respect he earned even from his enemies, Cuney could not stem the calls throughout the South that institutionalized segregation swept aside the civil and civic rights of African Americans and relegated them to second-class citizenship.

Yet Cuney found one safe harbor, one rock on which African Americans could maintain their economic independence, integrity and a measure of equality during the furious storm that assaulted them at the turn of the century. This safe harbor was the Galveston waterfront. With an army of African American workers behind him, Cuney successfully broke the monopoly of white unions on the city's wharves and thereby provided black workers with a reliable source of respectable employment. Although employers initially used African Americans as a means to lower wages for all waterfront workers, both races eventually recognized that cooperation and support would protect their common interests.

Wright Cuney's twenty-year involvement with the Galveston waterfront began in 1876. That year, he helped found the first African American labor union in Texas, the Longshoremen's Benevolent Association. Three years later, he helped found the Cotton Jammer's Association. In 1877, Cuney played a key role in one of the first African American labor uprisings in Galveston. On August 1, 1877, blacks working as day laborers on several downtown construction projects walked off the job. They demanded that their wages, which were about $1.50 per day, be increased to $2.00 per day. The Galveston strike began when fifty day laborers left their work on the Girardin building and marched through the commercial district, recruiting others to join them. The next day, the black strikers again marched through the city, and their numbers swelled to more than three hundred. At a cotton warehouse, white policemen attempted to disperse the crowd, and in the struggle that ensued, they shot a black striker. Some white workers supported the strikers. After the shooting, a white man named Michael Burns addressed the throng and urged them to burn the rail yard if their demands were not met.

Next, Cuney addressed the crowd. He agreed with their demands, but he disagreed with their methods. Parading through the streets and "creating bad blood" would only make matters worse. Reminding the crowd that whites maintained well-armed militias in Galveston and Houston to put down just

such instances of violence as Burns was recommending, he urged the crowd to return to their homes and negotiate peacefully with their employers lest a bloodbath ensue. The crowd dispersed, and the *Galveston Daily News* reported that some employers increased the daily wage to the sought-after two dollars per day. Cuney's calm reasoning with the angry crowd impressed the city's commercial elite. This new approval opened the doors for his assault on the racial walls that excluded blacks from regular waterfront employment.

Cuney's first maneuver began in 1883 when he targeted the white monopoly of longshoreman jobs on the docks. To break this impasse, he launched his own stevedoring business and sought contracts from the city's shipping lines. As a stevedore, he employed more than five hundred African American workers to handle cargo. A local newspaper reported, with some exaggeration, that Cuney "practically controlled labor on the Galveston waterfront." Cuney soon gained a stevedoring contract on the Morgan wharf, one of the port's largest. He brought in black workers from New Orleans to augment Galveston's resident black longshoremen, thus securing an adequate supply of labor. He paid these men a lower wage than the white longshoremen. This allowed him to underbid his white competitors. Quickly, he broke the white longshoreman's labor monopoly on the waterfront. The white Longshoremen's Benevolent Union grumbled about the arrangement but took no action. Cuney then set his sights on obtaining work for his men in the more lucrative and more prestigious field of cotton jamming.

On March 16, 1883, Cuney sent a letter to William Moody, president of the Galveston Cotton Exchange, seeking work for his cotton jammers on the Morgan wharf. He explained that he had the tools and the men—members of the Cotton Jammer's Association and a newly formed Screwmen's Benevolent Association No. 2 (the white union was called simply the Screwmen's Benevolent Association). Cuney argued that Galveston's commerce suffered from the shortage of skilled labor to jam cotton into the ships. He guaranteed satisfaction for work performed and asked Moody and the exchange to extend him aid in breaking the hold of the white unions. As one would expect from a businessman seeking to cut costs, Moody replied that members of the exchange liked what they heard and welcomed the additional laborers. On April 2, 1883, Cuney's men began their first job.

The white screwmen immediately walked off the job. Their strike lasted throughout the summer but ultimately failed. Cuney's timing had been perfect. In April, the supply of cotton was low, so when his men began work on the *Albion*, there was little demand for cotton jammers. Thus, the SBA strike did not cause a labor shortage that might have forced the shipping

lines or the Cotton Exchange to capitulate to the white screwmen's demands. Furthermore, during this slow time of year, the screwmen normally found other employment to supplement their income, and thus the white screwmen talked a hard line but did little, and their families did not suffer substantially. By the time the season picked up in the fall, black jammers were an established presence on the Morgan wharf, and since there was a labor shortage during the busy season, the white SBA members went back to work with little fanfare.

The African American longshoremen's and cotton jammers' success forced the Galveston Trades Assembly in 1884 to admit the two black unions into the membership. This represented the first step toward greater biracial cooperation. Blacks, however, still could not work on Galveston's other wharfs. Cuney sought to expand his business and find more work for his men when he negotiated a new contract with the Mallory steamship lines, one of the port's most important shipping companies. Cuney again used his men as replacement workers in order to force the white unions to open up the waterfront to black workers. In doing so, he solidified the place of African Americans on the waterfront in Galveston.

In the fall of 1885, white longshoremen in New York City struck the Mallory Line over a recent pay cut. For support, their local union called on the Knights of Labor, the most powerful national union of the time and one of the few that accepted blacks as well as whites. The Knights issued a strike call against the Mallory Line to force it to rehire fired workers and raise their pay. At that point, a ship, the *State of Texas*, lay ready to discharge at the Mallory wharf in Galveston. The company approached Cuney and asked if he could help. Cuney agreed to let his men work for the Mallory Line if they were not used, as he put it, as "cat's paws to pull the chestnuts out of the fire" and then abandoned. Offer his men steady work, and they would break the strike. He agreed. Then 120 of Cuney's men unloaded the ship under police protection. However, there was no violence or threat of violence.

The white longshoremen then agreed to accept the Mallory Line's offer to restore the old wage rates. The shipping line rebuffed the white union, saying that it just signed an agreement with the black longshoremen. The white unions again appealed to the Knights of Labor, and on November 3, 1885, they declared a general strike in Galveston. Between 1,500 and 2,000 men left their jobs on the Santa Fe Railroad, in the cotton presses, on the docks, in the printing offices and elsewhere throughout the city. At that time, it was the largest strike in Galveston history, and one of the largest in Texas history. The strike lasted a week. On November 9, Cuney and George

Sealy, director of the Santa Fe Railroad, negotiated a settlement between the Mallory Line and the Knights of Labor. From then on, black and white longshoremen on the Mallory wharves would divide all work equally. All parties agreed to this settlement, even though it meant that Cuney and his workers lost their temporary monopoly on the Mallory wharves. For Cuney's longshoremen, the agreement meant that each would earn about $500 a year, a good salary for the time. This translated to between $75,000 to $100,000 in income for Galveston's African American community. Significantly, this arrangement remained in effect throughout the 1920s and laid the foundation for continued cooperation between whites and blacks on the docks of Galveston.

By 1895, with Cuney's intercession, black and white longshoremen reached agreements on the division of labor throughout the port. Within the decade, both groups had signed agreements on wage minimums to prevent bidding wars that drove down pay as each sought to underbid the other. By 1924, the white and black screwmen's unions had joined the International Longshoremen's Association, although they maintained segregated locals.

Although it seemed to the white unionists on the Galveston waterfront that Wright Cuney had played into the hands of the shipping lines by letting them play white off black in cutting wages, and indeed wages declined in the short run, ultimately Cuney's efforts paved the way for greater interracial cooperation on the docks. By 1890, blacks and whites, while maintaining separate locals, were supporting one another. In 1898, for example, two thousand black longshoremen and other workers under the leadership of Harvey Patrick (the brother-in-law of Wright Cuney) went on strike at the New York wharf against the Mallory Line for higher wages. White unions provided moral and financial support and assisted with a union recruiting drive that culminated in affiliation of the black longshoremen with the American Federation of Labor. During the strike, white unionists declared, "Union labor would stand together regardless of race, creed or color, and that prejudice would be buried." Although such optimism was perhaps premature, such sentiments were a far cry from those prevalent among whites during the 1870s and early 1880s, when blacks first sought work on the waterfront. Thus, such an expression of class solidarity across increasingly rigid racial boundaries testified to the efforts of Cuney to achieve economic equality for black Galvestonians.

Although his political influence and his efforts as a defender of racial equality and African American rights are better known, his work integrating the waterfront in Galveston probably had a longer-lasting impact. The

Republican Party eventually turned its back on African Americans and embraced the Lily-White faction of the southern wing of the party. And the United States turned its back on African American civil rights, allowing southern states to erect an apartheid system at the turn of the century that lasted for more than fifty years. However, Wright Cuney's success in integrating the waterfront gave ex-slaves and their children jobs, a better material life and a strong sense of place in the community. It also forced white workers to awaken, slowly but surely, to the interests they shared with blacks, who toiled and sweated in the same lint-filled cargo holds and on the same crowded wharves as both groups struggled each day to earn enough money to put bread on the table and clothes on their children. The awakening of this knowledge of a common humanity that transcended religion, creed or race was Norris Wright Cuney's highest ambition and his greatest dream. In his life, on Galveston's waterfront, he achieved a measure of success.

Chapter 8

"Of Fine and Enduring Dignity"

Stephen Crane's 1895 Visit to Galveston

Edward Simmen

Any careful reader of the March 7, 1895 edition of Texas's oldest newspaper, the *Galveston Daily News*, was certain to have glanced through the "Personal Column" on the last page in order to follow the comings and goings and whereabouts of the city's most prominent citizens and visitors. The final item in the "Personal Column" that morning was more lengthy than the others: "Mr. Stephen Crane, representing the New York *Press* and the Bacheller-Johnson syndicate, arrived from New Orleans yesterday morning, and will spend some time in Galveston gathering material for articles of an interesting and historical character concerning Galveston and vicinity to be published in papers served by the syndicate. Mr. Crane is regarded as one of the brightest and most entertaining special writers of the day." There is no reason why the name Stephen Crane should have caused a reader of the Galveston newspaper to react. He was anything but famous, and his reputation was as a journalist—not as the novelist, poet or writer of short fiction that he would soon become.

Actually, Crane had been contracted by a New York newspaper syndicate to visit cities in the West, such as Omaha, Nebraska, and then travel south and visit Hot Springs, Arkansas, and New Orleans, Louisiana, where he witnessed the Mardi Gras, and then finally on to Galveston. After Galveston, he would journey to San Antonio and then spend three weeks in Mexico City. He would write feature articles on the cities he visited that would then be published in newspapers across the United States.

Crane arrived in Galveston by train on a cool Tuesday morning in March. He noted later in his essay on his trip to the island city that his train approached Galveston "by means of a long steel bridge across a bay, which glitters like burnished metal in the wintertime sunlight." Stephen Crane was only twenty-three years old. What is perhaps most ironic, however, is that by age twenty-three, Crane had already written several of the works that would soon establish his place permanently in American literature. They included *Maggie: A Girl of the Streets* and *The Red Badge of Courage*. In 1895, the world was simply not aware of it. Nor was Crane. At this time, he was merely "[o]ne of the brightest and most entertaining special writers of the day," looking for a story that he hoped he would find in the island city.

Stephen Crane's stay in Galveston lasted only three days, but they were days spent as any curious and clever correspondent would spend them: looking and asking and listening and always taking careful notes on what he heard and saw. One influential Galvestonian who befriended him was Samuel Moore Penland, a congenial man of fifty whom Crane probably

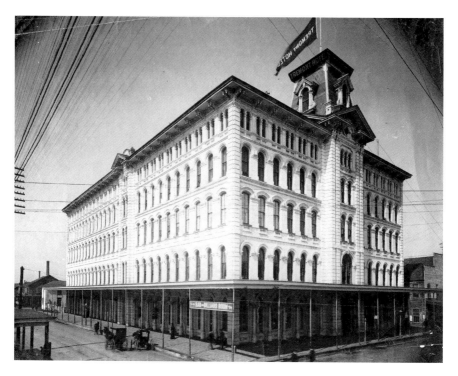

The Tremont House, where Stephen Crane stayed while he visited Galveston. *Courtesy of Special Collections, Rosenberg Library, Galveston, Texas.*

met when he lunched at the Tremont Hotel the day he arrived, March 6. Penland—or "Major Penland," as he was known to all—was a native Texan and nephew of Texas's most famous citizen, Sam Houston. He had moved to Galveston in 1870 at the age of twenty-five, and throughout his life on the island, he was always active in the educational and cultural circles of the city, especially in Masonic organizations. A childless widower of nearly twenty years, the Major roomed in a private home and boarded at the Tremont Hotel, a block and a half walk from his rooming house.

Penland was not only an amateur Texas historian with a special interest in his famous uncle, but he also collected autographs. His collection—held intact in the archives of the Rosenberg Library of Galveston—contains dozens of letters and other documents written by such famous personages as Henry Longfellow, Henry Clay, Harriet Beecher Stowe, William H. Prescott, Horace Greely, Henry Ward Beecher, Daniel Webster and Stephen F. Austin, as well as Presidents Ulysses S. Grant and John Quincy Adams and the Mexican dictator General Porfirio Díaz. He also had collected the signatures of Napoleon, Edwin Booth, John Greenleaf Whittier and Presidents John Adams, Thomas Jefferson and Millard Fillmore. The people in Penland's collection had one characteristic in common: each one was, in his or her own way, famous. Of course, when the Major met Crane, Crane was anything but famous, but Crane was a writer, and Penland was an avid reader, especially of contemporary fiction. After meeting Crane the journalist, Penland must have soon learned that he was actually talking to Crane the novelist—author of the soon-to-be published *Red Badge of Courage*, later to become a classic of American literature. From that moment on, Penland became Crane's unofficial host. He took the young writer to the right places, where he would meet the most influential Galvestonians.

He began that evening by taking Crane to dine at his club—the exclusive Aziola Club of Galveston, of which Penland was president. Located just around the corner from the Tremont Hotel, the club occupied the second floor above the ever popular Star Drug Store.

The Aziola Club was a landmark in the growth of Galveston as a city. Similar to most gentlemen's clubs in other older, well-established American cities, it was a symbol that Galveston, while only half a century old, had come of age. Its founding indicated that the once-rough edges of the booming seaport were being smoothed. There had been other clubs in Galveston, but never one with such a distinguished membership list. The idea for such a club became a reality when, on February 24, 1890, the founder sent an engraved

letter, as the charter stated, to two hundred of Galveston's "gentlemen of good and moral character." The club was certainly curiously named.

The invitation was an immediate success. The responses came in, and the charter members held their first meeting on April 7, 1890. They selected the name Aziola, which means "little owl," but no one seems to know why they chose this name. Another mystery is the club's motto, two lines from Tennyson's poem "The Lotus Eaters": "In the afternoon they came unto a land in which it seemed always afternoon." It is quite possible that they intended to reflect the idea that Galveston had indeed passed through the "morning" of its youth and was in the "afternoon" of its maturity, an "afternoon" that would never fade into "night."

The Aziola Club issued honorary memberships to many famous writers. As a result, the club possessed a small but incredibly fine collection of autographed letters written by some of the most famous American literati of the day. It is not recorded how many of these writers ever visited the Aziola Club. It is a fact that at least one American writer of note did: Stephen Crane. What Crane ate, what he said at the dinner, what he heard or whom he met can only be imagined. To be sure, since he was at the Aziola Club, he would have had the opportunity to meet at least some of the most prominent Galvestonians. And knowing Crane, he would have taken advantage of that opportunity and found out all he could.

In less than twenty-four hours, Crane—with the good fortune of meeting the staff of the *Galveston Daily News*, staying at the Tremont and befriending Major Penland—had been introduced to a city that was the epitome of progress, prosperity and culture. There were more obvious signs, including the buildings, the private and national banks, the paved streets and the busy harbor and wharves. He had use of the extensive and modern public transportation system that crisscrossed the city. There were eleven streetcar lines that served the town from the East End to the West End and from the busy wharves on the north side to the beach on the south. There was still one "antiquated" streetcar line pulled by mules that went from the corner of Eighth and Market around the city, ending all the way out in the West End at Thirty-ninth Street and Avenue O.

Also, had he known, he would even have been impressed with the efficient fire department, which had eight new fire wagons and stations spread across the city. Each station had its own telephone, as well as direct contact with a telegraphic fire alarm system composed of fifty-four telegraph boxes. The city was so well organized that each neighborhood had designated persons who held keys to the boxes. The instructions were explicit: "In case of fire in

your immediate neighborhood, unlock the box, pull down the hook and let go. Remain at the box." The directions further warned, "When the department arrives, direct them to the exact location of the fire. Do not try to remove your key from the box until it is released by the chief or assistant chief."

A few pertinent questions, coupled with a few apt answers, and Stephen Crane had what he wanted: the story of the dynamic city of Galveston, the "Queen of the Mexican Gulf." In his essay, he wrote:

In 1874 the United States Government decided to erect stone jetties at the entrance to the harbor of Galveston in order to deepen the water on the outer and inner bars, whose shallowness compelled deep-water ships to remain outside and use lighters to transfer their cargoes to the wharves of the city. Work on the jetties was in progress when I was in Galveston in 1895—in fact, two long, low black fingers of stone stretched into the Gulf. Undoubtedly in 1874 the people of Galveston celebrated the decision of the Government with great applause, and prepared to welcome mammoth steamers at the wharves during the next spring. It was in 1889, however, that matters took conclusive form.

The young journalist continued:

In 1889, Iowa, Nebraska, Missouri, Kansas, California, Arkansas, Texas, Wyoming and New Mexico began a serious pursuit of Congress. Certain products of these States and Territories could not be exported with profit, owing to the high rate for transportation to eastern ports. They demanded a harbor on the coast of Texas with a depth and area sufficient for great sea-crossing steamers. The board of army engineers which was appointed by Congress decided on Galveston as the point. The plan was to obtain by means of artificial constructions a volume and velocity of tidal flow that would maintain a navigable channel. The jetties are seven thousand feet apart, in order to allow ample room for the escape of the enormous flow of water from the inner bar.

Crane concluded:

Galveston has always been substantial and undeviating in its amount of business. Soon after the war it attained a commercial solidity, and its progress has been steady but quite slow. The citizens now, however, are lying in wait for a real Western boom. Those products of the West, which

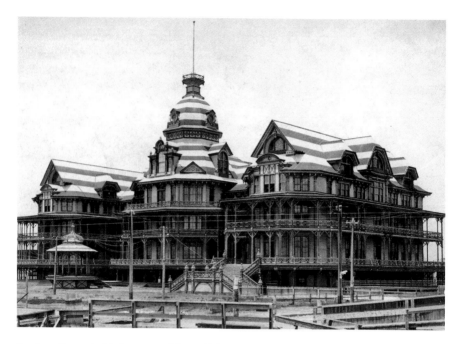

Stephen Crane, in his famous article on Galveston, described the Beach Hotel as a tourist mecca on the beach, "which overflows with humanity." *Courtesy of Special Collections, Rosenberg Library, Galveston, Texas.*

have been walled in by the railroad transportation rates to Eastern ports are now expected to pass through Galveston. An air of hope pervades the countenance of each business man.

Crane could see no reason for this hope to fade. On the contrary, stability and prosperity would continue to be the keystones of Galveston's success. The spring sun rose on the horizon. Summer was coming, and with it would come the heat, and life would become "sluggish in the streets." "Men," he wrote, "Move about with an extraordinary caution as if they expected to be shot as they approached each corner." But the beach, with its cool breezes, was always easily accessible. He was well aware that Galveston was not merely a center of commerce. Galveston was a summer resort town. "At the beach," he commented approvingly, 'There is a large hotel [the Beach Hotel] which overflows with humanity, and in front is, perhaps, the most comfortable structure in the way of bathhouses known to the race. Many of the rooms are ranged about the foot of a large dome. A gallery connects them, but the principal floor to this structure is the sea itself, to which a flight

of steps leads." Galveston, indeed, did have its ready relief from the intense summer heat. Its "35,000 people divide among themselves in summer a reliable wind from the Gulf."

Crane again had to rely on his native sources for that information. During those mad March days of his visit, the temperature was not too conducive to surf bathing. The thermometer hovered in the fifties during most of his brief stay, reaching seventy-five degrees on Thursday afternoon, the day before he left by train for San Antonio. At least he had one brilliant spring day in Galveston.

He obviously spent much time walking and taking the trolleys about the city, more than likely down Twenty-third Street to the beach. "Galveston," he observed, "has a rather extraordinary number of very wealthy people. Along the finely-paved drives their residences can be seen, modern for the most part and poor in architecture." Occasionally, he would come upon "a typical Southern mansion, its galleries giving it solemn shade and its whole air one of fine and enduring dignity. The palms standing in the grounds of these houses seem to pause at this time of the year, and patiently abide the coming of the hot breath of summer. They still remain of a steadfast green and their color is a wine."

He was certain to have been impressed by the John Sealy Home at 822 Twenty-third Street, which was built in the early 1860s and later remodeled and enlarged. Crane also could have been referring to the mansion at 1304 Twenty-third, which was constructed by Thomas League in 1859 and was sold in 1863 to Jonathan Waters. It operated as a boardinghouse until 1878, when it was purchased by Colonel W.L. Moody. He likewise could have been writing about the Greek Revival house that George Ball built in 1857 at Twenty-third and Avenue I. And he was quite right about Galveston having wealthy citizens, their wealth being reflected in the large homes that had been built during the last two decades in the East End.

Friday, March 8, had come. He had to catch his train for San Antonio. Still, he had one last task to complete that must have been nagging at him since he had arrived four days earlier. He had to write a letter to his New York editor at Appleton and Company about *The Red Badge of Courage*. It would not take long, just a matter of minutes, but he had evidently been so preoccupied with the island city that he simply never got around to composing it until the last morning of his stay. In New Orleans, he had already shortened the novel—cutting two thousand words—and had sent the manuscript to the publisher, Ripley Hitchcock. One editorial request, however, must have puzzled him. Hitchcock wanted a shorter title. That must have given Crane more than a moment's pondering—how does one shorten *The Red Badge of Courage*. At the last moment, he paused at a writing

desk in the lobby of the Tremont Hotel, took a sheet of hotel stationery and wrote, beginning by filling in the blanks of the date:

March 8, 1895.

Dear Mr. Hitchcock: I sent the Ms. from New Orleans. I made a great number of small corrections. As to the name I am unable to see what to do with it unless the word "Red" is cut out perhaps. That would shorten it. I am about to depart for Mexico for three weeks or a month. My address will be Hotel Iturbide, City of Mexico.

Very Truly Yours.
Stephen Crane

With the letter posted, he was ready to leave for San Antonio, where he stayed a few days collecting material for an essay, "Patriot Shrines of Texas," that for some unknown reason would not appear in newspapers across the country until January 1899. Before he could leave Galveston, goodbyes were in order to the reporters at the *Galveston Daily News* and in particular to Major Penland, who had introduced the young author to Galveston and the many Galvestonians whom he met. They had truly impressed him, leaving him to say, "There is a distinctly cosmopolitan character to Galveston's people. There are men from everywhere. The city does not represent Texas. It is unmistakably American, but in the general manner. Certain Texas differentiations are not observable in this city. Withal, the people have a Southern frankness, the honesty which enables them to meet a stranger without deep suspicion, and they are the masters of a hospitality which is instructive to cynics." And with that thought, he was gone.

From San Antonio, he took the train to Laredo, where he crossed the border into Mexico and rode the Aztec Eagle across the country to Mexico City. He stayed at the Hotel Iturbide, a colonial mansion built in the eighteenth century that was, from 1821 to 1823, the palace of the Mexican emperor Augustine Iturbide. His month in Mexico resulted in the inspiration for four short stories, which he wrote later in England—"A Man and Some Others," "Horses, One Dash," "Five White Mice" and "The Wise Men"—as well as several feature articles on Mexico, some of which Galveston readers would have the opportunity to read in the *News*.

By the time those articles had appeared in the newspapers across the country, however, Crane was already back in the United States, having

arrived in New York in mid-May. Waiting for him in the New York offices of the Bacheller-Johnson Syndicate was a letter posted from Galveston and written by his new friend and host, the president of the Aziola Club, Major Penland. In the letter, Major Penland offered Crane an honorary membership in the club. Penland, at sometime during Crane's visit to the club, would certainly have happily mentioned the great names in literature who were honorary members. The young novelist must have been impressed. And now he was to be added to the list.

Crane's fame and immortality were still before him. Copeland and Day published his collection of poems *The Black Riders* five days before he returned from Mexico. *The Red Badge of Courage* appeared in August of that year in the United States and England. Immediately, it soared to critical and popular success, first in England and then in America. Indeed, along with *The Scarlet Letter*, *Moby Dick*, *Huckleberry Finn* and *The Sound and the Fury*, it is one of the great American novels. Then came the reissue of *Maggie: A Girl of the Street*. Finally this wonderful story received the praise it deserved. In 1898, his exalted place in American literature was solidified when he published a collection of short stories titled *The Open Boat and Other Tales of Adventure*. Critics agree that this book contains some of the finest stories ever written in English. These include "The Bride Comes to Yellow Sky," "The Blue Hotel," "The Open Boat" and the stories he had written set in Mexico.

However, when Major Penland invited Crane to take his place alongside Henry James, William Dean Howells and the others, it must be assumed that he had knowledge only of several articles that he would have read in the *Galveston Daily News*. No matter. Penland saw in Crane a very gifted young writer who was on the verge of success and who undoubtedly had before him many years in which to establish himself. And it should not be forgotten that Major Penland was an inveterate autograph collector. Here was a way to add to his already impressive collection, and that was exactly what he received—the autograph and much more.

On July 10, 1895, from the New York offices of the Bacheller-Johnson syndicate in the Tribune Building, Stephen Crane answered Penland:

My dear Major:

I did not receive your notice of my appointment as an honorary member of the Aziola Club until yesterday or a reply would have been in your hands long ago. It is immensely gratifying to me to be thought at all worthy of so particular an honor, and I shall always think of it with extreme

pleasure. Someday I hope to be able to in some way return the altogether fine hospitality of the Aziola Club, by meeting you or any of your friends here in New York. And I shall always remain to you my dear major,

Stephen Crane

Although Stephen Crane never returned to Galveston, Galveston returned to him shortly after his death. And his articles about the city were the catalyst for this reunion. The publication of Crane's Galveston feature article is, if anything, curious. It did not reach print until November 6, 1900, five months after Crane's death in Germany on June 5. The prestigious London daily newspaper the *Westminster Gazette* did the honors. But the circumstances around its appearance are easily explainable. Crane and his wife, Cora, had left the United States in 1896 and settled in London, where he secured a job as a feature writer for the *Gazette*. That job took him to Cuba to cover the Spanish-American War and then in 1897 to the Near East to report on the Greco-Turkish War. Returning to England, he discovered that while in Cuba he contracted tuberculosis and malaria. In early 1900, he traveled as a reporter for the *Gazette* to South Africa to report on the Boer War. Declining health caused him to return almost immediately to England. He and his wife then went to "take the waters" in Germany in an attempt to recover from his illness. He died in June and Cora returned to England.

While searching through his manuscripts, she found the "lost" feature article on Galveston and sent it to the editor of the *Gazette*. It published it on the front page on November 6 and titled it "Galveston, Texas in 1895." Of course, there was a reason why British readers would want to read this article. It is because of the result of the 1900 Galveston storm that hit the island on September 7, 1900. The storm and its devastation to the island city were important news in England. It was Galveston after all that shipped a huge percentage of cotton that fueled a large number of English textile mills, especially those in and around Liverpool. Without the cotton, the textile industry in England would face perilous times. Throughout September and October, every major British paper filled its front page with gruesome news on the Galveston disaster. Then, as things settled down in Galveston and order returned, the hurricane and its horror disappeared from the papers. Finally, early in November, Cora found the article and sent it immediately to Crane's newspaper. England would for one last time read about the golden age of the Queen City of the Gulf, but the city would never be the same.

Chapter 9

The Great Galveston Storm

David G. McComb

The deadliest natural disaster in the history of the United States was the great Galveston hurricane of September 8, 1900. It killed 6,000 people. This figure comes from the Morrison and Fourmy Company, which published a city directory at the time. The population showed 8,000 fewer people after the hurricane, and the company estimated that 2,000 people had moved from the vulnerable site. This conservative estimate of mortality is confirmed by the death roll of 5,132 for the city and county, assembled by the Rosenberg Library at Galveston. The storm also smashed one-third of the city, including 3,600 homes, and inflicted a $30 million loss. Interestingly, people were not completely surprised by the hurricane; there was a warning after all. The tempest, however, was much worse than expected.

The Saffir-Simpson scale, developed in the 1970s, ranks hurricanes from one to five according to wind speed, barometric pressure and storm surge. Category one is the mildest, with winds ranging from 74 to 95 miles per hour. The storm surge, created by decreased barometric pressure, which allows the sea level to rise, is only four to five feet. Damage by such a storm is usually minimal. Category two has winds of 96 to 110 miles per hour and a surge of six to eight feet. Category three winds range from 110 to 130, and the surge is nine to twelve feet. Category four measures 131 to 155 mile-per-hour wind speeds, with a thirteen- to eighteen-foot surge. The worst is category five, with winds greater than 155 miles per hour and a surge over eighteen feet. Damage by such a rare storm is catastrophic.

After the storm, some areas of Galveston were wiped from the face of the earth. Notice the group of workers in the middle background. *Courtesy of Special Collections, Rosenberg Library, Galveston, Texas.*

The Galveston Hurricane of 1900 might be ranked in category four, but perhaps not. The anemometer at the Galveston weather station registered 84 miles per hour before it blew away; there were gusts estimated at 120 miles per hour. The lowest barometer reading of 28.44 was on the dividing line between a category two and category three storm. Depth of water, however, measured from 10.5 feet at the Union Station to 15.7 feet at Henry Schutte's grocery store on the eastern end of the island. The Coast Guard calculated 14.5 feet above mean low tide. Waves and spray were impressive. Thirsty refugees huddled on the stairwell of the 130-foot-high Bolivar lighthouse, placed a bucket at the top to catch rainwater and found that the captured water tasted salty. The storm surge was deep enough for a category four hurricane, but the lesser wind speed and barometer reading make it problematic. Regardless of classification, for Galveston, the hurricane was catastrophic.

It was not just a result of bad weather. Geography and human ignorance also contributed to the disaster. Galveston, with an official population of 37,789 in 1900, was located on the eastern end of a Texas coastal sand

barrier island that was three miles across at the widest point and twenty-seven miles long. The highest elevation was 8.7 feet above sea level. Thus, a 5.0-foot storm surge could flood much of the island, while a tide of 15.0 feet would cover it over. Three railroad trestles and a wagon bridge spanned the two miles of shallow bay water that connected the mainland with the natural harbor on the lee side of the island. People built wooden homes along straight streets across the island to the Gulf side. They were usually elevated on pilings, three to five feet high, to avoid the flooding during tropical storms.

During the nineteenth century, the island experienced at least eleven hurricanes. In 1837, while the founders were preparing to establish the town, "Racer's Storm" plowed into Galveston. One eyewitness observed, "In the month of October, during the storm which laid waste the whole southern coast, from Mobile to Vera Cruz, and still further south, it was my lot to witness vessels of considerable tonnage floating over the foundations of the future city. People clung to loose boards, one person died, and eight ships ended up on land. The storm washed away the two-day-old customs house and when rebuilt by the agent, Gail Borden, Jr., it was placed up on four-foot pilings." Another memorable storm came in 1875 and produced a tide thirteen and a half feet above normal, killed 6 people and destroyed some five hundred houses on the Gulf side of the island. Worse, down the coast at Indianola, the water raged through the low-lying port town for eighteen hours and killed 270 people. It happened again to Indianola in 1886, and the surviving inhabitants abandoned the city.

The lessons of these earlier hurricanes went unheeded in Galveston. The editor of the *Galveston Daily News* treated the 1886 storm as a squall and a curiosity. He argued that Galveston could never suffer like Indianola because it only happened when the storm surge hit the mainland. Moreover, Matthew F. Maury, a world-renowned meteorological authority, stated that Galveston lay in a "cove of safety" surrounded by shallow water and sandbars that ran parallel to the shore. As a result of such nonchalance and foolishness, there was little preparation for a hurricane assault. The city planted a line of salt cedars on top of small Gulf dunes to stabilize the sand, but there was no sea wall, no breakwater, no emergency planning and no reliable means of escape to the mainland.

One of the earliest weather stations of the United States Weather Service had been set up in Galveston. However, the resident climatologist, Isaac M. Cline, knew that a major hurricane, like the cyclones of India, could hit the island. The weather service informed Cline on September 4–7, 1900, by telegrams from

The Galveston beach in 1894. *Courtesy of Special Collections, Rosenberg Library, Galveston, Texas.*

Washington, D.C., that a severe storm moving westward had crossed southern Florida and was at sea somewhere between Galveston and New Orleans. Nothing else was known. This occurred at a time before ship-to-shore telephones, before airplane surveillance and before radar. The Weather Bureau advised caution to vessels sailing toward Florida and ordered storm flags raised as a warning. John D. Blagden, who worked at the weather station, later said, "We had warning of the storm and many saved themselves by seeking safety before the storm reached here. We were busy all day Thursday answering telephone calls about it and advising people to prepare for danger. But the storm was more severe than we expected." Ida Smith Austin, a social elite, commented in contrast, "A storm had been predicted for Friday night the seventh of September, but so little impression did it make on my mind that a most beautiful and well attended moonlight fete was given at our home Oak Lawn that night. Everyone remarked on the beauty of the night."

Cline, meanwhile, watched his barometer, the sky and the tides. On the night of September 7, the night of Austin's party, the moon was bright, and the barometer indicated nothing. There was only a slight wind, but Cline noticed

long swells breaking on the Gulf shore with an ominous roar. "The storm swells were increasing in magnitude and frequency," Cline later recalled, "and were building up a storm tide which told me as plainly as though it was a written message that a great danger was approaching." At dawn on September 8, high water began creeping over the lower reaches of the island, and the barometer slowly began to drop. Cline, alarmed, hitched up a horse and wagon and drove down the beach to warn people to seek higher ground.

The reaction to the warnings was mixed. Some people sought the safety of downtown buildings, some went to the beach to watch the excitement,

Isaac Cline was the head of the United States Weather Station in Galveston when the Hurricane of 1900 struck the island. *Courtesy of Special Collections, Rosenberg Library, Galveston, Texas.*

some simply stayed, others went to work and some paid no attention. Englishman James Brown wrote to his relatives in early October, "As you are aware it occurred on Saturday the 8th of Sept. Nothing previous to denote any storm coming only the usual warning from the signal station which no one notices." For many, there was a reckless disregard of the warning. As black survivor Ella Belle Ramsey explained in the vernacular of the slave stories collected by the Works Progress Administration: "Everybody 'round here got so used to de storms dat dey don' mean nothing. 'Bout time we got settled de wind come up an' den de water come. Chile, I can't tell you how dat water come. It jes come pouring in. Dere wasn' nothing to stop it den. We wen' on upstairs 'cause de water come in de downstairs. I was praying to de Lord an' I never think 'bout nothing else."

Louisa Hansen Rollfing, a middle-aged woman married to a Galveston building painter, said:

> *During the night of September 8th [September 7–8] the wind was blowing very strong and reports of a storm in the Gulf were heard. But no one was*

alarmed more than at any other time when we heard these reports. Everybody went about their business in the same way as on any other Saturday…At 9 o'clock [a.m.] the rain poured down in streams. Driftwood came down the street, and the wind got stronger and stronger every minute. For a while even ladies were wading in the water, thinking it was fun. The children had a grand time, picking up driftwood and other things that floated down the street. They went near the beach and told us that the bathhouses were breaking to pieces. Then it wasn't fun anymore. People began to vacate their homes, and went farther into town to safer places.

Several hundred took refuge in the Tremont Hotel and huddled in the dark hallways while the windows blew in and the plaster dropped from the ceilings.

As the swirling hurricane struck the coast and moved inland, the wind direction shifted from north to northeast, east to southeast and then south. The flooding that began in the morning fell sharply after midnight and receded by dawn. With reduced strength, the storm arched across Texas and Oklahoma, crossed the Great Lakes, traveled up the St. Lawrence River and returned to the sea on September 22 off eastern Canada, where it disrupted a French naval fleet in the Atlantic off Newfoundland. Meanwhile, in Galveston, the force of the wind and the amount of floodwater caught people by surprise. For the most part, people reacted in a rational, courageous and humane manner. After ensuring the safety of their own families, most people helped to rescue others regardless of race or personal prejudice. It was not the police force, fire department, city government or soldiers who saved people. It was neighbor helping neighbor. People were scared but rarely hysterical as they nailed boards across doors and windows to keep out the wind, chopped holes in the floor to use the weight of floodwater to anchor a house, gave shelter to strangers and retreated upstairs as the water invaded their home. They reached out with ropes and hands, sometimes at personal risk, to pluck victims from death in the churning water.

As the hurricane worsened, shortly after noon, Arnold R. Wolfram decided to close his store and head home to his family. Slate and glass was flying in the howling wind and rain, so he tied a pair of spare shoes over his head as a kind of helmet. Water was rushing down the street to the storm sewer, and Wolfram acted quickly to pull to safety a small Western Union messenger boy being swept into the whirlpool of the drain. Amid poles, snapping wires, flying debris and rapidly moving water, they pulled themselves along an iron picket fence near the Heroes of Texas monument in the center of town. The current swept them off their feet and flung them

into the branches of a tree. They clung there as a woman floated by on wreckage. They reached out to her, but the running water swept her under. Wolfram retained this image of her frightened face and her screams ringing in his ears for the rest of his life. A raft then wedged between their tree and a nearby house. Taking advantage of the brief dam against the current, the man and boy forced their way to a porch, and the people took them in for the remainder of the night.

Katherine Vedder Pauls was six years old when she asked, "Papa, is that a hurricane?" as her father surveyed a small cloud drifting in from the southeast on the late afternoon of September 7. Her family made plans to leave their home and put on woolen bathing suits for warmth. As it turned out, their house became a retreat for about fifty people even though a swell lifted it off its six-foot-high foundation and settled it on the ground. When the lower floor filled with water, Katherine grabbed her daddy's neck while he carried her to the comparative safety of the stairs. "Papa, there's my kitten," she yelled as the young animal struggled in the water. Her father scooped up the soaked, clawing feline and pitched it up the stairs. A woman caught it and screamed, "It's a rat!" before tossing it into the water. The cat had to be rescued again and later contributed its purring warmth to help revive a cold baby brought in from the storm. Part of the roof blew off, the first floor flooded and rain poured into the house. Worse, twelve- by twelve-inch beams twenty feet long from the construction of barracks at nearby Fort Crockett tumbled through the torrent and headed toward the house like a battering ram. These beams would have smashed the remainder of the home except that Katherine's father stationed himself at the front door and redirected these battering rams away from the house. It worked, but the glass, splinters and debris later picked from his lacerated hands and arms left scars for the rest of his life.

Storm-driven debris caused much of the destruction. This was the case at Isaac Cline's house. Located four blocks from the beach, Cline's home had been elevated and specially braced to withstand hurricane winds. About fifty people gathered there to wait out the hurricane with Cline's pregnant wife and three children. At about midafternoon, Isaac sent his younger brother, Joseph, to the telephone exchange to inform the Washington office that the storm had come ashore at Galveston and the city needed aid. He then waded to Isaac's home from the weather station office. Water flowed underneath the house through the pilings and leaked into the first floor of the structure. The home held its ground, and the refugees retreated to the upper floor. The hurricane, however, uprooted the beach streetcar line with its ties, cross

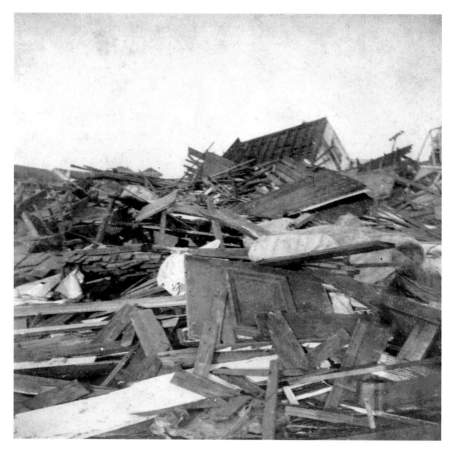

Line of debris at Twentieth Street and Avenue O ½. *Courtesy of Special Collections, Rosenberg Library, Galveston, Texas.*

pieces and fifty-foot rails. This scythe struck the pilings under Cline's house and rolled it on its side. Joseph grabbed two nieces by the hand, turned his back and crashed through a window as the house turned over.

Isaac, his wife, Cora, and a daughter were pinned in the wreckage and went under water with the others. Isaac lost consciousness, popped to the surface, woke up and found his daughter near him. Together they joined Joseph and the two other Cline children on the trolley trestle. The men turned their backs to the wind, placed boards behind them as a shield against the slate shingles and debris sailing in the gusts and gathered the youngsters in front. They listened to the crunch of shattered houses and the screams of the dying and pulled a seven-year-old girl from the water. The group moved to securer pieces of flotsam and finally grounded on a massive line of

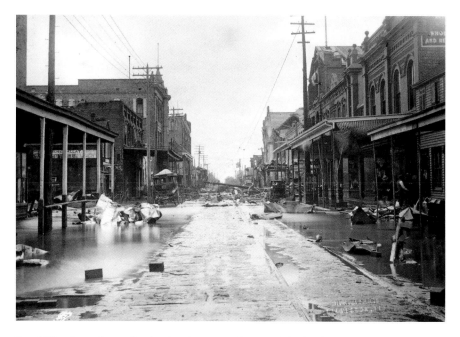

Post Office Street immediately after the storm. *Courtesy of Special Collections, Rosenberg Library, Galveston, Texas.*

wreckage that piled up and served as a breakwater about six blocks from the beach. Workmen later found Cora Cline's body entangled in the rubble at the point where the brothers and children had safely landed.

The Sunday morning weather after the hurricane was clear, bright, calm and warm. The sound of bells from the ruined Ursuline Convent called people to worship but also echoed the sounds of mourning for a city where, according to Joseph Cline, "[d]readful sights met our gaze on all sides." There was a thirty-block-long line of wet urban wreckage as high as twenty-five feet and one hundred feet wide with boards, shingles, wires, branches, sand, furniture, sewing machines, crockery, glass and clothing—the remains of a destroyed city, mixed with the bodies of cows, horses, mules, cats, dogs and humans all beginning to decay in the warm, moist air. The sixteen ships that had been in the harbor were scattered and aground. The telegraph, telephone and electric lines were down. The rail trestles to the mainland were damaged, the wagon bridge was gone and there was no fresh water. People had to pay twenty-five cents per pint for mineral water from the drugstores. Everything not stored eight feet above the first floor was damaged by salt water. The stunned survivors who emerged from the devastation first

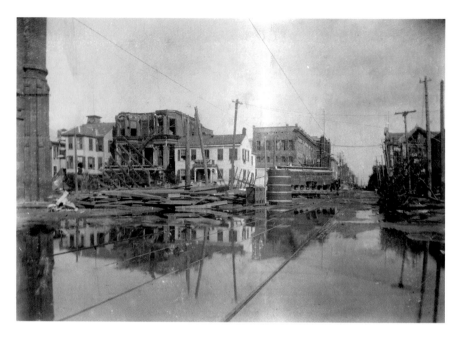

Twenty-second Street and Avenue G immediately after the storm. *Courtesy of Special Collections, Rosenberg Library, Galveston, Texas.*

searched for loved ones, living or dead, and then began the arduous task of cleaning up the town.

Mayor Walter C. Jones organized the short-run recovery effort—to bring in outside aid, restore urban utilities, care for the injured and destitute, bury the dead and clean up the city. A surviving twenty-foot steam launch carried a messenger group of six men across the bay to the flooded coastal plain. They waded ashore, found the railroad track, intercepted a train, rode to Houston and telegraphed the news to the world. Texas cities and others immediately responded with supplies and personnel. P.G. Tipp, a fisherman who had been swept off his boat and carried to the mainland, caught a ride on a small sailboat and was one of the first to reenter Galveston. This is what he saw:

After about thirty minutes the breeze died out and we just drifted with the tide. We kept running into so many dead bodies that I had to go forward with a pike and shove the dead out of the way. There was never such a sight. Men, women, children, babies, all floating along with the tide. Hundreds of bodies going bump-bump, hitting the boat. I was sort of in a daze picking them out of the way. It was the most horrible thing I have ever seen.

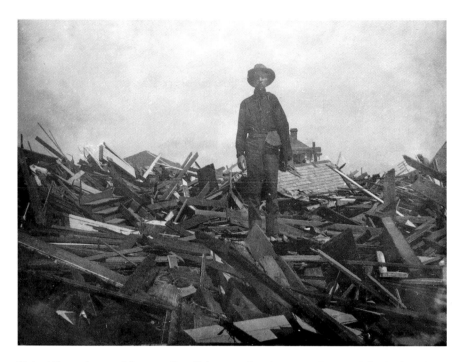

United States Army soldier guarding Galveston after the storm. *Courtesy of Special Collections, Rosenberg Library, Galveston, Texas.*

Meanwhile, Mayor Jones organized leading citizens into a Central Relief Committee and charged each member with a specific task—John Sealy for finances, Ben Levy in charge of burials, Daniel Ripley to take care of hospitals, W.A. McVitie for relief work and Morris Lasker to take control of correspondence. McVitie formed subcommittees for each of the twelve wards of the city. The committee decided that every able-bodied man should work on the cleanup squads and that those who refused would not be fed. The committee gave women and children preference on outgoing transportation, and it developed a pass system to control visitation. The committee also formed an armed militia group to keep order with permission to close the saloons and shoot looters on sight.

The national media and book writers of the time often told stories of looters and ghoulish people who cut off the fingers and ears of the dead in order to steal jewelry. There are frequent references to looters in the recollections of the survivors, but there are almost no eyewitness reports. Clarence Ousley, a journalist and writer who experienced the disaster, later edited a book in which he reasoned that no more than six

Shortly after the storm, this tug and barge took several loads of corpses out to the Gulf of Mexico and dumped them overboard. Tragically, these bodies soon washed ashore on the beach. *Courtesy of Special Collections, Rosenberg Library, Galveston, Texas.*

people had been killed for looting—not the seventy-five that the popular media proclaimed. Moreover, when Adjutant General Thomas Scurry of the Texas militia took over the police duties and declared martial law on September 13, there were two thousand armed police, soldiers and deputy sheriffs on duty in Galveston. The stories of extensive, gruesome looting in the days following the disaster at Galveston have been an unfortunate myth for more than a century.

Body disposal was problem enough. There is no odor more repulsive and overwhelming than that of a decaying human body. Crews worked with bandanas soaked in camphor tied over their noses and drank whiskey, officially distributed, to ease the task. There was a brief attempt to collect

the recovered bodies in makeshift open-sided morgues for identification. The ground was so saturated that burial trenches filled with water, and weighted bodies dumped into the Gulf merely bloated and washed ashore. The final solution was to place the corpses, after a minimal attempt at identification, on piles of storm-created lumber and burn them where they lay. Work crews discovered the dead, at a rate of about seventy per day, into October, and observers on the mainland viewed the glow of these funeral pyres into November. As Fannie B. Ward of the Red Cross commented, "That peculiar smell of burning flesh, so sickening at first, became horribly familiar within the next two months, when we lived in it and breathed it, ate it and drank it, day after day."

Still, vitality returned quickly to the city. There was a communal determination that Galveston would survive, that it would not give up in the face of hurricanes as Indianola had done. Major Robert Lowe, the general manager of the *Galveston Daily News*, expressed this "Galveston Spirit," as it was called, when Colonel William G. Sterett came to the city from the *Dallas Morning News* to survey the damaged press and dripping, broken workroom of his sister city's newspaper. Sterett suggested to Lowe that he print the paper in Houston. Lowe exploded, shook his fist and stamped the floor. "You would, would you? Well, I won't! You never lived here. You don't know—and you would ask me to desert? No, no, no! This paper lives or dies with this town. We'll build it again and *The News* will help." The newspaper did not miss a single issue.

During the first week, workers restored the supply of fresh water, electric streetlights and the telegraph. Banks reopened on Friday. During the second week, workers cleared most of the streets and alleys, began to restring telephone lines and repaired one of the railroad bridges by an around-the-clock labor effort. At the end of the second week, on September 22, the first train arrived. General Scurry lifted martial law, and during the third week after the disaster, the Houston relief groups returned home, the trolley system began to operate and the saloons reopened. Freight began moving through the port, and on October 14, one of Galveston's largest shipments of cotton cleared the port. On October 22, the schools reopened.

Clara Barton and the Red Cross arrived on September 17 and quickly took over administration of the relief commissaries. The relief stations distributed clothing, food and money to those who could not work. Barton validated the emergency and attracted additional national attention. The Red Cross ended its work on November 14. The Central Relief Committee continued to operate a relief commissary until the second week in February. The

committee also provided money to build 1,432 water closets and cesspools, gave away 222 Singer sewing machines, supplied funds for repairing 1,114 buildings and contracted for the construction of 483 three-room cottages. The committee utilized the $1,258,000 gathered in donations from around the world to fashion a recovery that in six months resulted in a condition whereby commerce had recovered, no one depended on relief and the population possessed the necessities of life. The Central Relief Committee presented its final report on March 3, 1901, and completed the task of short-term recovery.

After the storm, Galveston needed to take the steps necessary to ensure long-term protection. This effort preoccupied the city for the next twelve years. Unfortunately, while the city worked on its defenses against the sea, the first great discovery of oil in Texas occurred at nearby Beaumont in 1901. Consequently, the Texas oil boom bypassed the island city that now possessed an enduring reputation for tragedy and fragility. Nonetheless, Galveston survived as a medium-sized city, while other Texas places seized the leading spots in the urban race for population. The survival of the island city depended on erecting durable fortifications against hurricanes. The city accomplished this by constructing a massive sea wall to thwart the power of hurricane waves, by raising the grade level of the land to minimize flooding and by building an all-weather bridge to the mainland to provide people with a means of escape.

To do this, Galveston invented a new form of city government—the commission plan—that placed civic leaders in charge of specific urban functions. Modeled after the Central Relief Committee and promoted by a group of Galveston business elites, the plan required the governor to appoint the majority of commissioners. Two years later, citizens corrected this undemocratic aspect by requiring the election of all the officials. Meanwhile, in 1901, one year after the Great Storm, the new commission government took charge of the long-term recovery of the island city.

Everything that Mortal Men Can Do

The Galveston Sea Wall and Grade Raising

Patricia Bellis Bixel

In early 1900, a person standing at the intersection of Broadway and Twenty-fifth Street in Galveston could face the Gulf of Mexico, seeing and hearing breakers on the nearby beach. A quick turn to the opposite direction revealed ships in the busy port. No other situation at the turn of the century indicated more effectively both the narrowness of Galveston Island on its East End and the city's minimal height above sea level. As Galvestonians tragically discovered due to the Hurricane of 1900, life on a barrier island was precarious. And if the city were to rebuild and regain its position in the regional and national economy, measures to protect the island and prevent any future damage were essential.

Not rebuilding was never an option. In 1900, before the dredging of the Houston ship channel and development of other ports along the Gulf Coast, Galveston was the major port in the western Gulf. Since the 1890s, the federal government had invested significant time, money and energy for harbor improvements, most notably dredging the Galveston channel and constructing jetties to protect and increase its depth. After the storm, a quick investigation revealed that the ship channel suffered no major damage. Piers could be rebuilt, and the business community was anxious to get the port up and running. Southern Pacific railroad ordered a new two-track bridge across the bay, and by late September, the port had reopened to traffic. But city leaders faced a delicate dilemma. Constructing a sea wall or taking other precautionary actions would acknowledge the danger that the city still faced.

Galveston would protect itself, authorities decided, not because the location of the city was inherently dangerous but rather because the city was too important not to rebuild in the best and safest manner possible. Such action would also appease those who feared a future hurricane.

Protecting the island from future threats became a goal of city government, but was the current administration up to the task? Most feared not. To that end, reformers introduced legislation in the Texas legislature that would eliminate the existing mayor and alderman system and replace it with a city commission. On September 18, 1901, the new commissioners took office. Almost immediately, the new commission took up the issue of protecting the island from future storms. On November 20, the commissioners instructed Army Corps of Engineers general Henry M. Robert, Alfred Noble and H.C. Ripley to formulate a plan that would save the city from another hurricane like the 1900 storm.

When they presented their report on January 25, 1902, they first described the circumstances that caused extensive flooding. Since 1834, the city had flooded seven times. The worst was the Hurricane of 1900. In each case, currents developed as rising water from north and south merged across the island. They noted that "the greatest destruction was caused by currents and wave action." It was this wave action, in addition to the flooding, that created the devastation of 1900.

Could anything protect the island? Yes, the board decided. To do this, the engineers advised "the building of a concrete wall over three miles long… the top of this wall to be 17 feet above mean low water, or 1.3 feet higher than the highest point reached by the water in the storm of 1900. Second: The raising of the city grade…Third: The making of an embankment on top of this fill adjacent to the wall." Theoretically, the three steps would work together to prevent severe wave and water damage like that caused by the 1900 storm. The grade raising would lift streets and lots high enough to avoid the highest recorded rising water on the island. The sea wall would block the city from the force of waves from the Gulf. The engineers also calculated the costs of their plan. The sea wall would cost $1,294,755. Projected costs of the grade raising were $2,210,285. Galveston could protect itself against the ravages of Mother Nature for, roughly, $3,500,000.

The city commissioners gladly accepted the report. In truth, the recommendations were not new. During most of the nineteenth century, Galvestonians ignored the threat posed by Gulf waters. Islanders removed indigenous salt cedar trees so they could reach the beach. Developers hauled sand from dunes to fill in low-lying areas. By 1900, trees and dunes—natural

obstacles to rising water—were gone. Even weak tropical weather systems caused minor street flooding and standing water in yards and along alleys. City leaders refused to commit any funds necessary to improve the situation, and as Galveston passed more and more storm seasons unscathed, calls for protection faded.

The idea of building a sea wall was also not new. Since the 1870s, Galvestonians discussed sea walls and ways to prevent storm damage each hurricane season. Most citizens were unwilling to pay for such measures, and representatives in the legislature were unable to convince the state to foot the bill. When a hurricane in 1886 wiped out the coastal community of Indianola, a group of thirty Galveston businessmen formed the Progressive Association and passed a resolution calling for the construction of a sea wall. While this group failed to find funding for its project, the association lobbied the legislature and secured passage of an amendment to the city charter that authorized the issuing of bonds to pay for such work. The bond issue faced intense opposition, and as years without storm damage passed, the city lapsed into a false sense of security. As late as September 1, 1900—one week before the storm that destroyed the city—then colonel H.M. Robert, divisional engineer of the U.S. Army, presented a plan to the Galveston City Council for the "improvement, protection, and development of Galveston harbor" that included construction of a dike "that would form a wall diverting the heavy storm tides from the northeast, and thus protect Galveston from overflow."

After the storm, there were even more suggestions. By the end of September 1900, the *New York Herald* had collected ideas that ranged from a sea wall; working on Galveston for business during the day and sleeping on the mainland at night; rebuilding the city on steel or wooden piles as a "modern Venice"; consolidation with Houston; or complete removal of the city to Port Arthur, Sabine Pass or Port Aransas. One of the most creative contributions came from France, where a colonel in the artillery advocated "a plan to erect a battery for destroying hurricanes close to Galveston…If a West Indian cyclone approached he would fire at it and…break its back."

Not convinced that artillery bombardment was the answer, city leaders favored a sea wall. Moral support for the project abounded; financing was another issue. Given the recent destruction of the city tax base, the existing outstanding bonds, a new and untried government and the projected cost of the sea wall–grade raising plan, the city could not issue bonds to cover the costs of the project. After calculating the amount of taxes paid to the county by Galveston residents, city and county commissioners agreed that the county would issue bonds for a sea

Sea wall construction, first step: drive the wooden pilings. Photo circa 1903. *Courtesy of Special Collections, Rosenberg Library, Galveston, Texas.*

wall and the city would finance the grade raising. With a 98 percent turnout, the bond issue passed. The *Galveston Daily News* noted a "Grand Jollification" in response to the vote. Construction began on October 27, 1902, when workmen drove the first pile at the foot of Sixteenth Street.

Plans called for a concave sea wall so that crashing waves from the Gulf would shoot skyward when they struck it. The engineers built the wall on pilings driven into the sand. They drove sheet pilings in front of the traditional pilings to keep water from infiltrating and undermining the structure. The contractors also dumped riprap around the pilings to protect further the foundation of the wall. On March 12, 1903, the company filled the first wall sections with concrete. It completed the last section on July 29, 1904. The sea wall measured 17,593 feet. It was truly a spectacular achievement. On August 22, 1904, Galvestonians celebrated the event. Texas governor Sam Lanham dedicated two red granite markers at the foot of Twenty-third Street to commemorate the completion of the wall. About ten thousand people attended, no doubt appreciating the governor's words along with the fireworks display.

Second step: lay the riprap (foreground). Notice the sea wall's foundation on the right and the steam mixer pouring concrete in the background. Photo circa 1903. *Courtesy of Special Collections, Rosenberg Library, Galveston, Texas.*

The engineers built the sea wall in alternate sections along the beachfront. The breakfront extended from the foot of Eighth Street to Thirty-ninth Street. The federal government extended the sea wall in the front of the Fort Crockett military installation from Thirty-ninth Street to Fifty-third Street. In 1902, the federal government approved funding for this portion of the sea wall in order to protect that federal property. Only a few days after finishing the county's portion of the wall, J.M. O'Rourke Construction Company began the federal extension of the project. The Fort Crockett extension added another 4,910 feet of sea wall, ending in a rock revetment that extended northward from Fifty-third Street to Avenue U. O'Rourke completed the federal extension in October 1905. Not only did it protect the military installation at Fort Crockett, but it also secured the neighborhoods located to the north of the fort. Since its initial construction, the sea wall has undergone several extensions—in both directions. The first eastward extension, completed in March 1921 connected the wall from Sixth Street to the first battery at Fort San Jacinto. A further extension opened to the public on July 3, 1925. The final eastward segment, completed one year

The Galveston sea wall circa 1904. Notice that the houses behind the seawall are lower than the sea wall and have yet to be raised. *Courtesy of Special Collections, Rosenberg Library, Galveston, Texas.*

later, extended all the way to the south jetty. Westward expansion past Fifty-third Street soon followed. Galveston County extended the wall from Fifty-third Street to Sixty-first Street in 1927. It finished the final three-mile lengthening of the wall in 1962. Today, the bulwark spreads almost ten miles along the Gulf of Mexico side of the island and protects nearly one-third of the island's beachfront.

One perhaps unforeseen consequence of building the sea wall involved increased erosion of the beach in front of the wall. Those who kept an eye on the status of the Galveston shoreline worried about beach erosion. Early records indicated that the beach along the gulf side shrunk almost 450 feet from 1850 to 1900. After sea wall construction, especially after a mild hurricane in 1909, the erosion in front of the wall became quite noticeable. To counter this, the city constructed thirty-two small wooden groins between Eighth Street and Thirty-ninth Street. The relatively flimsy structures did

not connect to the wall, and they were not tall enough to stop the erosion. Gradually, the water undermined the sand around these wooden groins. Eventually, the waves beat them to bits, and finally they became a hazard to beachgoers and swimmers. The county removed this failed experiment for safety reasons.

A large hurricane in 1915 washed away most of the sandy beach in front of the sea wall. Scouring action wore away the riprap in some areas, lowering it as much as 3 feet and exposing the timber sheet piling of the wall. Since this piling was untreated lumber, any incursion by worms or other marine borers jeopardized the structural integrity of the entire wall. The city replaced the riprap as quickly as possible, but the threat remained. Also, a 4- to 5-feet-deep channel about 115 to 165 feet from the toe of the riprap of the sea wall unexpectedly formed, and 2- to 3-foot tides regularly reached the base of the wall. By 1934, tides had swept over the protective riprap and had begun to undermine the foundation of the wall. After studying the problem, engineers determined that the sea wall faced long-term damage if the present situation did not change.

All along the sea wall, extensive settling washed away the embankment fill behind the wall. Water that topped the sea wall during a storm washed away some of the fill behind the wall. Buildings near the wall also suffered extensive damage. City leaders asked General Robert if he had any suggestions. After studying the situation, Robert recommended that the city construct a series of rock groins perpendicular to the sea wall that sloped into the Gulf. The city completed the last groin in 1938. It worked. Sand soon accumulated around the groins, and the undermining disappeared. Unfortunately, the groins did not replenish the beach. Forces that worked against the depositing of sand still existed, and periodic hurricanes and tropical storms contributed to ongoing erosion. But the city could pump more sand from the Gulf. Even in the early twenty-first century, Galvestonians pay for "beach renourishment," a process that pumps sand from the Gulf of Mexico onto the beach.

The other component of the plan to protect Galveston, the city grade raising, proceeded along a slightly different path than sea wall construction. The new city charter specified that the governor would appoint three Galveston residents to a "board for the management, control and direction of the work of filling and raising the avenues, streets, sidewalks, alleys, lots and outlots in said city, and to make all expenditures of funds for that purpose." On May 3, 1903, Governor Samuel Lanham appointed Captain J.P. Alvey, John Sealy and E.R. Cheesborough to the board. Once the board was in place, the job could begin. The biggest problem was money. The

projected cost was $2.2 million. The state agreed to remit to Galveston about $1 million. The city possessed the authority to issue bonds to fund the grade raising, but the dismal overall financial condition of the town made those securities hard to sell. The city could not pay for the grade raising with cash, so any contractor who bid the job had to accept bonds as a partial payment. In September 1903, the commissioner of finance and revenue told a joint meeting of interested city and county boards that the best the city could offer was one-third cash and two-thirds bonds.

Meanwhile, the board hired Captain Charles S. Riché, a former U.S. Army Corps of Engineers district engineer, as the supervising engineer for the project. He surveyed the island and determined exactly which areas needed fill. He drew up specifications and solicited bids. The response was disheartening. During the bidding period, only two firms—Goedhart and Bates and the Atlantic, Gulf and Pacific Company—bid the project. Goedhart and Bates won the bid. Most importantly, the company agreed to accept two-thirds of the total payment amount in bonds if the city guaranteed sale of the bonds at a fixed price. P.C. Goedhart and Lindon Bates developed a plan that involved the use of large, self-loading hopper dredges. These boats would pick up dredge material from the Gulf and deliver it via a canal cut through the island parallel to the sea wall. Once they unloaded the new soil in an area, the dredges would back out of the canal and fill it in. What choice did the city have? They agreed to the proposed course of action.

On January 5, 1904, Goedhart and Bates began work on the grade raising. The federal government allowed the contractors to cut an opening in the south jetty that would serve as the mouth of the canal. In addition, the local government agreed to move any structures off the proposed temporary canals at no cost to the owner and return all buildings to the newly raised lots. Local leaders also agreed to pay to raise all municipal services in the work area. Writing in January 1903 in support of the project, a reporter for the *Galveston Daily News* commented that "all the property owner has to do is loan the city the use of his lot and permit the city to move his house to another lot while the grade raising project is under way and replace the house on the original property after the grade of same has been raised."

All other property owners had to pay to raise their buildings. While supporters of the grade raising assured homeowners that the cost of raising their homes would be low, some remained skeptical. Victoria W. Campbell wrote to her daughter that "[w]hen the grade raising reaches us I may be obliged to have the house raised a foot or two—and that will cost lots

The dredge *Holm*. Photo circa 1905–7. *Courtesy of Special Collections, Rosenberg Library, Galveston, Texas.*

of money." Instead of raising homes and businesses, owners could fill in basements or first floors. Florence and Charles Vedder took it one step further. They removed walls and flooring from their basement and built an addition to their home.

As secretary of the Grade Raising Board, Edmund R. Cheesborough's responsibilities included gathering the leases. In all, Cheesborough secured 284 leases. By June 1904, the board had reported to Governor Lanham that the project was on schedule. The contractor had moved most of the houses, and they had dug the first thousand feet of canal. They expected the new hopper dredges to arrive any day and would begin the actual grade raising by the middle of the month.

The arrival on June 12 of the smallest of the three dredges, the *Holm*, was big news on the island. The *Daily News* noted that "the proximity of the little mechanical giant, calculated to play such an important part in the grade raising operations, was good tidings to the citizens of Galveston." The contractors built the other dredges in Europe because American shipyards did not know how to construct this type of dredge. The naval architects claimed that the dredges could easily cross the Atlantic. They were wrong.

The grade-raising canal looking east from Twenty-third Street. Photo circa 1906. *Courtesy of Special Collections, Rosenberg Library, Galveston, Texas.*

One of them, the *Texas*, sank off the Azores. Caught in a twelve-day gale, the dredge went down with the loss of fifteen men. The remaining crew and officers took to the lifeboats and spent thirteen days adrift before rescuers plucked them from the sea.

Once the *Holm* arrived in Galveston, it started to widen the canal and dig two basins so that the vessels could turn around and go back to the Gulf for more fill material. When the other dredge arrived, the grade raising proceeded quickly. First, surveyors marked quarter-mile sections, and workmen enclosed them with a dikes. Next, contractors raised all gas, water and sewer pipes, buildings and trolley tracks within the space. Finally, engineers pumped fill into the section until the grade level matched the survey.

Contractors also constructed rickety catwalks and trestles. These allowed residents and business people to access their homes and offices. The *Galveston Daily News* described this "City on Stilts":

> *Galveston…claims the distinction of being the only city in the United States that can boast a system of elevated sidewalks…On each side of the various streets are to be found temporary board walks, in many instances nothing more than planks, supported by uprights, the whole being attached by fences. They have not been built with any regard to conformity to straight*

The Platte Home (2213 Avenue P) before the fill. Notice the rickety catwalk and trestles to the right. *Courtesy of Special Collections, Rosenberg Library, Galveston, Texas.*

lines, and their permanency is a mere questions of a few weeks…they do not give assurance to corpulently inclined gentlemen, and they are certainly not reassuring to the man with the downtown club habit.

People adapted. One reporter noted that one resident whose house backed up to the canal tied a cow to a railing along a back gallery shared by chickens, a dog and a cat. Galvestonian Florence Vedder remembered a wedding under these trying circumstances. She quipped, "The boardwalks, erected for the convenience of homeowners during the grade-raising were already up, but the fill had not been turned in, so everyone prayed that the wedding would pass without any complications. But, Fate had decreed otherwise, and to the chagrin of family and friends, the fill began to pour through the pipes…Carriages which were to take the wedding party to Grace Church had to stop two blocks away, and they all walked gingerly down the rickety boardwalks…it was all accepted in a spirit of fun."

Vedder also remembered some advantages to the massive civil engineering project. "All the housewives took the opportunity to have a general housecleaning. They watched trash, tin cans, broken and discarded objects

disappear in the muddy fill and fast hardening sand. Everyone tossed in so called *white elephants*—things they had wanted to get rid of for years. Even the kitchen stove disappeared."

After the grade raising, Galveston looked like a wasteland. Trees and vegetation covered by feet of dredge material could not survive the onslaught. Some homeowners tried to save their plants by placing them in new soil. That usually did not work. The fill, 15 to 45 percent sand and the rest salt, was toxic to plants. The *Daily News* tried to prepare readers for the bleak prospect. "As is well known to every one who knows the arboricultural beauty of the city, there are hundreds and hundreds of the most beautiful tropical shade and ornamental trees…hundreds, perhaps, of stately palms and wide-branched live oaks…the effect of the salt upon a large percentage of the trees will prove disastrous." Victoria Campbell wrote her daughter about the family house, lamenting that "[our] old home never looked so sweet desirable [*sic*] and shady as it does this spring. The house and fence and everything is on stilts which of course is disfiguring, but the palms the elms and Oleanders are simply beautiful it is distressing to know that after the filling is put in the trees will all die and the place will look as desolate as the desert of Arizona."

Some Galvestonians wrote to plant experts around the country. The chief landscape architect for the Louisiana Purchase Exposition at St. Louis, George E. Kessler, recommended that people who wanted to save trees and shrubs should lift the vegetation immediately before the fill poured into their lot and replant them as quickly as possible. Some homeowners surrounded trees with wooden walls and raised them using topsoil or dirt uncontaminated by dredge fill. Residents scavenged sweet soil from other parts of the island, the mainland or even overseas. "All up and down Broadway chaos reigns," wrote Victoria Campbell, "people are digging dirt from esplanades and streets to fill their yards rather than have the sand." Dr. Randall, a neighbor of the Campbell family, filled his yard with soil that came from South America as ballast. These noble actions bore no fruit. The majority of live oaks, palm trees and plantings that now flourish on the East End of the island date from post–grade raising efforts to revegetate the island.

The Women's Health Protective Association (WHPA) assumed responsibility for replanting programs after the grade raising. The WHPA turned its attention to replacing trees and bushes lost during the raising process, consulting with experts, obtaining seeds and cuttings and even convincing railroads to transport thousands of palm trees from Florida and California to the island. The group first restored public areas—parks and

boulevards most often used by residents and visitors. Other city organizations teamed up with the WHPA and relandscaped their properties. At the height of its work, the WHPA operated a nursery and gave away or sold at cost thousands of seeds, rose bushes, oleander cuttings and other plants to property owners for home gardens. It also sponsored citywide competitions for successful landscape replanting and awarded prizes.

Galvestonians raised 2,156 structures during the project. The most spectacular of these was the lifting of St. Patrick's Church, one of the largest churches on the island. The building measured 53 feet by 140 feet and weighed about three thousand tons. Workers excavated under the church and installed a cradle of heavy timbers and iron girders. They secured seven hundred jackscrews under the cradle and slowly lifted the structure five feet in the air. "Owing to the nature of the construction of this building," the *Daily News* reported, "Fears were entertained as to the feasibility of raising it. It is virtually a big brick shell with the exception of the solidly constructed tower." The paper also noted that "no accidents occurred during the operation and services have never been discontinued while the raising was in progress. On St. Patrick's Day a record-breaking congregation attended the services while the church was elevated high in the air."

The grade raising of St. Patrick Church. *Courtesy of Special Collections, Rosenberg Library, Galveston, Texas.*

Work continued for years. In 1910, the North American Dredging Company assumed responsibility for the work—mainly refilling the canal—and finished the project in 1911. Goedhart and Bates claimed that they lost $400,000 on the job, but they transformed the city forever. Contractors filled five hundred square blocks with 16.3 million cubic yards of sand.

Over the years, Mother Nature has tested the sea wall and the grade raising. Since 1909, Galveston has weathered a number of hurricanes and other tropical weather systems. The sea wall is a Galveston landmark, and parts of the island lifted during the grade raising blend seamlessly with the surrounding original elevations. Such massive and drastic action taken to protect a barrier island of constantly shifting sand would be impossible—and perhaps undesirable—in the twenty-first century. Maintaining the wall for protection and the beach for tourism demands constant infusions of money and effort, and hurricanes continue to pose a very real threat to life and property. But Galvestonians never hesitated in the dark days of September 1900. A change in government and bold plans to protect the city sent a message to the world that Galveston had no intention of succumbing to wind and waves.

"A Municipal Broom"

Urban Reform and the Woman Suffrage Campaign in Galveston

Larry J. Wygant

Galveston in 1912 was a city well pleased with itself, poised to reclaim the title "Queen City of the Gulf." Only a dozen years earlier, the worst natural disaster in the history of North America, the "Great Hurricane of 1900," devastated the island. Galveston citizens had rebuilt their city. They had constructed a mammoth sea wall and had raised a large part of the city to as much as seventeen feet above sea level. They had replaced the wooden railroad trestle with a new concrete causeway that provided rail and highway connections to the rest of the world. In 1911, the Hotel Galvez, the most magnificent hotel on the Texas Gulf Coast, had opened its doors on the new Seawall Boulevard. This robust activity had sent a message to the rest of the world: Galveston was back, and it was ready once again to welcome tourists to the sandy beaches and sea breezes of the island.

Under the surface, other forces were at work that would change Galveston and the Lone Star State forever. Despite earlier failures, the woman suffrage movement by 1912 had begun to gain momentum and support. In Galveston, women and men argued tirelessly for woman suffrage, and these efforts gained support from many citizens. However, in 1919, the state constitutional amendment that granted the vote to women failed in Galveston by a two-to-one margin. A look at the progress and the goals of the Galveston campaign suggested a number of reasons for this defeat.

In Galveston, organized interest in the woman suffrage movement began in 1893 when Rebecca Hayes of Galveston issued a statewide call for the formation of a Texas Equal Rights Association. Forty-eight women and men

organized the association and elected Hayes president. The following year, delegates to the state convention in Fort Worth reelected her to the office. However, internal bickering weakened the association, and Hayes left the movement. By late 1896, the Texas Equal Rights Association lay dormant. Despite Hayes's leadership, Galveston failed to organize a local chapter of the state association.

In December 1903, members from Galveston and Houston met in the Bayou City and formed the Texas Woman Suffrage Association. They elected Annette Finnigan of Houston president and Mrs. C.H. Moore of Galveston vice-president. Efforts to organize chapters in other Texas cities failed, and only Houston, Galveston and La Porte sent delegates to the 1904 state convention in Houston. After the convention, interest in the association dwindled, and it never met again. Even with this setback, Texas, like the rest of the nation, entered a period of change that would make final victory possible. During this period, as one historian of the movement explained, "women's clubs proliferated, women college graduates were almost becoming accepted as normal, women factory workers increased enormously in number and were beginning to organize, and middle class women were finding that recent household inventions and changes in living patterns gave them more time for outside activities, while their training was making them dissatisfied with traditional middle class women's activities."

The highly visible economic successes of businessmen of Galveston did little to solve the basic problems of urban life that Galveston shared with other cities. These ills included primitive sanitation conditions, impure milk and food, underachieving schools, inadequate police and fire protection, substandard housing and moral decay. In Galveston, as elsewhere, the chief impetus behind efforts to solve these urban problems came from women. After more than a decade of struggles to gain the vote, many Galveston women believed that political power was the only way to achieve their goals. Soon after the 1900 storm, prominent Galveston women formed the Women's Health Protective Association (WHAP) to solve the sanitary problems caused by the storm. This organization helped to rebuild the city, and it taught the women of Galveston how to operate in a political environment.

The stunning successes of Galveston businessmen provided women with an effective model to achieve urban reforms: control city government. If achieving control of the political process helped Galveston businessmen rebuild their city, could WHAP reformers move into the political arena and reinvigorate Galveston women's interest in woman suffrage?

In Galveston, interest in woman suffrage revived in February 1912 when Anna M. Jones of Galveston, then living in New York, addressed about 150 women at the Hotel Galvez. Two days after this meeting, more than 200 women held an organizational meeting at the Hotel Galvez, founded the Galveston Equal Suffrage Association (GESA) and elected Mary F. Bornefeld their president. The Galveston organization immediately sought assistance from other suffrage groups around the country. Sally Trueheart Williams, who chaired the committee on constitution and bylaws, contacted a number of suffrage groups and inquired about constitutions, speakers and brochures on the movement.

The corresponding secretary of the National American Woman Suffrage Association (NAWSA), Mary Ware Dennett, sent Williams a leaflet that outlined a model constitution for a local suffrage association. Dennett noted, "We have heard a great many interesting reports of new life among the Texas suffragists lately. Galveston is to be congratulated upon the formation of a new suffrage organization." At the March meeting, the membership of the GESA accepted the constitution proposed by the constitution and bylaws committee and set the first Saturday of each month as their meeting date. These monthly meetings, held from October through June, often featured lecturers who elaborated on suffragist themes.

The association sought to instruct and inform both its own members and the general public on the issues important to the woman suffrage movement. It used a number of different tactics to educate the public. The women sponsored a booth at the annual Cotton Carnival, where suffragist literature "was widely scattered and all visitors were invited to enter their names in the suffrage register." The association subscribed to the *Woman's Journal*, the leading suffragist paper, and placed it in the reading room of the Rosenberg Library, the city's public library. Additionally, the local press published a series of suffragist articles, and GESA scheduled a series of public lectures on woman suffrage.

To draw further attention to its cause, and to raise money for educational activities, the GESA in March 1913 sponsored a three-part program at the Grand Opera House: "A Dream of Brave Women," "An Anti-Suffrage Monologue" and a *commedietta* entitled "Lady Geraldine's Speech." The *Galveston Daily News* reported a "packed house" and applauded the "capable efforts of Galveston women [in] making use of good-humored raillery" and offering "an appeal for the cause of women suffrage in the form of solid argument, sugar coated with laughter."

Galveston suffragists persuaded the *Galveston Tribune* to devote an entire section of its June 14, 1913 issue to the equal suffrage cause. Bold red ink

"Consistency, Thou Art A Jewel!"

THE law of Texas says a girl shall not give herself in honorable marriage without parents' consent, until 18 years of age. Well and good; it should be enforced. The same State, Texas, Art. 633 Penal Code, says a girl of 15 (a child) may, without parents' consent, give herself in adultery to a dishonorable man and ruin her whole life, that of her mother, and perhaps the life of an innocent, illegitimate child. Is it safe to trust our girls to man-made laws? The reasons why women should vote are legion, but this one alone should arouse every respectable woman to see the necessity of woman's vote. The legislature has been appealed to, in vain, to raise the age of consent. Shame to the manhood of Texas!

A SUFFRAGETTE

An example of Galveston suffragette literature. *Courtesy of Special Collections, Rosenberg Library, Galveston, Texas.*

across the front page proclaimed the "Equal Suffrage Edition." The section covered local suffrage work and noted that the Galveston association had lobbied for the women's property rights bill and the bill that would submit the suffrage question to a vote in Texas and had sent letters to every member of the state legislature and asked them to support these measures. Most importantly, the editorial called for all men to "contribute to progress by giving the ballot to women, not because of economic expediency, but because she is a human being and has earned, through patient service, a recognition, at last…in the art and government of life."

The local membership committee was equally active. It distributed pamphlets at all open meetings of the GESA and passed out its literature to any club that would take it. Between acts, members even handed out brochures at the opera house. The committee proudly pointed out that between March 1912 and June 1913, membership more than doubled.

Galveston women also participated in the statewide and national suffrage movements. In April 1913, Texas witnessed the first state convention by suffragists since 1904. Galveston was one of the seven Texas cities to send a delegation to the convention in San Antonio. At the 1914 state convention of the Texas Equal Suffrage Association, held in Dallas, the Texas suffragists elected Mary Bornefeld, of Galveston, its first vice-president. At this meeting, the association decided to intensify its educational campaign and "make a trial of strength of the movement in 1916." They asked Perle Penfield to serve as the state field secretary and coordinate much of the organization that would be necessary for a statewide effort in 1916.

As a reaction to the state suffrage convention, the *Houston Chronicle* on July 5, 1914, carried an entire page on the woman suffrage movement in Texas. Headlined "Leading Texas Women Work for Ballot," the *Chronicle* reported the views of many prominent Galveston suffragists, including Mary Bornefeld, Minnie Fisher Cunningham, Emma Harris and Sally Trueheart Williams. The *Chronicle* praised the strategy employed by the Texas suffragists and singled out the clever use of education rather than militancy as a winning combination. The paper noted, "If there is any smashing done it will be confined to the arguments of the opposition."

During the first months of 1915, the Galveston suffrage leaders decided to take their campaign to the streets. They invited Helen Todd, a noted suffragist from California, to the island city. She spoke to a crowd of about three hundred men and fifty women from the back of an automobile parked near a busy downtown intersection. Mayor Fisher, who "advocated the cause she represents," introduced Todd. Also, Minnie Fisher Cunningham

Minnie Fisher Cunningham was a tireless advocate of woman suffrage in Galveston. *Courtesy of Special Collections, Rosenberg Library, Galveston, Texas.*

journeyed to Palestine, Texas, where she encouraged women to organize an equal suffrage group in that city. From January to March, Cunningham, Emma Harris and Mrs. J.H.W. Steele of Galveston unsuccessfully lobbied in Austin for the passage of a resolution to submit the suffrage amendment to the electors.

This untiring devotion by the women of Galveston found its just reward. Galveston hosted the 1915 annual meeting of the Texas Equal Suffrage Association. The membership elected Minnie Fisher Cunningham the new state president. She held this post for the remainder of the suffrage campaign.

Later that year, Emma Harris represented Galveston women at the Forty-fifth Annual Convention of the National American Woman Suffrage Association. Her report of the meeting suggested that Texas suffragists had a long way to go before they could match the organizing skill and the large-scale support given to their northern counterparts. Harris was impressed by the women she met and also "learned a lot about finance, and when they asked me of our budget I felt much chagrined at knowing nothing on the subject, I learned afterward from Miss Murphy we had none."

The most talented lecturer in the movement and president of the National American Woman Suffrage Association was Dr. Anna Howard Shaw. In May 1912, she spoke before a meeting of the GESA and discussed many of the leading arguments for woman suffrage. In her talk, Dr. Shaw dismissed all objections to the suffrage movement as "illogical, sentimental, half-witted, and silly." Shaw believed that the early years of the twentieth century had changed the traditional labor market. Men now earned wages for work that traditionally belonged to women, such as sewing, laundering and food preparation. She commented on the growing tendency of women to go out

into the world and perform men's work. According to Shaw, women now sought employment in factories and mills in the same type of activities that they once performed at home. She argued, "It is not women who have taken up the work of men but the men who have taken up women's work and so forced them out into the world. The great modern factories are doing work which was once done by housewives, and so leave the women without the work which once belonged to them."

Galveston ladies also provided reasons for granting women the vote. In 1912, Sally Trueheart Williams called for women to follow "their housekeeping to the place where it is now being done, the polls." Rebecca Brown tried to link the rights of property ownership rather than the rights of the individual to the right to vote. She used the race issue to try to persuade southern white males to allow property-owning women to vote. In doing so, she recognized that the recent attempts by southern states to maintain white supremacy with constitutional amendments limiting the right to vote by property qualifications suggested "strongly that every property holder should have a vote."

Margaret Watson, in an article headlined, "Foreigners Vote, but Women Denied: Lower Classes of Ignorant Europeans Welcomed to the Ballot," substituted nativism for the old natural right argument for suffrage. Watson expressed the frustration of some native-born suffragists in a city that served as the port of entry to thousands of immigrants. She stated, "Too many who take out their 'papers' here are only weights to counterbalance the intelligent vote of Galveston." These southern women seethed when they saw former slaves vote. They joined their northern sisters' humiliation at having to obey laws made by what they considered "lower classes of ignorant Europeans."

During 1912 and 1913, Perle Penfield wrote articles for the Galveston newspapers. In one article, she implored women to support equal suffrage so they could wield political influence in such urban reforms as street paving, housing ordinances, inspection of foods, garbage disposal and public education. She noted, "Galveston abounds in crowded alleys, where houses lack all the conveniences of a civilized city. One lot has two and even three or four houses crowded upon it, all occupied. The control of such conditions is quite as much a part of politics as the early closing of saloons." This argument represented a shift from earlier emphasis on the gains women could obtain from the vote or what benefits they could receive from the government. Women now recognized that many reform measures of the Progressive Era failed because women could not vote. For Penfield and others, universal suffrage was a vehicle to reform rather than an end in itself.

A number of highly respected Galveston men supported woman suffrage and joined GESA. Although women dominated the organization, they made sure that male members of the GESA maintained a high profile. This was an effort to show the men of Galveston that woman suffrage was not solely a women's issue. Seven prominent Galveston men became charter members of the GESA: Judge Robert Street; Rabbi Henry Cohen; Charles Fowler, a banker and member of the Deep Water Committee; Lieutenant Kenneth Harmon, an army officer at nearby Fort Crockett; John W. Hopkins, superintendent of Galveston public schools; and two men from active equal rights families, Edward Lasker and Henry M. Trueheart.

At the first open GESA meeting in 1912, more than one hundred women and men listened to Judge Robert Street talk on the "Legal Status of Women in Texas." Judge Street offered a simple solution to the problem of woman suffrage in Texas. "It's a simple matter," Street counseled. "Strike out the word 'male' in section 3, article 6 of the constitution of the state of Texas and women can vote, Nothing else is necessary." Apparently, Judge Street did not elaborate on how to convince male voters to approve this "simple matter" except to caution the women to be "conservative, yet persistent" in their methods to obtain the franchise.

An attorney, Edward F. Harris, argued that if the eighteenth-century premise of natural right based on the democratic ideal that all men are created equal was correct, then women, being equal to men, had the same inalienable right to political liberty. The *Galveston Tribune* concluded that Harris "argued for the cause on the ground of democracy, convincing his hearers that for this reason alone women should be entitled to a voice in the making and enforcing of laws which concern the whole people."

Rabbi Henry Cohen suggested that recent labor-saving devices in the home allowed middle-class housewives new leisure time. He hoped that women would use this time to become involved in the world outside the home. While not challenging woman's place in the home, Cohen observed, "Woman has her own sphere—this sphere can be broadened, inasmuch as by the invention of domestic labor saving devices, she has more time upon her hands now than formerly; moreover, without loss but with actual profit to herself, she can forego some of her trivial pastimes." These views echoed a popular belief expressed by many men who felt that the suffrage movement was good for women because it would make them better persons.

The gubernatorial campaign of 1918 showed that the women's vote was a useful tool for moral reform. When former governor James E. "Pa" Ferguson announced his candidacy, most Progressives in Texas believed

that he would win the nomination unless the composition of the electorate dramatically altered. At this moment, woman suffrage advocates in Texas played their trump card. Allow women to vote in the primary, and they would vote for the incumbent reform governor, William P. Hobby. Deny them the vote, and the reactionary "Pa" Ferguson would win the primary, control the Governor's Mansion and dismantle all Progressive reforms in Texas. This "win-win" situation convinced the Progressive reformers in the state legislature to pass an amendment to the primary law that allowed women to vote in primary contests in Texas. These new female allies did not disappoint the Hobby Democrats. William Hobby served another term as the chief executive of the Lone Star State.

Even before the vote for female suffrage in primary elections became law, members of the Galveston County Hobby Campaign Committee asked Minnie Fisher Cunningham to join the team. Cunningham used her position as the leader of the woman suffrage movement in Texas to prove that women voters could be a powerful influence in Texas politics. She believed that the impeached former governor's quest for reelection was illegal. She also charged that the "liquor ring" controlled the Ferguson campaign. With their usual flair for organization, the Texas women vigorously campaigned for Hobby and contributed to his overwhelming primary victory.

Governor Hobby, in 1919, endorsed state constitutional amendments to prohibit the consumption of alcohol and grant women the vote. The legislature set May 24 as election day. The GESA members focused all their efforts on the suffrage amendment. However, those opposed to woman suffrage were also very active. On May 21, Corrine Rowe, an anti-suffrage lecturer from Washington, D.C., spoke in Galveston against woman suffrage. Rowe labeled suffrage as "a menace to the fundamental institution of the home and an entering wedge for socialism." Her visit was part of a statewide campaign by the Women's National Anti-Suffrage Association to link the suffragists to miscegenation and Bolshevism and to depict woman suffrage as a threat to the institution of marriage. These anti-suffrage arguments carried the day.

Statewide prohibition passed, but suffrage failed by only 25,120 votes out of a total vote cast of 308,666. In spite of GESA's hard work, the men of Galveston rejected woman suffrage by a margin of almost two to one. The vote was 1,578 for and 2,984 against. This humiliating defeat suffered by the Galveston suffragists was partially mitigated eleven days later when the United States Congress passed a national suffrage amendment. The Texas suffragists pressed the state legislature for speedy ratification of the Nineteenth Amendment to the United States Constitution. The Texas House ratified the national amendment

on June 23, and the Senate followed suit on the 28. Texas became the first state in the South to ratify the controversial amendment.

The Galveston suffragists should have easily convinced the men of Galveston to vote for woman suffrage. By using skills they developed during the reform battles of the Women's Health Protection Association, these ladies secured the endorsements of the business elite, the city fathers, the local newspapers and organized labor. Yet the lopsided vote of May 24 suggested that they failed to sway the men of Galveston. Suffragists believed that linking women's vote with a clause disenfranchising resident aliens on the same ballot doomed suffrage to defeat. However, a number of other factors combined to defeat woman suffrage in Galveston.

An important ingredient missing from the suffrage campaign was a sense of crisis. Following the 1900 storm, many Galvestonians believed that they might have to abandon their beloved city. Local leaders generated broad-based community support for a program that promised security and economic prosperity for the city. Even the WHPA achieved some modest successes when it linked illness and death, particularly among children, to poor sanitation. The suffragists did not create an equivalent feeling of urgency or reward.

Universal suffrage was also a victim of white racism. Galveston men, with memories of the "Lost Cause," did not forget the old suffragist-abolitionist alliance. The suffragists' refusal to include black women in the cause failed to erase those memories. It did guarantee that black women would find little reason to support the suffrage cause. Galveston physician Dr. George M. Lee voiced many whites' concern over the "Negro Question" when he observed that women's place was in the home, existing "on a high plane of gentle refinement," not in the voting booth. Give women the vote and you would open the door to "the ignorant masses of women, that is in certain parts of the South—the Negro woman, [who] would by their votes bring about results probably overwhelmingly disastrous."

The June 6, 1919 editorial of the *Galveston Daily News* considered racism a major reason why the national movement still faced a struggle to gain ratification by three-quarters of the states. In part, the article noted:

It is equally evident that the chief reason of opposition in the Southern states is of a kind which will not be easily overcome, The South, or at least most of the states in the South, see in the presence of a large number of Negroes a fact which vitally modifies the issue as it is presented to them. This is not to imply that the chief reason of the South's opposition is a valid one, for we believe the danger which looms so large and realistic to

their imagination is largely spectral. Specter or fact, these concerns had an adverse effect on the suffrage movement.

The urban reforms advocated by the Galveston suffragists did not appeal to the lower classes of working people. Long workdays and low wages left little time for any concern other than their immediate economic survival. The suffragists tried to win the endorsement of organized labor. The reformers argued that women should receive equal pay for equal work and that workingwomen needed the vote to protect their special interests. The suffragists also contended that disfranchisement had undermined female workers' power to bargain and that women's lack of the vote had lowered men's wages and weakened organized labor.

Endeavors to link woman suffrage to social reforms may have also contributed to the defeat. The suffragists' close identification with prohibition alarmed a large portion of the male electorate. Judging by the vote in Galveston, the "wets" saw the suffragists as "bone-dry" prohibitionists and used the election as an opportunity to defeat both amendments by almost equal margins.

Finally, the submission in 1919 of a state constitutional amendment granting universal suffrage by Governor Hobby was not attractive to Texas suffragists. Their leaders had decided that it was unlikely that the men of Texas, especially German and Mexican voters, would pass a suffrage amendment. Under those circumstances, the work and money involved in a statewide campaign would only weaken their efforts to pass an amendment to the national constitution. With Washington as the focus of attention for the movement, it was unlikely that the Galveston women could command the resources necessary for a maximum effort.

The Galveston suffragists, like their counterparts elsewhere, gained little from their efforts except the right to vote. Even though Galveston was the epicenter of the woman suffrage movement in Texas, the return to what President Warren G. Harding called "normalcy" in 1921 ended immediate prospects for expanding women's rights. The Galveston women won the suffrage battle without convincing a majority of the city's male citizens that woman suffrage was a cause worthy of their support. And it would take the support of those men to achieve other urban reforms envisioned by the suffragists when they obtained "a municipal broom," the right to vote. While the city embraced some urban reforms, particularly sanitary reforms advocated by the WHPA, Galveston retained its reputation as a wide-open seaport until the mid-1950s, when the Texas Rangers closed down the most flagrant examples of vice.

Boyer Gonzales

Galveston's Greatest Artist

Edward Simmen

On February 14, 1934, Galveston's greatest artist, Boyer Gonzales, a critically acclaimed marine and landscape painter, died while attending Mardi Gras. He was sixty-nine years old. His works, both in oil and watercolors, graced the walls of some of the world's greatest museums. And the awards and memberships in prestigious art organizations filled many pages. Even so, whenever anyone discussed Boyer Gonzales's life and work, they always forgot one important fact. Boyer Gonzales was not only the first Texan of Mexican descent to receive critical acclaim as an artist. He was also the first American with Mexican ancestors to gain national recognition as a premier artist.

However, aside from his tremendous successes later in life, as a typically successful artist, Boyer Gonzales was most atypical. Gonzales did not decide to dedicate his life to his art until he was in his mid-forties. Before that, art for Gonzales was an avocation, a hobby and a pleasant pastime. Gonzales always knew that he wanted to be an artist, and everyone recognized his talent. But circumstances prevented Gonzales from devoting himself to his art until he was older.

Even as a child, Gonzales displayed artistic talents. He always sketched and painted. And there were the summers, beginning in 1886, when he traveled to Maine and met one of America's most highly regarded painters, Winslow Homer. Winslow's brother was a businessman in Galveston and a friend of Boyer's father and mother. After that first meeting in Maine, whenever Gonzales traveled east on vacations, he always visited Homer in his Prouts

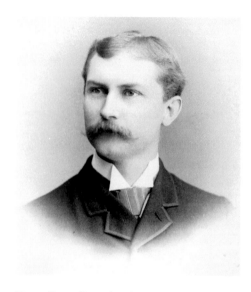

Young Boyer Gonzales. *Courtesy of Special Collections, Rosenberg Library, Galveston, Texas.*

Neck studio. There the aspiring artist listened to the master explain how he had created some of his prize-winning works. And wherever Gonzales visited, the two artists painted together. Of course, there is an obvious Homeric influence on Gonzales. This influence carried over into his maturity, long after the two men stopped seeing each other. However, there is no evidence that Homer took on the young man as a student. Whatever help Homer may have given the young artist, it was certainly welcomed but quite informal.

Why did Boyer Gonzales wait until so late in life to pursue his passion? To answer this question, it is necessary to understand Gonzales, his youth, his family and, in particular, his father, Thomas Gonzales. Boyer Gonzales, the fourth of five children, was born in Houston on September 22, 1864, just before the Civil War ended. Soon after his birth, however, the family returned to Galveston, where his father began to build one of the South's most successful cotton brokerage firms.

Each summer, Boyer would sail from Galveston to Boston to visit his sister. While home, Boyer Gonzales loved to travel down the island and hunt. He especially liked to hunt during November after a freezing, wet blue norther had stormed through the area. This change in weather would bring with it thousands of game birds migrating south from Canada. He always brought his sketchbook. On his return home, he would record the events of the day in his diary. It became a sort of confessional. From the time he was in his teens, he began to record not just his observations but his reflections as well. Boyer Gonzales was a pensive, thoughtful and solitary young man. He mostly enjoyed activities that he could do alone. He loved to sketch, paint, write in his diary or simply reflect on what he saw or heard or thought. While he had an imagination and wit that were boundless, he was not a very gregarious person. Nor did he show any indication of his father's and older brother's love of business. It soon became evident that Boyer Gonzales was caught between doing what he wanted to do and what others expected him to do. In

a word, he gravitated between attending to his familial duties and his own personal desires.

After the Civil War, Thomas returned to Galveston and reestablished his offices on the Strand. In 1875, he joined in a partnership with H.T. Sloan of Philadelphia and opened the Sloan and Gonzales cotton-factoring firm. Gonzales brought his eldest son, Edward, who shared many of the qualities of his dynamic father, including his business work ethic, into the firm.

Boyer's father, Thomas Gonzales. *Courtesy of Special Collections, Rosenberg Library, Galveston, Texas.*

Then, in 1880, he allowed his youngest son, Boyer, to work as a clerk for the firm.

The first conflict arose when Boyer was fifteen. That year, his father decided to introduce young Boyer to the world of business, just as his father had done to him and as he had done to Boyer's older brother, Edward. In the summer of 1880, Thomas hired Boyer as a clerk in the family's cotton brokerage firm. The adjustment for Boyer was difficult. Almost immediately, Boyer developed a strange, recurring respiratory ailment that plagued him for years. There were periods when he could not control his breathing. As he grew older, the attacks became more frequent and serious. One fact was clear: the attacks always occurred during times of great anxiety, stress and tension. To understand many of Boyer's problems, it is necessary to understand his father. The conflict within Boyer surfaced whenever the diametrically opposed personalities of the father and the son collided. If there were ever two personalities so uncommonly different, it was Thomas Gonzales and his son, Boyer.

The firm prospered. In 1888, Thomas opened the doors to Thomas Gonzales and Sons with his two sons, Edward and Boyer. Each year, the firm increased its business. In 1892, tragedy struck. Unexpectedly, Edward died suddenly at the age of thirty-four. With some hesitancy, Thomas turned to Boyer to run the business.

Until Edward's death, Boyer maintained a balance between his public and private lives. From the time he entered the firm, work came first. What time he had free, he gave to himself. His diary, which he began just before he turned nineteen, did not contain one entry that mentioned his work. Rather,

the entries celebrated the activities of a young man filled with curiosity. They painted a cheerful portrait of someone whose leisure hours revolved around his favorite pastimes: bird hunting and walking down the island. And wherever he went, he took his sketchbook and carefully drew what he saw.

That carefree life ended with Edward's death. Boyer now stood in his brother's shoes. His brother had scheduled an important business trip to England, the Netherlands, Germany and Switzerland. Now Boyer had to go. This added responsibility triggered the old respiratory ailment. In the past, rest and relaxation cured the attacks. Now there was no time for that. The hyperventilation became so intense, the heartburn so strong and headaches so severe that he (and his father) feared that he would not be able to function effectively.

As ill as he was, he sailed early in May from Galveston and arrived in New York, where he visited a doctor who suggested that Boyer visit Schwalbach, Germany, and register at one of the most fashionable health spas in Europe. After a month in Germany, Boyer left the spa and set off on a two-week grand tour that took him to Frankfurt, Leipzig, Vienna, Venice, Verona, Milan, the Italian Lakes, Zurich, Paris, London and finally Liverpool. Most importantly, he did something that he had not done since his arrival at Schwalbach: he once again turned to his sketchbook and therein recorded his pictorial observations of his trip. By the end of September, he returned to Galveston and his dreaded job.

The next year, he traveled to the 1892 Chicago Columbian Exposition. This trip did more to underline his desire to paint than anything else he had ever done. He spent most of his time at the exposition in the Palace of Fine Arts. It displayed the most recent works of the most famous artists in the United States. What thrilled him the most were fifteen works by Winslow Homer.

Once home, he wrote a lengthy and enthusiastic letter to Winslow Homer, telling him of his visit to Chicago. Homer's response was all the encouragement Boyer needed to continue his plans to paint. Homer mused, "Well, Old Gonzales is a brick and a poet. I think that with your nice observations of things & your power of description you could make a very profitable—and interesting to you as well as others—connection with some newspaper. After a short time be able to go anywhere with perfect independence with only a pen and brush for baggage." What thrilled him even more was Homer's invitation: "I have improved my place & have more room & and I am in what is known as a flourishing condition so if you should happen to be up here when I am home, I should be happy to see you again."

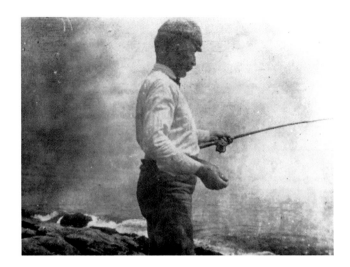

Boyer's mentor and confidant, Winslow Homer. *Courtesy of Special Collections, Rosenberg Library, Galveston, Texas.*

Boyer soon planned to study at an art colony in Annisquam, Massachusetts, with William Whittemore, a New York watercolorist with a growing reputation. However, during the months prior to leaving for Boston, Boyer began to experience a recurrence of his old malady. The indigestion became so acute that he often could not work. Tensions at the office had become unbearable.

As Boyer sailed out of Galveston Harbor, he turned to his diary and began to analyze his life and his trip. He asked, "What am I going for?" The answers began with his father. "First, Dad is arriving at an age when his business is getting to be a secondary consideration with him. He does not devote his old time [and] energy to it that he did in years gone. Then, too, the general demoralization of values has so disheartened him. My first object then is to get the reins stronger around the business." And although he did not enjoy admitting the inevitable, he did. "Probably, I will have to make many personal sacrifices, but if good results follow and I can get Dad in his old time mood or prevent trouble from settling on his shoulders, who is there to say that I will be amply repaid." Then he wrote, "My second objective will be to try to get rid of this d—m indigestion…or whatever the deuce it is that checks my natural general good naturedness." Finally, he turned briefly to himself, vowing to "try and learn more about watercolors."

And he did. He associated with and painted among other artists. Of the art colony, he wrote, "It is certainly a quaint place. A rocky shore and rugged country. Exceedingly picturesque. And I scarcely wonder that it is resorted to by so many artists…Everywhere there are plenty of artists at work, getting

together Winter material. The place is enveloped in an atmosphere of art and is very agreeable." Of his work, he noted, "I am doing wonderfully well with my sketches and see a great improvement in my work. Probably the greatest difficulty I have to overcome is timidity where color is concerned. 'Pitch right in. Slap it on.' Mr. Whittemore says, and I find where I observe his formula, my sketches are more successful."

However, when he returned to Galveston, his mother suffered her first stroke. Understandingly, Boyer's father could not take a greater interest in the business. He assigned more responsibilities and more work to his son while he sat and grieved beside his bedridden wife. On Christmas Day, Edith Gonzales suffered the final attack. She died at home on January 2.

Still, the business continued, more or less, as usual. This time, Boyer journeyed to Mexico with letters of introduction to clients in Monterrey, Mexico City and Puebla. He left Galveston two months after his mother's death, and he accomplished his business goals. More importantly, he took time to venture out of the cities and spend time in the countryside. And he captured several of those scenes in his sketchbooks, including Indian men in straw sombreros, dressed in white peasant clothes with bright red serapes draped over their shoulders. He sketched the simple Mexicans walking unhurriedly down dusty streets or standing in doorways of cantinas or huts or seated sleeping against adobe walls. Several of the works have backgrounds of mountains and cloudy blue skies with brilliant green banana and palm trees and other vegetation in the foreground. While he did not know it, Boyer Gonzales had become not just the first American of Mexican descent to capture rural Mexico in paintings; he was the first American artist to do so. He painted a Mexico that even the most well-known Mexican painters ignored.

Upon his return, he discovered that the family business was in financial trouble. His father had lost considerable amount of money gambling on cotton futures. With all the pressures, Thomas Gonzales could not hold on. His heart condition worsened, and his health declined. Boyer took his father to treatments at a series of spas in Tennessee and North Carolina. Then they visited a clinic in Philadelphia and on to Boston, where Thomas died in his daughter's home on December 1, 1896.

During the weeks following, the pressures of these added duties increased the tensions and the recurring respiratory problems. In June 1897, just six months after his father's death, Boyer checked into another fashionable health resort, this time at the sanitarium in Battle Creek, Michigan. He again wrote to Winslow Homer and asked if he could visit. Homer's answer was

positive and immediate. He confided, "I know several cures for indigestion & shall be very happy to see you." Once again, the visit was therapeutic. Homer had found a willing audience, and he enthusiastically talked about how he had painted some of his most famous works.

The year 1900 was the turning point in Boyer Gonzales's life. Mentally, he prepared himself for the change from businessman to artist. However, physically, he continued to suffer from his respiratory problems. He celebrated the arrival of the new century as though it were a new age for him. Early in the spring, he returned to Topo Chico, the spa in Mexico that he had visited five years earlier. More importantly, he returned to New England and spent the entire summer studying with a highly respected marine painter, Walter Lansil.

By early September, he was ready to return home when he learned of the devastation caused by the Hurricane of 1900. When he returned, he sold the remainder of the Gonzales family holdings. The change to Boyer Gonzales was obvious. Now he had time to work, and he began to produce and sell his works in galleries in Boston and Galveston. His breakthrough occurred at the 1904 St. Louis World's Fair. The State of Texas built an art

Boyer's wife and muse, Nell Hartford Gonzales. *Courtesy of Special Collections, Rosenberg Library, Galveston, Texas.*

gallery and asked Boyer to exhibit. This exhibition was the first time that Gonzales showed alongside other painters whom he knew and respected.

After the 1900 storm, Boyer began to court Nell Hereford, the sister of a good friend. They married in 1907. After the wedding, they attended a summer art colony in the village of Woodstock. At Woodstock, Gonzales's work improved dramatically, and he met several well-known artists of the time. And he worked, but there were many days when he and Nell would take long walks in the woods. Boyer was experiencing one of those "quiet times" that had eluded him for most of his life.

Boyer needed to return to Galveston in order to untangle his remaining business responsibilities. At home, they made plans to take the trip of their lives, a honeymoon tour of Europe, during which Boyer could settle in Florence and look for an artist who would help him develop his watercolor techniques. They left Galveston bound for Bremen in 1908. After spending time in Germany, they traveled to Switzerland before continuing on to the Italian lake district and then to Venice. They fell in love with the city and its canals, bridges and palaces. Boyer wrote, "For six days, we have been in dreamland. A dreamland of enchantment. Surely it is the Show City of the World. Each moment is more alluring than the last, and we think after all Aladdin must have rubbed his lamp and made a wish here."

They spent much of their time sightseeing, but Boyer did find time to work. He wrote to a friend, "I have painted several fine things and Nell thinks that as soon as they are shown in Boston, they will sell on sight. Let us hope she is correct." After ten days living under the Venetian spell, they traveled to Florence. Gonzales wasted no time finding a teacher. Nell wrote in her diary that they "went to see and decided to paint with Giuliani who is a finished artist in the Italian technique in water color. Besides learning a great deal from him, Bo has found him a mighty fine young fellow." They spent their spare time sightseeing and enjoying many of the city's museums. Next, they spent a few days in Paris, making the most of the Louvre. Finally, they visited London for three weeks and then sailed for Galveston. By the time they arrived home, Nell was five months' pregnant. Their son was born on February 11. "Our baby came today…a dear little boy." Exuberantly, he confessed, "I am having about every experience that comes to a man." Boyer Jr. was christened at Trinity Church.

During the spring, Boyer received word that he was one of sixty-seven artists invited to participate in an exhibit at the 1909 state fair of Texas. Organizers touted the exhibit as "the finest collection of art work ever seen in the Southwest." This was the first invitation Gonzales had received

Boyer and Nell Gonzales in 1927. *Courtesy of Special Collections, Rosenberg Library, Galveston, Texas.*

from the state fair organizers. From then on, the invitations came annually. After the fair, Gonzales's works began to attract critical attention. By 1911, galleries in Boston and New York showed his works to enthusiastic audiences. Then, early in 1911, the organizers of the Third Annual Cotton Carnival of Galveston asked Gonzales to direct an art exhibition as part of the celebration. With a little help from his Woodstock friends, Boyer put together a show that drew international attention. Not surprisingly, one of Boyer's works, *Sunrise Off Galveston Bar, A.D. 1521* was the hit of the show.

In May 1912, Boyer participated in the Third Annual Exhibition of Texas Artists sponsored by the Fort Worth Museum of Art. By this time, Gonzales's reputation as an artist had expanded beyond the regional Southwest. In May 1916, the Chicago Art Institute invited him to send works for its Twenty-

eighth Water Color Annual. That fall, he exhibited at the New York Water Color Club. The show included his work entitled *Snapper Fisherman*, which the art critic for the *New York Herald* singled out as "exceptional."

Now the invitations to exhibit arrived regularly. In 1917, he assembled one-man shows in Beaumont, San Antonio and Dallas. By 1918, recognition for his work had expanded dramatically. He received an invitation to become a member of the prestigious New York Water Color Club. It limited membership to seventy-seven. A year later, the prestigious Salmagundi Club of New York asked him to join its ranks. He agreed. A few months later, he became a member of the exclusive National Arts Club on Gramercy Park.

In March 1921, his paintings hung in exhibitions sponsored by the Salmagundi Club and the All Southern Show. A month later, he exhibited sixteen recent watercolors at the Tenth Annual Dallas Women's Forum, where he won his first gold medal for best landscape. Less than a year later, the Twenty-first Annual New Orleans Art Show praised his work *Above the Rapids* as "deserving special mention." In June 1922, he participated in the combined watercolor exhibition mounted jointly by the New York Water Color Club and the American Water Color Society. In October, he displayed twenty-three works at the Arts Club of Washington. Additional fame came when the *Christian Science Monitor* featured his painting *The Wings of Morning* in its newspaper.

Later in November 1922, Boyer Gonzales's career reached even greater heights. His first one-man show in New York City opened to rave reviews. Comparisons of his work to Winslow Homer soon became common. The critic for the *New York Tribune* commented:

> *Boyer Gonzales, a protégée and friend of Winslow Homer, who is exhibiting a series of water colors at the Brown Robertson Gallery, also is attracted by the sea as well as other subjects which were typical of the great American water colorist. But, his manner is his own. His impressions of the Indies are radiant with light and atmosphere, though there is nothing subtle or impressionistic in his method. He paints directly in washes of thin color giving stress to form and detail. The New England coastal environment induces him to use stronger color and he warms up these impressions with more enthusiasm. The bleak impression of winter, "The Two Crows" is one of the most successful in quality and perspective.*

His New York City one-man show was so successful with the public that it spent time at the Salmagundi Club before traveling to Detroit and

Philadelphia. This famous show ended in Dallas as one of the highlights of that year's state fair. Curiously, as his national status grew, he shed his regional origins. Art critics now hailed Boyer Gonzales as a "former Galvestonian." The front page of the *Dallas Morning News* on October 17, 1923, proclaimed, "TEXAS ART WINS ACCLAIM AT EXHIBIT / Landscapes and Marines of Boyer Gonzales Show Spirit of Sea." The critic commented, "The former Galvestonian is a protégée of the great New England artist, Winslow Homer…[but] While Mr. Gonzales has learned to love the sea and the small types of coastwise vessels, as much as Homer did, he quite escapes any imitation of that great artist. All of his work is strikingly individual."

In November 1924, Gonzales exhibited at the famed Corcoran Gallery of Art in Washington. Shows in New York, Chicago and Los Angeles, as well as in San Antonio and Dallas, now became commonplace. Art collectors worldwide sought Boyer Gonzales creations, and his works sold in the most highly respected galleries throughout the United States.

The invitations and critical praise continued unabated. In May 1929, the Fort Worth Museum of Art included Boyer's work in the Nineteenth Annual Exhibition of Selected Paintings by Texas Artists. The August 26 1929 issue of the *Christian Science Monitor* featured Gonzales's *Voice of the Rapids*, and in October, he once again displayed at the Forty-sixth Annual Exhibition at the State Fair of Texas. From December 1932 through January 1933, his work hung at the First Annual Exhibition of Water Colors, sponsored by the California Legion of Honor in San Francisco.

As the years passed, the Gonzaleses spent more and more time at their home in Woodstock. They wintered in San Antonio, where they lived at the Adolphus Hotel, and spent the month of December at the elegant National Arts

The elder Boyer Gonzales. *Courtesy of Special Collections, Rosenberg Library, Galveston, Texas.*

Club on Gramercy Park in New York City. It was, more or less, a bohemian life that moved with the seasons.

Over the years, the Gonzaleses traveled on various occasions to Florida, California and Colorado, and occasionally, they ventured into Mexico, but rarely did they travel farther south than Monterrey. Wherever they went, he was well received as one of America's finest artists. However, Gonzales never lost complete touch with Galveston. As his son later recalled, "Even though my father lived very little [in Galveston] during the last decade of his life, he refused to sell the house because it was the tie with his family and his anchor to windward, as it were."

Boyer and Nell always kept in close touch with their friends on the island, and they occasionally returned, as they did in February 1934 when they joined in the annual Mardi Gras festivities. But on Wednesday, February 14, Boyer Gonzales suffered a stroke and was immediately taken to John Sealy hospital. He died later that day. His obituary noted that his only survivors were his wife and son. The following day, he was buried at the Episcopal Cemetery on Broadway near his father, Thomas; his mother, Edith; and his brothers, Edward and Alcie.

The life of Boyer Gonzales had come full circle. The man who would later be remembered as "one of the few artists who have understood so intimately the moods of the sea and the ways of the seabirds" had finally returned to his island home in Galveston.

Chapter 13

"There's Sin in This Here City!"

Galveston and the Great Depression

Gary Cartwright

On October 23, 1929, while investors on the New York Stock Exchange were losing $50 million per minute and jumping from tall buildings, nothing extraordinary occurred in Galveston. What became known to the rest of the world as the Great Depression was scarcely more than a dip in the road to islanders. There were no food riots in Galveston and no massive demonstrations. Since there were hardly any factories to lay off workers, unemployment was something islanders had only read about. Port business was stable; throughout the Depression, Galveston remained one of the world's top exporters of cotton and grain. Military commands at Fort Crockett and the Coast Guard station at Bolivar Point got by with no reduction of manpower or payroll. The Works Progress Administration (WPA) set up a workshop at the old Alamo School on Broadway, but it closed for lack of attendance.

Not a single Galveston bank closed because of the Depression. Quite the contrary; because of the demand for cotton in Europe, millions of dollars from banks in Switzerland, Germany, England, France and other European countries traveled the Atlantic and found their way to the banks of Galveston. The Moodys' insurance company, American National, actually *grew* by 104.8 percent during the Depression. When times were the hardest, ANICO's assets nearly doubled: $6 million in 1930 ballooned to $11.5 million in 1935. When the economic relief arrived in 1940, the company's assets skyrocketed to $89 million.

There was one other reason, however, why the Great Depression went almost unnoticed in Galveston, and it was the biggest reason of all—the rackets. Gambling and prostitution had always thrived in Galveston, but the national crisis that really jump-started Galveston's economy and kept it at full throttle for years was prohibition. During its fifteen-year run, from 1919 to 1933, prohibition altered the city's power structure and changed its character. Galveston became the Chicago of the Southwest. After 1919, rumrunning became the new growth industry on the island. And did it grow! Galveston became a main supplier of bootleg liquor for Dallas, Houston, Denver, St. Louis, Omaha and other thirsty cities in the Southwest and Midwest. The gross income from illegal liquor rivaled the money that flowed into Galveston's economy from legal imports, with the important difference being that the city didn't share directly in rumrunner profits.

The death knell in 1933 of prohibition posed a serious economic dilemma for the island city. Legal booze meant lost income and fewer jobs. If Galveston didn't do something quickly, the Great Depression might actually come to the island, and nobody wanted that. Actually, the solution to this problem was already there—prostitution and gambling—but these old and reliable products needed a new and shiny cover. And Galveston had the men to do it.

Sam Maceo, like the pirate, Jean Lafitte, was the smooth and diplomatic brother. *Courtesy of Special Collections, Rosenberg Library, Galveston, Texas.*

The Maceo brothers, Sam and Rose, were born in Palermo, Sicily. They immigrated to Louisiana around the turn of the century and moved to Galveston in 1910. The Maceo brothers were barbers. Sam worked in the shop at the Galvez Hotel, and Rose operated a single barber chair in the corner of a seafood canteen at Murdoch's Pier. Once prohibition began, the brothers also sold illegal bottles of hooch on the side. Eventually, their small-time operation expanded, and they became, along with Dutch Voight and Ollie Quinn, Galveston's leading bootleggers.

Quinn and Voight liked the Maceo brothers. Rose was mean, tough and calculating, not unlike his counterpart a century before, Pierre Lafitte. Sam, like the pirate Jean Lafitte, was smooth and diplomatic. When Quinn and Dutch Voight opened the island's first big-time nightclub in 1926, they included the Maceos in the partnership. They built the Hollywood Dinner Club from the ground up, at Sixty-first and Avenue S. Instantly, it was the swankiest night spot on the Gulf Coast—Spanish architecture, crystal chandeliers, rattan furniture, a dance floor bigger than the ballroom at the Hotel Galvez and air conditioning! The Hollywood was the first air-conditioned nightclub in the country. Sam Maceo gave instructions that the temperature remain at sixty-nine degrees. He believed that drinkers who were cool didn't feel the booze, and drinkers who didn't feel the booze played lousy at the craps tables.

The casino had thirty craps tables in addition to roulette, blackjack and slot machines of all denominations. None of the gambling places downtown and along Seawall Boulevard went out of its way to hide what it was doing, but Sam Maceo was the consummate showman. He made certain that high rollers all over Texas heard about the Hollywood Dinner Club. A pair of searchlights out front made the place impossible to miss. For opening night, San booked Guy Lombardo and his Royal Canadians, one of the biggest names in the business. The club drew twenty thousand customers during Lombardo's three-week engagement. In the months that followed, Sam brought in only the biggest names— Ray Noble's band, with Glenn Miller playing first trombone; Sophie Tucker; Joe E. Lewis; and the Ritz Brothers. Rumba contests that offered first prizes of $1,000 lured some of the best dancers in the country. For a while, a young hoofer named Fred Astaire was the Hollywood Dinner Club's resident instructor.

The country's first remote radio broadcast also originated at the Hollywood. It featured Ben Bernie and All the Boys. Stations all over the Midwest picked it up. Phil Harris and a number of other stars gained national attention by way of the radio hookup. A young musician from Beaumont sat in one night when the regular trumpet player was drunk and landed regular work with the band. His name was Harry James.

The opening of the Hollywood was a landmark event not just in Texas but nationwide as well. Nobody had ever offered the public gambling, gourmet food and top-name entertainment all under one roof. (Remember, this was 1926, years before other mobsters imitated the Galveston model and built the Strip in Las Vegas.)

Dutch Voight, Ollie Quinn and the Maceo brothers in 1926 built the Hollywood Dinner Club at Sixty-first Street and Avenue S. It was the first air-conditioned nightclub in the United States. *Courtesy of Special Collections, Rosenberg Library, Galveston, Texas.*

The Grotto, renamed the Sui Jen and then the Balinese Room, replaced the Hollywood Dinner Club as the leading casino on Galveston Island. *Courtesy of Special Collections, Rosenberg Library, Galveston, Texas.*

Rose was the muscle and the brains of the family. He didn't speak much English, but everyone understood him clearly. Dutch Voight once knocked a revolver out of Rose's hand to keep him from gunning down a relative. Rose's first wife, along with her lover, was mysteriously murdered. Galveston police never solved the case. Rose's second wife was wise enough to remain faithful. Sam Maceo, on the other hand, was as smooth as velvet. Everyone liked Sam. He was gregarious and well mannered and wore suits custom-tailored in New York. He didn't gamble, seldom took a drink and knew how to cultivate celebrities and make them comfortable. There were two other brothers, Vincent and Frank, and a number of cousins and in-laws, but Rose and Sam were the unquestioned dons. They were the perfect complement: the enforcer and the diplomat.

The Maceos opened a second big-name dinner club and casino called the Grotto on a pier off Seawall Boulevard, at the foot of Twenty-first Street. The Grotto was damaged by a hurricane in 1932 and reopened later that year as the Sui Jen (pronounced "swee rin"), with a Chinese menu and a bandstand shaped like a pagoda. In 1942, the Maceos renovated the Sui

Jen and renamed it the Balinese Room. It replaced the Hollywood Dinner Club, the victim of axe-wielding Texas Rangers in the late 1930s, as the swankiest and most famous nightspot on the Texas coast. The decor was South Seas, with a lot of fishnets, clamshells and fabric-covered walls hand-painted to look like tropical beaches. The food was spectacular. Sam Maceo hired the top names in the entertainment business: Peggy Lee, Freddy Martin, Ray Noble, Shep Fields, Jimmy Dorsey, Phil Harris and more. The Balinese attracted exactly the sort of high rollers from the mainland whom Sam Maceo always wanted. Houston oilmen like Diamond Jim West, Glenn McCarthy and Jack Josey were regulars, and spectators became accustomed to watching big-stakes players win (or lose) a hundred grand with a single roll of the dice.

Strictly speaking, the Balinese was a private club. By the 1940s, most joints across the state used this designation to sidestep Texas liquor laws that prohibited the sale of mixed drinks. Membership in most clubs required a modest donation, or sometimes just a dropped name or a friendly smile. In the case of the Balinese Room, club privileges were part of the security system. The casino spread out along a two-hundred-foot pier at the end of Twenty-first Street, and it terminated in a T-head over the Gulf of Mexico.

The gambling took place inside the T-head. To get there from the street, a visitor had to negotiate a guard station and present his membership card. Next, he walked through a door and past the bar. They he passed another door, crossed the dining room and walked down a long hallway, past the kitchen, where a Chinese cook usually fished through a trapdoor in the floor. From there, the visitor went through the last in a series of six heavy glass doors and into the casino. The Maceos usually knew in advance when law officials planned a raid. Raids were few and far between, and even when there was a call for action, the Maceos knew about it hours in advance. When the flatfoots arrived, the guard up front sounded the alarm. At this signal, the slot machines folded into the walls, and the green felt-covered craps tables casually converted into backgammon and bridge tables. During one raid, the bandleader announced, "And now the Balinese Room takes great pride in presenting, in person the Texas Rangers!"—at which point the band struck up "The Eyes of Texas."

Rarely did any Galveston lawman get caught taking bribes, although it was inconceivable that an illegal multimillion-dollar business could have existed all those years without a system of payoffs. Some people believed that the Maceos ran some sort of hotline directly to the governor's office in Austin. In those days, the Texas Rangers were the governor's private police

force, and no Ranger captain would make a move on the Maceos without the governor's permission.

Different governors, of course, had different attitudes toward the "Free State of Galveston." In the mid-1930s, when James V. Allred was governor, the Texas Rangers wrecked and shut down both the Hollywood and the Turf Club. The Turf reopened, minus several hundred badly damaged slot machines. Ten years passed before the Rangers made another run on the Maceo syndicate, this time knocking off the Balinese Room, chopping up furniture and smashing slot machines with sledgehammers. The B-Room reopened a few weeks later with new equipment. The real target of these raids was the gambling paraphernalia. Lawmen could close down a gambling house with a temporary restraining order, but they couldn't keep it closed. On the other hand, the law permitted them to destroy gambling equipment on sight, without a hearing or court order or any other legal inconvenience. On the occasions when they were unleashed, the Rangers were extremely adept at converting slot machines into paperweights.

The downtown district, which had once been the exclusive province of Ollie J. Quinn, now became the exclusive realm of the Maceos. They allowed other gambling joints to operate as long as their owners understood that they existed at the pleasure of Papa Rose and Big Sam, as they came to be called. This live-and-let-live policy had served Ollie Quinn for years, and now it served the Maceos as well. The Maceos formed a new business called the Gulf Vending Company. It replaced the old Modern Vending outfit that Quinn had operated. Soon every barbershop, drugstore, washateria, café and bar in Galveston County rented slot machines, pinball machines and tip books from the Maceos' company. "They didn't ask if you wanted their slots," said Mike Gaido, whose family owned a seafood restaurant on Seawall Boulevard. "They just asked how many." But everyone made money. One café owner estimated that his six slots turned more profit than his food service. Otis Skains's little joint on Twenty-fourth Street, the Alamo, counted on $600 a week from its five machines.

The Turf Athletic Club, a three-story building on Twenty-third between Market and Post Office, served as the syndicate headquarters for the Maceo family. The ground floor housed the bookmaking parlor, where bettors could wager on baseball or buy a ticket on any horse in any race in the country. The club's public address system broadcast live race results. Security for the second floor consisted of a private elevator and a highly sophisticated electronic buzzer system. An elegant partition divided the floor into two sections: a bar and nightclub called the Studio Lounge. The Maceos

decorated the club in an Art Deco fashion, with murals, black lights and mirrors trimmed in zebra skin, and there was a second bar and restaurant called the Western Room. The top floor was actually an athletic club, with a boxing ring, weightlifting equipment, pool tables and a steam room.

In the months and years that followed, the Maceos expanded their empire until it included dozens of casinos, nightclubs and betting parlors, not only on the island but also in such small mainland towns as Texas City, Kemah, La Marque and Dickinson. Motorists driving south on the Galveston highway from Houston spoke of crossing the Maceo-Dickinson Line. With their unabashed attitude toward vice and corruption, the Maceos brought prominence, notoriety and an enduring nickname to the island. For the next three decades, Texans called it the "Free State of Galveston."

The Maceos changed the rules in Galveston. The underworld became the overworld. Illegal became legal, frowned upon became the norm and the underground economy rose to the surface. Professional criminals became respected businessmen—and friends (not to say patrons) of the police commissioner. In time, the island's elite grudgingly accepted the Maceos by conducting business with them and by patronizing their nightclubs and casinos.

Ike Kempner once rented the Hollywood Dinner Club for a debutante party. After a visit to the Turf Club, he wrote to his daughter, Cecile, who was living in New York: "Nowhere this side of Hollywood has there been more lavish or lurid decor. It is on the whole in good taste—but I imagine it would be rather trying to live with it night after night." The commission form of government was the perfect tool for organized crime. For $25,000, the Maceos could buy an entire slate of candidates. Nevertheless, Kempner blithely defended the system and didn't ask a lot of questions.

Papa Rose Maceo was a preferred customer at the Moodys' City National Bank. He borrowed up to $500,000 at a time. On his signature alone, Maceo could borrow $100,000 for a load of bootleg liquor. He usually repaid the money within two weeks, at 25 percent interest. Big Sam Maceo went to his broker's office every Monday morning and bought a $25,000 municipal bond. In those days, municipal bonds were a foolproof method of laundering money. The Moodys and the Maceos used the same lawyer, a master of the loophole named Louis J. Dibrell. When the city looked for investors to build its Pleasure Pier at the foot of Twenty-fifth Street, the Moodys and the Maceos came forward to do their civic duties. Sam Maceo headed every charity's fundraising list. He was one of the founders of the Galveston Beach Association and sponsored an annual Christmas party for underprivileged children.

Had they chosen to, the island's ruling families could have shut down the Maceos with a few phone calls. But they didn't. Maybe they didn't notice, or maybe they didn't care. An article in the *Chicago Journal* in 1930 suggested as much: "Galveston generally seems to be a community satisfied to live withdrawn in the smugness and fallacies of its self-appraisal and conceit." But there was something else about the Maceos, something near and dear to the hearts of Galveston's upper class. The brothers from Sicily had a primary instinct for laissez faire, and they always took care of business first. The Maceos had their own private police patrol, a group of hoods known as Rose's Night Riders. They protected slot machines and maintained law and order in the gambling joints. Crime rates remained low, at least statistically. There was no unemployment. And everyone made money. The banking and insurance businesses had never been better. The Moodys' hotels were full, even in the winter. Without the Maceos, it seemed, the island might have dried up and blown away.

Now that the Hollywood Dinner Club had broken the barrier, there were gambling joints on all four corners of the Sixty-first Street and Avenue S intersection. Supper clubs with names like the Roseland and the Kit-Kat Garden spread across town. Bathhouses and amusement piers ran for five miles along the sea wall. The chamber of commerce advertised the sea wall as "Galveston's counterpart to the famous Boardwalk of Atlantic City." Investors expanded Murdoch's Pier to three floors, which now included a gambling casino, a bathhouse and Gaidos restaurant. Across the Boulevard was the Crystal Palace, a multifaceted emporium that offered gambling, a dance pavilion, a restaurant, a bathhouse, a penny arcade and an indoor saltwater pool billed as the largest in the South. The Grotto, which later became the Sui Jen—and still later became the Balinese Room—extended out over the Gulf at the foot of Twenty-first Street. A block west of the Grotto, at the foot of Twenty-second, was a dance pavilion called the Garden of Tokio, where marathon dancers worked for cash prizes. On the Boulevard at Twenty-fifth, the city put up a sixty-foot-high sign spelling out, in three thousand electric light bulbs, "GALVESTON, THE TREASURE OF AMERICA."

The Galveston Beach Association hired a professional showman named Bill Roe to promote the island's wide-open image and manage its annual bathing girl revue. Under Roe's leadership, the beach area became a perpetual carnival, with a roller coaster, a Ferris wheel, the Kentucky Derby merry-go-round and a game of chance call Corno that paid out in hard cash. The bathing girl revue eventually became the International Pageant

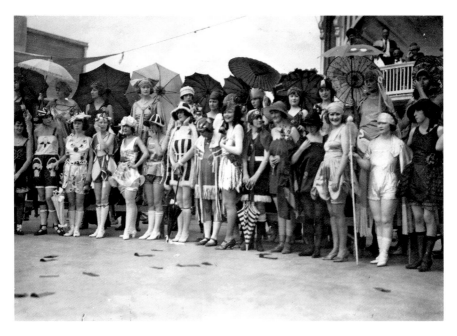

The 1922 participants in the Galveston beauty pageant. Galveston's annual bathing girl revue evolved into the International Pageant of Pulchritude. This competition eventually became the Miss Universe contest. *Courtesy of Special Collections, Rosenberg Library, Galveston, Texas.*

of Pulchritude. This, in turn, evolved into the Miss Universe contest. In 1929, contestants came from Russia, Romania, Turkey, France, Hungary, England, Austria, Luxembourg, Spain, Cuba and Brazil. Despite a protest from Bishop Christopher Byrne that the pageant was indecent, an audience of more than 150,000 cheered for its favorite contestant.

The death knell in 1933 to prohibition signaled a new golden age for another aspect of racketeering in the Free State of Galveston: prostitution. In the decades that followed, Post Office Street became synonymous with the red-light district. Every schoolboy in Texas knew intimate details about Post Office Street, or at least claimed he did. In the 1930s, every big city in Texas had prostitution, and some of it was fairly open. But only in Galveston did the district have identifiable, official boundaries and tacit police protection. The district started at Twenty-fifth Street and ran west along Post Office to Twenty-ninth. Over the years, generations of young men from the mainland crossed over the causeway, drove east along Broadway, turned left when they spotted the bronze statue of Lady Victory atop the Texas Heroes monument and headed toward their personal rendezvous with destiny.

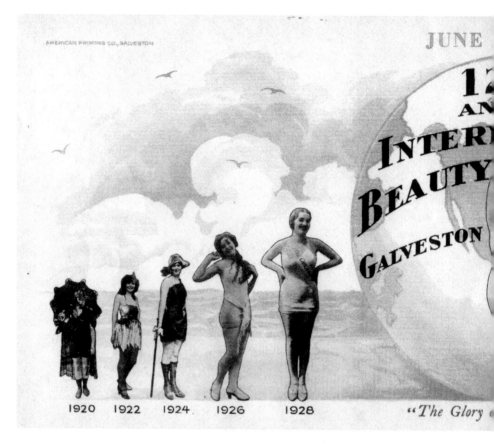

"The Glory of Beautiful Girlhood." Winners of earlier Galveston beauty pageants, including future Hollywood movie star and 1930 Miss Universe winner Dorothy Dell Goff. *Courtesy of Special Collections, Rosenberg Library, Galveston, Texas.*

In earlier times, this strip on Post Office had been a neighborhood of pricey two-story homes with narrow, ornamental front porches and carved railings. Over the years, the aristocracy moved farther west and south of Broadway and abandoned Post Office Street. These properties passed down from one generation to the next and finally collected into stacks of unliquidated estates owned by the widows of railroad executives, firemen and butchers. The managers were usually real estate agents or law firms. These professionals did not wish to maintain these homes. They only wanted to collect the highest possible rent. The fancy railings soon broke, and the salt air ate away most of the paint. Stately trees once lined the neighborhood. Now only a single tree—an ancient pecan on the north side of the street—remains in front of a two-story mansion that had faded to the color of dead grass.

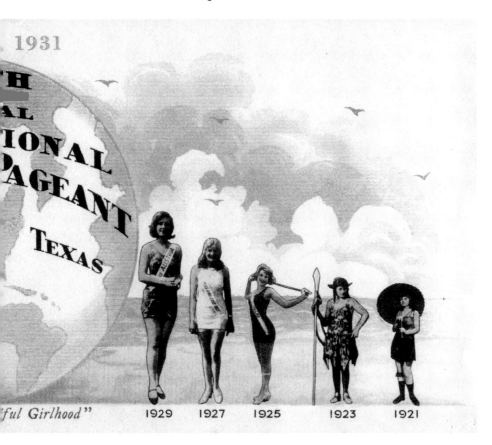

During daylight hours, Post Office Street remained deserted, except for an occasional delivery truck or a streetcar that didn't stop. But it came alive after dark. Prostitutes dressed for the evening appeared in lighted doorways or leaned against the sills of open windows, where they called to the passing parade of seamen, dockworkers, soldiers, medical students and conventioneers. Businessmen, trying to look nonchalant and appear as though they were just pricing the real estate, ducked behind latticework screens discreetly positioned in front of the houses. Some houses had steep flights of steps in various stages of disrepair and doors with tiny stained-glass windows and peepholes. Black maids answered the doors and led customers to shabby parlors. The madam permitted these potential clients to buy watered-down whiskey for themselves and colored water for the girls. They also urged these johns to feed quarters into the music box and take a turn around the dance floor before they took their newfound lady friends upstairs. If the guests behaved, they could hang around afterward to dance

and drink. Standard price in the late 1920s was three to five dollars for sailors. Interestingly enough, those prices prevailed into the 1950s.

Scattered among the houses were small cafés, barbershops and soft-drink stands. As a professional courtesy, there were no speakeasies or organized gambling in the district, although there was plenty of both a block away on Market Street. In the alleys between the numbered streets were tiny one-room shacks inhabited largely by blacks. On the opposite corner from a house patronized mostly by Mexicans was the power plant of the Galveston Electric Company. Across Twenty-ninth Street, at the edge of the railroad yards, stood a mysterious green-shaded two-story structure known as the "Brick House," owned by a madam and practitioner of the occult named Ardis. Several of the madams owned their houses and practiced their trade like hard-eyed capitalists. One madam left the district, purchased a medium-sized hotel for $50,000 and ran it as a respectable business. Another, who called herself Queen Laura, lived regally, with a coach and footman for business trips.

In 1929, there were fifty-five houses of prostitution in the district, with an average of six working women per house—this according to a University of Texas graduate student named Granville Price, who surveyed these women and wrote a remarkable thesis on the subject. Counting other prostitutes spread along the beach area, as well as in residential flats and down-the-island nightclubs, Price estimated a total of nearly 900 prostitutes for an island population of about 50,000—that's a ratio of 1:55. By way of comparison, London had a ratio of 1:960; Berlin, 1:580; Paris, 1:481; Chicago, 1:430; Tokyo, 1:250; and Shanghai, 1:130. For men seeking professional female companionship, Galveston was indeed "Hooker Heaven."

At one time, the city attempted to register and inspect the girls. This didn't last long. In 1921, this experiment into public health failed when the city discovered that the officer in charge accepted bribes from the women. After that, the city left it up to the individual houses to take precautions against disease. Apparently, the system worked well. Residents of the district looked after their own. Hookers who remained within the red-light district never worried about paying for protection. Considering the number of people who passed through, there were few muggings. An old-time newspaperman recalled that seamen would get off ships with $2,000 in their pockets, go down to the district and give their money to a madam for safekeeping. When they were ready to leave, the money was waiting. The madam might charge them fifty cents for a ten-cent beer, but she would never dream of robbing them. Apparently, the district also served as an outlet for sexual frustrations.

According to another former reporter, there was an eight-year stretch in which the city did not record a single rape.

The only law against prostitution that law officials enforced in the district was a city ordinance prohibiting miscegenation. Reports of sex between blacks and whites drove the cops crazy. When six white women opened a house in a black section of the district, police ran them out of town. Cops had no quarrel with perversion. A madam named Janet opened the district's only "French House," spreading the word that she would cater to the "pervert trade." Janet's was one of the most popular and highest-priced houses on the island. Business was so good that Janet treated her star hooker, Stella, to an all-expenses-paid trip to the 1929 World Series.

Another madam named Mary Russell recruited college girls from the mainland to work the summer vacation trade. Some fresh-faced coeds plied the oldest profession as a way to pay their fall tuition, and some, like the daughter of a prominent Houstonian, did it just for kicks. Mary Russell's house was a favorite hangout of some of Galveston's wealthiest citizens, including John Sealy Jr. Sealy, who never married, would rent the entire house and throw parties that lasted two or three days.

Most businessmen considered prostitution, like gambling and drinking, a natural part of island charm and culture. And everyone understood that as long as the Free State of Galveston existed, the poverty and suffering brought on by the Great Depression would never come ashore on the island. Islanders survived World War II without missing a beat. While German U-boats prowled the Gulf, new casinos and clubs opened on Seawall Boulevard. Old Italians sat around the Turf Club cursing the Immigration Service and playing the stock market, and the small garrison at Fort Crockett happily participated in the island's unique cultural activities. By the time the war started, the fort's coastal batteries were obsolete, but the army used the facilities for training and recreation and later as a camp for prisoners of war. There is a story, never confirmed, that German submariners landed on the beach one night, enjoyed an evening in Galveston's bars and cathouses and returned to their vessel undetected. Neither the Great Depression nor world war nor Hitler's vaulted Kriegsmarine could deter business as usual in the Free State of Galveston.

Author's note: This chapter is an adaptation of several chapters from Gary Cartwright's Galveston: A History of the Island *(New York: Atheneum, 1991).*

Chapter 14

Stalag Galveston

Arnold Krammer

Just a year and a half after the attack on Pearl Harbor that embroiled Americans in the world war, the Afrika Korps surrendered in the spring of 1943 and more than 150,000 German prisoners filled every available military transport arriving from the battlefields. After that, an average of 20,000 POWs arrived each month. By the end of the war, the United States found itself holding more than 425,000 prisoners of war: 372,000 Germans, 53,000 Italians and 5,000 Japanese. And some of them found their way to Galveston.

The first group of 165 German prisoners arrived at a temporary POW enclosure at Galveston's Fort Crockett—an army base that dated to the 1890s—from POW Camp Hearne on November 15, 1943. Betty L. Defferari, a lifelong Galveston resident, remembered the change:

> *In the fall of 1937 (when I was ten years of age), my family moved across the street from the Fort Crockett Army Base. There was no fence around the army base at that time. My sister, brothers and I would fly our kites on the Fort Crockett lawns, and we would go to the movies every week at the army theater.*
>
> *My brother had a bugle, and one evening, he went outside and played taps. We could see the lights going out at Fort Crockett. Then the lights started gradually coming back on. I'm sure the GIs realized something "fishy" as it was too early for "lights out."*
>
> *Every Friday afternoon, the army band would parade in front of a grandstand that was set up on the grounds. We would sit in the bleachers and watch the band perform.*

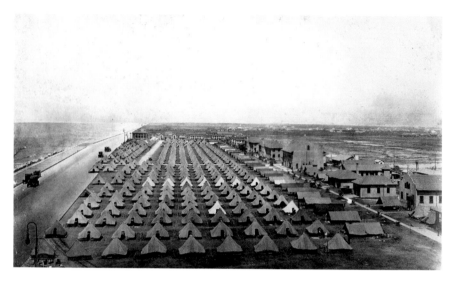

Early housing for German POWs in Galveston at Fort Crockett. Notice Seawall Boulevard and the Gulf of Mexico to the left. *Courtesy of Special Collections, Rosenberg Library, Galveston, Texas.*

However, all this changed when the German prisoners were incarcerated at Fort Crockett. The army erected a barbed wire fence…and anyone entering Fort Crockett had to pass through the Guard Gate on Forty-fifth Street and show proper identification—which we certainly did not have. Almost daily, from our backyard we could see some of the prisoners mowing grass or trimming hedges, etc.—always guarded by the army GIs.

The Afrika Korps had arrived.

The section of Fort Crockett allocated for the German prisoners was relatively small. It was built along the present boundaries of Avenue Q on the north, Seawall Boulevard on the South, Fifty-third Street on the east and Fifty-seventh Street on the west, an area about four blocks wide and eight blocks long. The compound fence went across Seawall Boulevard, across the beach and into the water. Galvestonians frequently watched the German prisoners cavorting in the surf. It's little wonder that people often referred to the German compound as the "Fritz Ritz."

Living conditions for the POWs were based on the rules set out in the Geneva Convention of 1929. It required that their living conditions and treatment be identical to those of American soldiers, including military salaries. In fact, even the menu was the same, including turkey for Thanksgiving and Christmas. Wood-frame buildings on concrete slabs (to

deter enthusiastic diggers) appeared in neat rows. Each barrack had black tarpaper walls, with cots and footlockers and a potbellied stove in the middle. In addition to the barracks, there was a mess hall, a workshop, a canteen, an office, a shower house and a recreation hall. A wide, flat area served as a combination inspection ground, processing center and soccer field. The POW camp looked like any hastily constructed army training center, except for the barbed wire and chain link fences everywhere and guard towers equipped with searchlights at opposite corners. The soldiers of the 347th Military Police Escort Guard provided security for the camp. Along several lengths of fencing, the camp administration adopted a so-called "Death Line" eight to ten feet inside the fence where sentries could shoot anyone who strayed too close to the main fence.

On February 1, 1944, the army designated this temporary section of Fort Crockett a permanent POW camp with the capacity for 750 prisoners, although the total count never exceeded 650. A typical monthly camp report to the army's Provost Marshal General's Office in Washington listed 5 noncommissioned officers and 624 privates—all described as "mild Nazis." Regardless of the appearance of a normal military camp, the residents were tough NCOs and enlisted men who had fought in Africa, Sicily and Russia.

The arriving German prisoners were cautious at first, finding their treatment and especially the availability of food beyond their highest hopes. Most were young men who had grown up on a steady diet of Nazi government propaganda. And all were captured in battle. They were much relieved to find that they were safe in enemy hands. Moreover, the army turned over control inside the POW camp to the German officers in order to free as many American soldiers as possible for overseas service. The German enlisted men snapped to attention when their officers crossed their path. Across America, discipline at the more than six hundred German POW camps was firm although not always under American control.

Periodic visits by Swiss delegates acting as representatives for German interests reported that discipline was fair and firm. The American authorities occasionally sent prisoners to the guardhouse for refusing to obey orders, avoiding work details or "laxness" during the morning flag-raising and playing of the national anthem. Near the end of the war, with emotion running high, there were several incidents when a dozen die-hard Nazis intimidated or beat vocal anti-Nazis who displayed too much enthusiasm for an Allied victory.

The War Department in Washington, D.C., decided to ease the American labor shortage by putting the prisoners of war to work. Not only would it help

American farmers and small businessmen, but heavy work would also keep the prisoners too preoccupied and fatigued to escape. Officers did not have to work and seldom volunteered. Guards accompanied the POWs, although they only straightened up and shouldered their rifles when giggling young girls waved from passing pickup trucks. Theoretically, the prisoners were forbidden to approach within fifteen feet of the guards, but these rules were seldom followed. Former guards and former prisoners recall many warm friendships.

Groups of German prisoners could be seen working all over the island. Some worked at the cotton shed or at the Southern Select Brewery. Others helped to upgrade the West End storm sewer system and repair the city streets. A larger number worked around Fort Crockett, in the refrigeration rooms, bakery, canteen, laundry, warehouse, garage repair shop and landscaping shed. They were waiters in the officers' mess and bartenders in the enlisted men's club, much to the anger of American combat veterans fresh from the front. But most Germans worked at the Galveston Army Air Force Base two miles away, where they worked in the kitchens, performed routine maintenance and poured most of the concrete for the streets and airfield. It is still in excellent condition today.

All POWs were issued blue work uniforms with the letters "P" stenciled in bright white paint across the front and back—as identification and, if necessary, as a target. On Sundays and holidays, most proudly wore their Afrika Korps desert shorts until they were in shreds. The prisoners earned eighty cents per day—a paltry sum by today's standards, but in 1943, when beer cost ten cents a bottle and cigarettes were five cents a pack, a day's wages of eighty cents went a long way. They received canteen coupons to prevent POWs from pooling their money to bribe a guard or buy a bus ticket to escape. They spent these coupons at the PX and used them to buy beer, Coca-Cola or other luxuries. The POWs could place any unspent money in a saving account. Many POWs returned to Europe at the end of the war with several hundred dollars in their pockets.

Fort Crockett, like most POW camps, provided a well-stocked game room with a variety of phonograph records; table tennis; multiple copies of such magazines as *Time*, *Newsweek*, *Life*, *Reader's Digest*, *Field and Stream*, *Better Homes and Gardens*; the *New York Times*; and one motion picture per week, usually a hokey western. The camp even sported a talented twelve-man camp orchestra and a thirty-man theatrical group that performed plays, vaudeville slapstick and naughty skits with the hairy-legged prisoners playing the women.

Elected by the prisoners, the "Spokesman" acted as a conduit between the American camp administration and the 650 German prisoners. It was

a delicate job; he had to be seen as cooperative by the Americans but as a good German by his comrades. The Spokesman at Crockett was Feldwebel (sergeant) Franz Raba. His task was to convey the Americans' orders or concerns to the prisoners and diplomatically reiterate the prisoners' anger or frustration to their captors. Apparently, Franz displeased one side or the other because he was soon voted out of office and replaced by Feldwebel Martin Wagner.

Both Catholic and Lutheran services were available in the guardhouse every Sunday afternoon. Under the auspices of the aptly named Chaplain Love, these services met irregularly because of the indifference of the prisoners. Even Jewish services were offered, presumably for the American personnel.

Meanwhile, Washington decided that too much leisure time would spell trouble among the prisoners, so it launched an education program in every camp. Teachers were hard to find, since most of the prisoners at Crockett had never finished grade school. A few high school graduates and musicians among the prisoners volunteered to organize classes, and the men met in small groups to learn English, agronomy, chemistry, math, physics and beginner violin lessons. Under the direction of German feldwebel Ludwig Ruf, an ordained priest and one of the few educated prisoners, the student-prisoners took notes, studied for exams and received diplomas, which were actually honored by the German government when the men returned home. Six prisoners received permission to take correspondence courses from the University of Texas in Austin. They are doubtless among the very few former POW ex-Texans who are flashing class rings with a Longhorn logo in Germany today.

The prisoners could study at the compound library. It began with thirty German-language novels and twenty-five instruction books donated by the German Red Cross. By April 1945, the library had grown to 740 books, most in constant use, more than half having been provided by the YMCA. By the end of the war, the POW library was large enough to do justice to a small American high school.

As if the prisoners didn't have enough to occupy them, the Germans at Camp Crockett formed an orchestra of twelve talented musicians with a selection of mandolins, saxophones, clarinets, trumpets, trombones, drums and a glockenspiel, all paid for by the American commanding officer. By all accounts, their many concerts and accompaniment of theater performances were quite professional.

Sunday was sports day. Fort Crockett contained two large fields for soccer, gymnastics, boxing, handball and the German game of fistball, but

soccer was *the* game. Teams moved up the championship lists, and many Galvestonians watched the important games. Local girls, starved for the company of young men who were overseas fighting, gathered at the fence line on Sunday afternoons to drool over the tanned, blond, shirtless Germans but were shoo-ed away by the American guards. On rainy days, the German prisoners crowded indoors to read, write letters home and play table tennis.

The POW camp also contained a large craft room where the handy could use tools and scrap wood to make handicrafts and trinkets for sale to the guards or as gifts to local farmers. The men made everything imaginable, from complex wooden trains to decorated jewelry boxes, cigarette boxes and framed drawings. Fort Crockett's POWs enjoyed a recreation unique to their camp: swimming and frolicking in the Gulf of Mexico on especially hot Texas afternoons, while ninety thousand American captives in Germany barely survived on poor treatment and occasional Red Cross parcels.

Despite all the distractions, movies, concerts, religious services, classes, library books, handicrafts and afternoon ocean dips, some prisoners remained unhappy. Although the Americans classified the prison as a "mild Nazi" camp, some Germans delighted in showing off their precision marching and their Prussian cadence, and gangs of hardcore Nazis roamed the barracks terrorizing "defeatists," "anti-Nazis" and "communists." In this way, Camp Crockett was no different from any of the other 650 POW camps in the United States: political thugs were always listening. If a prisoner joked about Hitler or predicted a bad end to the war, the word made its way across the small camp in record time. Sometimes the Nazi element would organize a work strike, claiming that their work violated some clause or other of the Geneva Convention. Punishment usually began when the Nazis held secret "kangaroo courts" at the back of the barracks or at the latrine where they decided what to do about a suspect prisoner. Sometimes the prisoner was exiled from the Germanic "Ring of Friendship"—in other words, he received the silent treatment from everyone for the duration of the war. In some cases, a prisoner received the "Holy Ghost" treatment, when several prisoners would pull a pillowcase over a sleeping suspect and beat him senseless.

At Camp Crockett, there was plenty of evidence that the Nazis were present. When the army's Special Projects Division created a "U.S. friendly" POW newspaper, copies of each issue of *Der Ruf* (*The Call*) were destroyed by a handful of Nazis. Most prisoners never saw a copy of *Der Ruf*. An army investigation stated the obvious when it concluded, "The camp officials are of the opinion that <u>Der Ruf</u> will be purchased and read by the prisoners of

war once sufficient evidence has been obtained to uncover and segregate the Nazi clique suspected of preventing circulation of the paper." Eventually, the Americans caught ten diehard Nazis burning copies of *Der Ruf* to prevent the other prisoners from reading them. They were shipped to POW Camp Alva, Oklahoma, a holding camp for Nazi POWs, where they spent the final months of the war clicking their heels with 3,500 fellow Nazis.

Only once did the prisoners attempt a full-scale riot. It didn't happen in Camp Crockett proper, but rather at nearby Branch Camp Wallace, near Hitchcock, about twenty miles northwest of Galveston. On January 3, 1945, about twenty POWs created a distraction while others attacked and beat a number of their fellow prisoners. Arrested and charged with rioting and assault, eighteen faced trial in March 1945 at Fort Crockett. Four were acquitted, but fourteen were sentenced to eight to fourteen years at hard labor in Leavenworth. In a separate incident, four prisoners were tried on March 7, 1945, for administering a Holy Ghost beating to five POWs.

Throughout the war, there were only three attempts to escape from Crockett, a small number compared to the dozens who tried to escape from larger camps. It should be noted, however, that there were numerous cases at every camp when a prisoner slipped away from a worksite but returned to the camp voluntarily when he got hungry or was marched back by a vigilant band of Boy Scouts on an overnight hike. Many times, the recaptured prisoners surprised the guards, who hadn't even noticed their absence.

The first of the three escape attempts at Crockett occurred when three German POWs smooth-talked a local woman who worked in the post laundry into letting them slip out the gate with her. Whether her motive was political or glandular, the woman later had second thoughts. Maybe the real possibility that, if caught, she could spend the next twenty years in a federal prison helped her to convince them to return voluntarily. Another escape attempt was more violent. Three POWs on a ground-cleaning detail beat a guard and clambered over the fence in what is now a fashionable section of Galveston. The violence of their escape attempt brought out the army and every law officer on the island. Eventually, authorities found the Germans huddled on the municipal golf course.

A third incident occurred when a prisoner decided to swim away from his group as they cavorted in the water near Sabine Pass. Of all things to happen: he was badly stung by a Portuguese man-of-war and taken to the doctor by strangers. The doctor, in turn, called the military authorities. The limping runaway returned to camp, where the cheers of his fellow prisoners temporarily soothed the large red welts on his arms and legs.

Ironically, only a few miles off shore from the German POWs, German U-boats prowled the Gulf of Mexico in search of vulnerable ships. Whether the German POWs at Crockett knew about any of this is not known. Information about military matters was heavily censored during the war, and while the POWs couldn't help but speculate about the undersea war beyond the water's edge, there is no particular evidence that the Germans knew any details about their own submarines operating off the Galveston coast or their success in sinking American vessels.

One of the prisoners at Camp Crockett, Hans Stumpf, received some good news in January 1945. His father, who was also in Hitler's army, had been captured by the Americans, put on a Liberty Ship headed for the States and was currently cooling his heels in a POW camp in Missouri. Andreas Stumpf, at Fort Leonard Wood, learned that his son was being held at Camp Crockett and agitated for Hans's transfer to Missouri. His plaintive requests went all the way to the Provost Marshal General's Office in Washington, in charge of the POW program in the United States. Given the close relationship between the two men, the lateness of the war and old Andreas's persistence, Washington agreed, "provided it can be accomplished without cost to the United States Government including transportation and meals for the guard personnel." The authorities must have found the money because arrangements were made, and Hans Stumpf, his guards, personal effects and records were put on a train to Missouri, where he joined his father. They sat out the rest of the war in that American POW camp in Missouri.

As the war in Europe wound down during the spring of 1945, most of the prisoners had grown sick of war. Many hadn't heard from their families in Germany for months or more. Their American newspapers and magazines graphically described the bombings and the devastation to the fatherland. Some even learned of their family's deaths. They were shown newsreels of the newly liberated concentration camps, and while a sizeable number refused to believe what they saw, many knew in their hearts that they had been fighting for an evil cause. In March 1945, the prisoners at Crockett donated $353 to the International Red Cross and $442 to the YMCA, and April 20, Hitler's birthday, a tense day usually filled with speeches to the Führer's health, passed almost unnoticed. In fact, with the end of the war only weeks away, camp officials feared that some POWs might commit suicide when Germany surrendered. To prevent this, American officials doubled the guard details and ordered squads of MPs to practice their crowd-control tactics to suppress a major disturbance. Yet, when May 8 arrived, Germany's surrender passed

uneventfully. German POWs dispersed to various parts of the camp to talk, plan for the future or cry.

There was another reality to worry about: when would they return to the fatherland? Were their homes intact and families still alive? And, especially, would men from eastern Germany be forced to return to their new occupiers, the Russians, as required by the Geneva Convention? The prospect of being handed over to the Russians was blood-chilling, particularly after the brutality of Germany's invasion of the Soviet Union. The idea of being returned to occupied west Germany was no more appealing since most large cities were bombed to ruins and the economy was in shambles. Moreover, the camp rumor mill speculated about the possibility of a Nazi resurgence in Germany and that Germans who were too friendly to their American captors in the POW camps might be in trouble. An informal survey conducted among the POWs at Crockett indicated that half, it not more, wanted to stay in the United States.

Unbeknownst to them, however, an argument about their fate was raging at the highest levels. First, the American unions wanted them out of the country. "American boys will not return from overseas to find their jobs in the hands of enemy prisoners," thundered the union leaders. "But we need them here," countered American farmers. "Who's going to bring in the crops until the boys return?" To add to the confusion, General Lucius Clay, in charge of the American occupation forces in Germany, refused to take the German prisoners back. "The last thing we need," he growled, "is the appearance of nearly 375,000 well-fed German soldiers who hadn't experienced the last throes of Germany's defeat and might not believe how badly they had lost the war." The unions wanted them out, the farmers wanted them to stay and the deputy military governor of Germany didn't want them at all. President Harry Truman, never one to mince words, cut the Gordian Knot. "Get 'em out of here and give 'em to our Allies," was his decision. That may have solved the immediate problem, but it led to one of the darker episodes in American history. The German POWs spent the next several years in the unkind care of Britain and France, both of whom heaped their anger from two world wars on the German prisoners. They were put to work in the mines, building roads and clearing areas of explosives. Many German prisoners did not return home until early 1948.

The prisoners in Galveston, however, knew none of this. They spent the summer and autumn of 1945 speculating about ending up in the hands of the Russians and grousing about the sharp decline in the quality of food. Washington claimed that everything was needed for the approaching

invasion of Japan, but the POWs didn't believe it. They were convinced that with the war in Europe over, and America's prisoners safely liberated from German stalags, there was no reason for Washington to "pamper" the German prisoners any longer. The quality and quantity of their food did drop sharply, although they were far from hungry.

In August, the Japanese surrendered after the A-bombs destroyed Hiroshima and Nagasaki. The German prisoners continued to worry about their fates. Branch camps were feeding their prisoners to the larger base camps, and from there, groups of POWs were shipped to either Britain or France as shipping became available.

With the transfer of all the POWs at Crockett, the end came simply. The small POW compound on Galveston Island officially closed on May 8, 1946, and the entire military camp closed in 1947. In July 1953, the remnants of the camp were declared "surplus," and usable buildings were sold and carted off. They may be seen all around the island—at Galveston College, a church, Texas A&M University at Galveston and as housing for military personnel who were permanently stationed nearby with their families. A portion was cleared and sold privately for the construction of a large apartment complex, the Fort Crockett Apartments. The remaining twenty-two-acre Fort Crockett area property was purchased in January 1972 by entrepreneur, developer and civic supporter George Mitchell for $1 million to slant drill for offshore gas.

And so the war receded into the past. The German prisoners returned home from Britain and France, some as late as 1948. Because many learned some English while in the United States and developed a strong positive feeling for democracy, they found work with the British and American occupational forces. Moreover, they could prove that they were innocent of the atrocities in the east because they were sitting out the war on the other side of the Atlantic. Former POWs rose quickly in their businesses, and by the mid-1960s, one could scratch many a German CEO, writer, banker or politician and find a former prisoner of war. Regardless of their success, many still maintained contact with one another. For decades, they have held regular reunions and subscribed to newsletters. Many have written detailed memoirs about the war and imprisonment for their families, and aging groups of former POWs can still be found in their local beer halls, sitting around their regular Stammtisch and retelling dramatic stories about the war years. Once in a while, an elderly German in the group will smile and, for the umpteenth time, recall how he spent hot Texas afternoons frolicking in the surf on a beach in Galveston.

From the Sand Crabs to the White Caps

Professional Baseball in Galveston

Bill O'Neal

O h, pshaw! They have stolen our old game of town ball!"
Sporting fans of Galveston first witnessed baseball as played by
Union occupation troops right after the Civil War, and they immediately
recognized familiar qualities of the game. The first game between Yankee
soldier teams was played just north of the Ursuline Convent on an open
prairie. A number of Galvestonians came out as spectators, and soon the
citizens began to play a new version of town ball at locations throughout the
city. On San Jacinto Day, April 21, 1867, the Stonewalls of Houston crushed
the Robert E. Lees of Galveston, 35–2. Undiscouraged, Galvestonians
continued to organize such amateur nines as Major Burbank's Artillery,
Turf Association, Galveston Stars, the News, Athletic Drummers, Santa Fe
Athletics, Island Juniors, Bricklayers, Cornice Makers, Invincibles, Western
Union, Young Joplins and the Flyaways, a crack Negro team.

The first appearance of an all-professional team in Texas occurred in
Galveston in 1877. The Indianapolis professional club stopped over on a
barnstorming tour long enough to play an amateur team, but the Texans
were hopelessly overmatched. The Indianapolis pitcher, Edward "The
Only" Nolan, was an experienced pro with a sharp-breaking curve. Nolan
completely baffled the Texans, striking out twenty-six of twenty-seven men
he faced (one Galveston "hitter" managed to tap a ground ball to short).

During the next several years, the popularity of baseball soared throughout
the United States, and "major" and "minor" professional leagues were

organized. A Texas Baseball League was formed in 1884 with teams in Galveston, Houston, San Antonio, Waco, Fort Worth and Dallas. But each team paid only a few players, usually the pitcher, catcher and shortstop. This semipro circuit played from August 3 through October 16, with fifteen games scheduled for each club.

The first all-professional league in Texas was organized in a series of meetings late in 1887 and early in 1888. Galveston was the state's leading city and a key franchise. Other teams were from Houston, Austin, San Antonio, Dallas and Fort Worth. Amateur teams, as well as non-baseball forces, had already created keen intercity rivalries between Galveston and Houston, Austin and San Antonio and Dallas and Fort Worth.

William Henry Sinclair was the first president of Galveston's first professional baseball team, the Galveston Giants. *Courtesy of Special Collections, Rosenberg Library, Galveston, Texas.*

Colonel W.H. Sinclair was the first president of the Galveston Giants (also called the Galvestons and the Sand Crabs), and Charles Dooley was named player-manager. The Giants featured a battery of brothers, pitcher T. Stallings and catcher George Tweedy Stallings. George went up to Brooklyn in 1890 and later managed in the big leagues for a dozen years, leading Boston's "Miracle Braves" to a world championship in the National League. Infielder Joe Dowie also won promotion to the big leagues in 1889.

Togged out in maroon and blue uniforms, the Galveston club opened the inaugural Texas League season in Houston, accompanied by six hundred fans who paid $1.50 each to ride an excursion train. Although Houston "downed the Galveston Giants with apparent ease," the keen rivalry between the two cities stimulated attendance and gambling. Galveston finished fourth in 1888, repeatedly turning down a $500 guarantee from the Flyaways, who were frantic to play the white professionals.

The Galveston stockholders, like all Texas League owners, lost money in 1888. But backers were found for 1889, when the Sand Crabs again finished fourth, despite the efforts of batting champ Farmer Works (.372). In 1890, with Farmer Works as player-manager, the Sand Crabs won the pennant in a shortened season.

The Texas League did not operate in 1891, 1893 and 1894. But the next three Galveston teams—in 1892, 1895 and 1896—finished third. The 1895 club was the best, winning 16 games in a row and being paced by pitcher-manager George Bristow, who won 16 straight victories in a splendid 30-16 season; by 22-game winner Piggy Page; and by Will Blakely, who stole 116 bases—still an all-time Texas League record. Indeed, the hard-running Sand Crabs stole a total of 374 bases, another all-time Texas League mark. First baseman Pierce Nuget "No Use" Chiles would average .301 for Philadelphia's National League team in 1899 and 1900. His particular nickname derived from his favorite insult as a dedicated bench jockey.

The early home of Sand Crab baseball was Beach Park, located on Tremont near the beach and close to the site of the later Buccaneer Hotel. A board fence was erected around the field, and grandstands were built—one eighty feet in length, the other fifty—behind each foul line. Down the right field side, a special grandstand was put up "especially for the ladies from which they may view the game without being annoyed by the noisy crowd," and on April 11, 1888, a ladies' day was inaugurated—free admission every Wednesday. "Houlahan's tally board" was located on the right field fence, posting scores of all Texas League games, thanks to the telegraph wire at the scorer's table (several dives in town also had wires, for the benefit of gamblers).

In 1895, Sand Crab first baseman Charles Meyers recorded fifteen round trippers to become the home run champ. During this period, Meyers or some other Sand Crab slugger had a unique home run experience. Nelson Leopold, Galveston club president and owner from 1920 to 1924, was fond of recalling the controversial incident that happened when the Sand Crabs of the 1890s played a game against hated Houston at Beach Park.

"The outfield fence was right on the beach and there was a high tide on the day of the game," explained Leopold. One of the Galveston players slammed a pitch over the plank fence and began a leisurely trot around the bases. But, a wave washed the ball back under the fence, and a Houston outfielder hurled the soggy horsehide toward the catcher, who tagged the startled Sand Crab slugger. "There was the biggest hassle you ever saw about that," laughed Leopold. The beleaguered umpire finally decided that the home run would count, and Galveston went on to win the game.

The 1896 Sand Crabs finished in third place, but team president George Dermody put together another championship club for 1897. Batting champ Kid Nance (.395) and infielder Pop Weikert (.383) led the Sand Crabs to the 1897 pennant. The Spanish-American War diverted interest from baseball, and the Texas League operated only a little more than a month in 1898. The next year, George Dermody served as league president, but only Galveston, Houston, Austin and San Antonio fielded clubs. Galveston finished first in the four-team circuit, recording the third Sand Crab pennant in the nine Texas League seasons of the nineteenth century.

The Texas League could not field enough teams to operate in 1900 or 1901. It was revived in 1902 by playing with six cities in north Texas, which reduced travel expenses but excluded Galveston and other south Texas communities. In 1903, therefore, Galveston, Houston, San Antonio and Beaumont organized the South Texas League. The new circuit would play a split season, with the winners of the first and second halves of the schedule staging a postseason playoff series.

The Sand Crabs won the second half of the 1903 season but dropped a long playoff series to San Antonio. The next year, Galveston again won the second half, but Sand Crab owner Marsene Johnson refused to participate in postseason play in Houston, where the first-half winners had an unfenced park. All games of the playoff were staged in Galveston, which probably gave the Sand Crabs the winning edge in a 4-3-3 series. In each of the league's four seasons, Galveston had the leading hitter and pitcher of the South Texas League: outfielder-manager Ed Pleiss (.360) and Baldo Luitich (17-7) in 1903 and first baseman-manager Prince Ben Shelton (.352) and John Reuthor (24-7) in 1904. However, in 1905 and 1906, the Sand Crabs suffered losing seasons, going through a record eight managers in 1905.

By 1907, the northern and southern cities had decided to join forces. A merger brought Galveston back into a healthy, eight-team Texas League. The Sand Crabs abandoned old, outdated Beach Park for Gulfview Park, located at 2802 Avenue R. (Gulfview would be badly damaged by the hurricane of 1915.) The right field fence was merely 260 feet down the line. In batting practice, one fly ball after another would sail over the short fence, so the team instituted a rule that hitters had to retrieve any baseballs they hit over right. Eugene Moore Sr., a lefthander whose fondness for the sauce helped send him from the National League down to the minors, saw opportunity in the team rule. He deliberately pulled batting practice pitches over the right field fence and then dutifully jogged out of the park to find the ball. To

reward himself, Moore always stopped in at the nearby Blue Goose Saloon and downed a "cool one."

Moore was a native Texan in his late thirties. The former big leaguer led the Texan League in strikeouts in 1912 (213 Ks, with a sparkling 19-4 record) and in 1914 (240 Ks, 21-10). Crowd-pleasing C.H. Harben was a league leader in 1913 (204 Ks, 20-5). In 1916, infielder Ed Miller was hit by pitches twenty-seven times, establishing a Texas League record. But such unpleasing performances were about all Galveston fans had to enjoy because from 1907 to 1924, there were only four winning seasons. Indeed, Galveston dropped out of the league during the First World War.

Returning to Texas League play in 1919, the 1920 Sand Crabs staggered into last place with a miserable 49-100 record. But pitcher Bob Couchman established an all-time Texas League record with 34 complete games (in 37 starts; he pitched 309 innings and compiled an 18-17 record). Left fielder Dave Callahan led the league with a dead ball total of 12 home runs, but he only batted .252. Even during this dismal era, opening day attendance was at least 6,500 every year. Sunday attendance averaged 1,800 to 3,500, Saturdays 1,000 and weekdays 500 to 1,000.

A change of name to the Cubs brought no change of luck, although in 1923, Roy Ostergaard (.328 with 25 homers) walloped a record six grand-slam home runs. Ostergaard had suffered a broken shoulder and could not make the throw from third base, but Galveston manager Pat Newman decided he could play second successfully. Galveston owner Nelson Leopold picked up Ostergaard from the White Sox for $500 as damaged goods and then sold him back to the Chicago organization for $15,000 after the 1923 season. But shrewd deals could not offset poor attendance, and following seventh-place finishes in 1923 and 1924, the Galveston franchise was sold for $22,000 to the Texas League, which found a home for the Cubs in Waco.

Six years later, Shearn Moody brought Texas League ball back to Galveston by purchasing the Waco franchise and renaming his team the Buccaneers. The new owner built Moody Stadium at 5108 Avenue G. Although Moody's Bucs were managed by former big-league slugger Del Pratt, the 1931 team finished last with a dismal 57-104 mark, and the 1932 edition rose only to sixth place. But in 1933, under Manager Billy Webb, the Bucs finished second behind the play of George Darrow (22-7), third baseman Buck Fausett (.324) and outfielders Wally Moses (.294), Tony Governor (.294) and Beau Bell (.293). In the Shaughnessy playoffs (a postseason playoff system between the top four teams, utilized by almost all minor leagues to increase

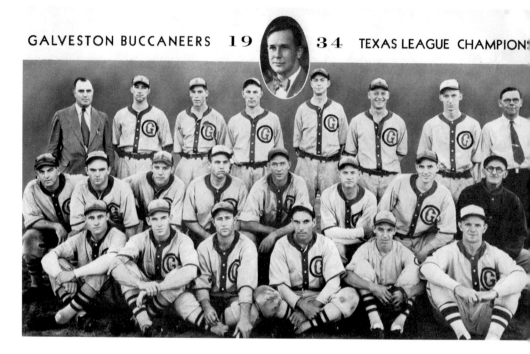

GALVESTON BUCCANEERS 19 34 TEXAS LEAGUE CHAMPION

The 1934 Galveston Buccaneers won the Texas League championship. *Courtesy of Special Collections, Rosenberg Library, Galveston.*

revenues), Galveston beat Dallas, three games to two, but lost six games to San Antonio, despite a shutout by Darrow in the fourth game.

Darrow was gone in 1934, but the hard-hitting outfield and most of the rest of Webb's team returned, and Moody bought pitching help. The Buccaneers squeaked into first place by a percentage point (.579 to .578) over San Antonio. Moses (.316) and Bell (.337) would go up to the American League the next year, and second baseman Charles English (.326) was voted the Most Valuable Player of 1934. In the playoff opener, the Buccaneers again beat Dallas and then once more faced off against San Antonio in the finals. More than 9,200 fans crowded into Tech Field to see Galveston win the first game on the road. San Antonio evened the series the next night, but when play shifted to Moody Stadium, Galveston took two in a row. Although the Missions won the fifth game, the Buccaneers clinched an outright championship with a 9–8 triumph back at Tech Field. In their only Dixie Series (the "World Series of the South," which pitted the champions of the Texas League against the Southern League champs in a best-of-seven playoff) appearance, Galveston lost to New Orleans in six games.

Most of the 1933–34 team was gone by 1935, but English (.304, with 104 RBIs) returned for another fine season. The best new players were Max Butcher (24-11, with 7 shutouts and 30 complete games in 36 starts) and left fielder Joe Prerost (.316). On July 10, Eddie Cole (15-19) won a 1–0 decision over Tulsa with the Texas League's first perfect game. The Bucs made the playoffs for the third straight year with a third-place finish. Galveston won the first two playoffs games in Moody Stadium over Beaumont and then dropped three in a row to the Exporters.

Shearn Moody died unexpectedly in 1936, and the Buccaneers sank to last place. Roy J. Koehler handled the club for Moody's estate, but he was badly injured in an accident, and after a sixth-place finish in 1937, the club was sold to Shreveport for $23,000.

Thirteen years after dropping out of the Class AA Texas League, Galveston resumed professional baseball, playing for half a dozen seasons in leagues of lower classification. Minor-league baseball soared in popularity in the years following World War II. In 1950, the Class C Gulf Coast League was formed by six cities: Galveston, Port Arthur, Lufkin, Jacksonville and, in Louisiana, Crowley and Lake Charles. The Galveston White Caps finished second, eleven games behind Crowley, and posted the league's leading attendance with 89,592 fans. White Cap hurler Ramon Rogers was the ERA champ at 2.51, but the team lost to Jacksonville in the opening round of playoffs.

The Gulf Coast League advanced to Class B in 1951 by expanding to eight teams. But Galveston's club was mediocre and finished fifth. The next season, the White Caps managed a fourth-place finish but lost to first-place Port Arthur in the playoff opener. Twenty-two-game winner Ray Contreras led the league's pitchers in victories.

In 1953, the White Caps roared to first place, winning the last Gulf Coast League pennant by eight games over second-place Texas City. Slugger Henry Robinson led the league with 29 homers and 130 RBIs, while power pitcher Tillman Conovan won the strikeout title by whiffing 212 batters. Galveston handily beat Laredo in the opening round of playoffs, winning four out of five games. Still, Texas City won the playoff trophy, dumping the Whitecaps in the finals, four games to two.

By 1953, the spread of television, along with other forces, had reversed the minor-league prosperity of the postwar years. Attendance declined precipitously, causing teams to fold and entire leagues to disband. The Gulf Coast League disbanded, while another Class B Texas Circuit, the Big State League, survived thanks to a skilled minor-league executive, Howard Green. Green had served as president of the Gulf Coast League from 1950 through

1952, and he persuaded Galveston, Harlingen and Corpus Christi to bring their teams to the Big State League.

Early in the 1954 season, Galveston enjoyed the services of the league's best player, Dean Stafford, who won a Triple Crown (.362, 38 HR, 171 RBI). But Stafford was traded to Corpus Christi, and the White Caps sagged to fifth place. Ominously, only 34,205 fans came to the ballpark. The White Caps had another mediocre team in 1955. Attendance remained weak, and on June 12, with a record of 28-30, the White Caps disbanded. Tyler pulled out on July 1, and the league staggered on with six clubs. The Big State League played for two more years and then disbanded after the 1957 season. By that time, professional baseball was a faded memory in Galveston, but baseball buffs will always recall the Sand Crabs, the Pirates, the Buccaneers and the White Caps.

About the Authors

PATRICIA BELLIS BIXEL is an associate professor of history at the Maine Maritime Academy. She received her PhD from Rice University. She has published several books on Texas maritime history, including *Galveston and the 1900 Storm: Catastrophe and Catalyst*.

CHESTER BURNS (deceased) was the James Wade Rockwell Professor of Medical History at the Institute for the Medical Humanities, University of Texas Medical Branch. He received his PhD from Johns Hopkins University. He wrote several books on medical history, including *Saving Lives, Training Caregivers, Making Discoveries: A Centennial History of the University of Texas Medical Branch at Galveston*.

GARY CARTWRIGHT is an independent writer. He received his BA from Texas Christian University. He is a writer for *Texas Monthly* and has written several books, including *Galveston: A History of the Island*.

MARGARET SWETT HENSON (deceased) was a retired professor of history at the University of Houston Clear Lake. She received her PhD from the University of Houston. She published several books on early Texas history, including *Samuel May Williams: Early Texas Entrepreneur*.

ARNOLD KRAMMER is a professor of history at Texas A&M University. He received his PhD in history from the University of Wisconsin. He is the author of numerous books, including *Nazi Prisoners of War in America*.

DAVID McCOMB is a professor emeritus of history at Colorado State University. He received his PhD from the University of Texas at Austin. He is the author of numerous books on Texas history, including *Galveston: A History*.

BILL O'NEAL is a retired chair of social sciences at Panola Junior College and is the state historian of Texas. He is the author of numerous books, including *The Texas League: A Century of Baseball*.

MERLINE PITRE is a professor of history and the former dean of social sciences at Texas Southern University. She received her PhD from Temple University. She is the author of several books on African Americans in Texas, including *In Struggles Against Jim Crow: Lulu B. White and the NAACP, 1900–1957*.

ROBERT SHELTON is an associate professor of history at Cleveland State University. He received his PhD from Rice University. He is writing a book on Norris Wright Cuney and African American labor in Galveston.

EDWARD SIMMEN is a professor emeritus in modern languages at the Universidad de Las Americas in Cholula, Mexico. He received his PhD from Texas Christian University. He is the author of numerous books on Mexican-American literature, including *With Bold Strokes: Boyer Gonzales, 1864–1934*.

ELISE HOPKINS STEPHENS is a retired professor of history at Alabama A&M University. She received her MA from Yale University. She is writing a book on the women of the Kempner family.

DONALD WILLETT is a professor of history at Texas A&M University at Galveston. He received his PhD from Texas A&M University. He has published numerous books on Texas history, including *The Texas that Might Have Been: Sam Houston's Foes Write to Albert Sidney Johnston*.

LARRY WYGANT is a retired research archivist at the University of Texas Medical Branch in Galveston. He received his PhD from the University of Texas Medical Branch. He has published numerous articles on public health and woman suffrage.